INSIDE BRUEGEL

THE
PLAY OF
IMAGES IN
CHILDREN'S
GAMES

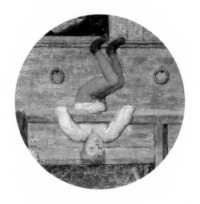

North Point Press

Farrar, Straus and Giroux

New York

INSIDE

BRUEGEL

EDWARD SNOW

North Point Press
A division of Farrar, Straus and Giroux
19 Union Square West
New York 10003

Copyright © 1997 by Edward Snow
All rights reserved
Distributed in Canada by Douglas & McIntyre Ltd.
Printed in the United States of America
Designed by Cynthia Krupat
First edition, 1997

Library of Congress Cataloging-in-Publication Data
Snow, Edward A.
Inside Bruegel : the play of images in Children's games / Edward
Snow.
p. cm.
Includes index.
ISBN 0-86547-527- X (cloth : alk. paper)
1. Bruegel, Pieter, ca. 1525–1569. Children's games. 2. Bruegel,
Pieter, ca. 1525–1569—Criticism and interpretation. 3. Games in
art. I. Title.
ND673.B73A63 1997
759.9493—dc21 *97-10538*

Parts of this book appeared, in somewhat different form, in The Threepenny Review,
Representations, The Kenyon Review, *and* Raritan.
I would like to thank the National Endowment for the Humanities and the Center for
Advanced Study in the Visual Arts for their generous support of research for this book.
I also would like to acknowledge special debts of gratitude to Michael Gervasio and Laurie Smith,
who provided crucial insights, and to Leo Steinberg, who counseled me to wait.
—E.S.

To Winnie

Contents

In play there is something "at play."

JOHAN HUIZINGA, *Homo Ludens*

INSIDE BRUEGEL

Introduction

Peter Bruegel's *Children's Games* (1560) presents painting as a way of thinking. And this thinking entails a way of looking, a certain willingness to credit what one finds inside images. Consider the boys playing tug-of-war in the painting's central region (Fig. 1).

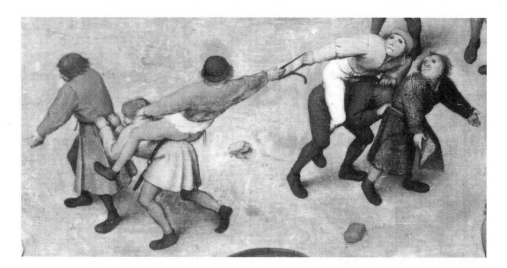

Fig. 1

One can regard this image as a straightforward illustration of sixteenth-century behavior. But even from that historical standpoint one has to marvel at how Bruegel can transport us across four centuries into the immediate *kinesis* of the game. The boy being stretched toward the right offers a heightened experience of the body per se. The collective muscular energy the players expend seems to energize the image and leap across the belted loop from one contending group to the other. It is as if the game holds out the human bond as a synaptic gap. And with this idea active in the image, many other issues of the social body can come into play: co-operation based on opposition, the individual's visceral experience versus

anonymous collective purpose, power struggles taking place on the backs of laboring lower classes, linear energy bound in circular configurations, and opponents as stabilizing counterparts. A self-contained detail becomes a switching point where all sorts of thematic tracks intersect.

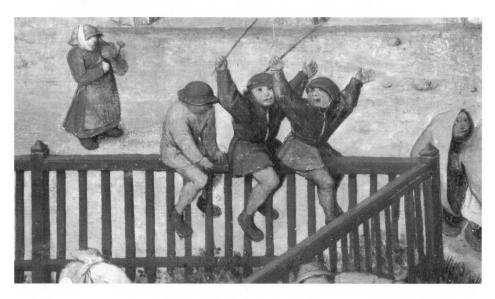

Fig. 2 Even the painting's minor details open up this way to vision. Take the three fence riders just beneath the central building's Gothic arches (Fig. 2). Though all three boys are playing the same game together, Bruegel directs us to their differences. He pairs the first two riders (a red cap helps us tell them apart) and then portrays the third almost as if he is a member of some alien species. It is a difference of more than dress and physique: the twinned pair fling themselves outward, while the third boy remains hunched in and only half-disclosed. Latent themes seem present here also: the effortful "whipping up" of shared experience in the first two boys, the potential for disconnection in the third; a contrast between passive and aggressive modes of involvement that might translate at the psychic level into "manic" and "depressive"; the more general question of how "one" human and "two" humans become a collective "three." Even the kinetic postures of what we might call "outflungness" and "indrawnness" become structuring motifs: they revolve, for instance, in the game of leapfrog (see foldout), and materialize as gendered opposites in the hunched stilt walker and the small girl gesticulating beneath him.

The fence riders also "progress" from left to right, as if they represent degrees of mastery or points on a learning line. Bruegel strengthens this perception by isolating a piece of fence farther back to the left and attaching to it another boy trying to mount—with prospects for success

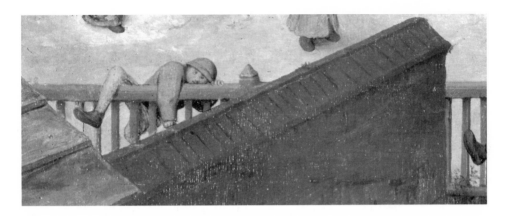

that seem uncertain at best (Fig. 3). The leftmost of the three mounted Fig. 3 riders is at the difficult first stage: he still holds on with both hands and has to concentrate all his effort on maintaining balance. The second boy, by contrast, lifts his arms high, just this side of full competence. Only a slight tentativeness in his gesturing (his lash still helps him balance) and a residue of caution in the way he bears himself separate him from the virtuoso front rider he seems trying to keep up with. This foremost boy's momentum seems to have carried him *past* the point of mastery, over into an almost antithetical realm of excess and wild exuberance. (His lash triumphs over gravity.) He has left the learning process behind. The spirit that possesses him places competence at hazard. Given his example, one would be hard-pressed to say whether "purpose" or "anti-purpose" is at play in play.[1]

The twinned boys, then, also *differ* across a complex threshold. And the painting works many variations on both the difference and the threshold. The two gauntlet runners make their ways with analogously different mixes of zeal and caution. The foremost barrel rider attacks his game with a recklessness that balances his counterpart's timidity. The pillar that divides the top spinners into a group and a single player marks a threshold across which an extrovertive energy appears—ominously—to come under

the self's control (Fig. 4). The game of "how many horns does the goat have?" (Fig. 5) has been so infiltrated by a spirit of excess that the rules which govern it seem lost or out of action, and its underlying structures of dominance and submission (Fig. 6) virtually incidental to a passion for coupling bodies and adding on. Even a simple game like "odds and evens" (Fig. 7) inserts cryptic differences into the space between.

Thinking one's way into the particulars of *Children's Games*, then, can lead one out into many general areas at once. The rationale of play, the innocence of children, the social imperative, the body's urges, the forms of culture, the affect in images, Bruegel's vision, Renaissance beliefs, the status of one's own perception—all come into question. And whatever route one takes through the painting, the incredible details are always there, catching one's attention and shaping one's responses. Remaining true to this language of detail and visual nuance while trying to convey its discursive range is one of the challenges that writing about *Children's Games* poses. No sustained investigation of the painting can hope to reach summarizable conclusions. The painting's "aboutness" can be made manifest, but only as the tacit dimension of an inquiry that keeps producing what Blake calls "particular knowledge."[2] And because in *Children's Games* Bruegel so brilliantly makes the human figure "come alive" in consciousness, a sense of empathetic connection needs to underlie the whole reflective enterprise. "Caress the details, the divine details," urged Nabokov. Yes—as long as "caressing" entails opening up, being infiltrated, going farther and farther inside.

———

When I began this inquiry in 1979, all I intended was a short essay on a single image group in *Children's Games*. (That starting point now occupies pages 136–40 of the present book.) But looking closely—and slowing down to write—was enough to trigger the painting's unfolding of motifs, so that eventually the whole of *Children's Games* was under scrutiny, along with many other works in Bruegel's oeuvre. And as the material of interpretation increased exponentially, historical context became crucial, both as an area of responsibility and as an issue to be addressed. Sixteenth-century attitudes toward children, the Renaissance fascination with plural meanings, the conflicts of Bruegel's cultural moment—all impinge on *Chil-*

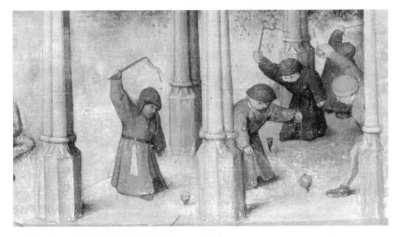

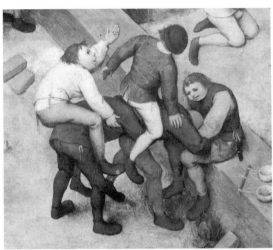

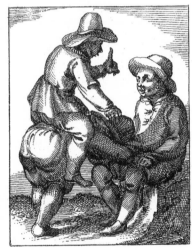

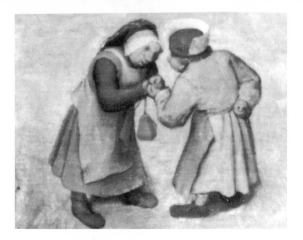

Fig. 4

Fig. 5

Fig. 6. Claes Jansz.
Visscher, emblem from
Pieter Roemer Visscher,
Sinnepoppen, 1614
(Houghton Library, Har-
vard University)

Fig. 7

7

dren's Games, but none provide viewpoints that ground it or limit its meaning. Another of the challenges of this book has been to make the painting's contextual milieu available while at the same time treating context as a complicating factor, a fund of possible connotations rather than a controlling frame.

Now, eighteen years and countless details later, this book is still not really finished, but I can hear voices saying, "Enough." In my poorer moments I fear that time has passed this study by. But when I look at the course Bruegel criticism has taken, I can't see that the case I want to make for a "modern" Bruegel—modern in the same sense that Shakespeare is modern—has yet been proposed. And as for the "close reading" this book's approach exemplifies, I must confess that it seems to me not obsolescent but vital and endangered—a meditative activity that is also political in the deepest sense. Political, that is, in its holding out against the mandates in culture that would hasten its demise. Nietzsche, in his preface to *Daybreak* written in the autumn of 1886, described a cultural climate that unsettlingly resembles our own, and opposed to it an activity he chose to call "slow reading." It is one of the most beautiful passages he ever wrote:

This preface is late but not too late—what, after all, do five or six years matter? A book like this, a problem like this, is in no hurry; we both, I just as much as my book, are friends of *lento.* It is not for nothing that I have been a philologist, perhaps I am a philologist still, that is to say, a teacher of slow reading: —in the end I also write slowly. Nowadays it is not only my habit, it is also to my taste . . . no longer to write anything which does not reduce to despair every sort of man who is "in a hurry." For philology is that venerable art which demands of its votaries one thing above all: to go aside, to take time, to become still, to become slow—it is a goldsmith's art and connoisseurship of the *word* which has nothing but delicate, cautious work to do and achieves nothing if it does not achieve it *lento.* But for precisely this reason it is more necessary than ever today, by precisely this means does it entice us and enchant us the most, in the midst of an age of "work," that is to say, of hurry, of indecent and perspiring haste, which wants to "get everything done" at once, including every old or new book: —this art does not so easily get anything done, it teaches to read *well,* that is, to read slowly, deeply, looking cautiously before and aft, with reservations, with doors left open, with delicate eyes and fingers.[3]

I have tried to write on Bruegel in the spirit of Bruegel, not Nietzsche, and so the traces of self-justification, rancor, and pedagogical fervor in this passage cause me some unease. Yet the passage voices strongly the desire in which this book on Bruegel has gestated. I offer the book now as a contribution to Bruegel studies, but also as an inducement to "slow reading." Deep down, I like to think, we are all friends of *lento.*

PART ONE

Thinking in Images

At the ledge of the window in the left foreground of *Children's Games* (see foldout), two faces are juxtaposed (Fig. 8). One is the round face of a tiny child who gazes wistfully off into space; the other is the mask of a scowling adult, through which an older child looks down on the scene below, perhaps hoping to frighten someone playing beneath him. Bruegel takes pains to emphasize the pairing by repeating it in the two upper windows of the central building (Fig. 9). Out of one of these, another small child dangles a long streamer and gazes at it as a breeze blows it harmlessly toward the pastoral area on the left; out of the other, an older child watches the children below, apparently waiting to drop the basket of heavy-looking objects stretched from his arm on an unfortunate passerby.

 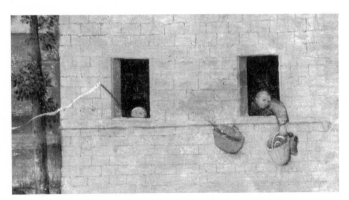

At the two places in the painting that most closely approximate the elevation from which we ourselves view the scene, Bruegel has positioned images that suggest an argument about childhood. The two faces at the windowsill pose the terms of this argument in several ways at once. Most obviously, they juxtapose antithetical versions of the painting's subject: the child on the right embodies a blissful innocence, while the one on the left

Fig. 8 / Fig. 9

13

makes himself into an image of adult ugliness. But they also suggest an ironic relationship between viewer and viewed: we see a misanthropic perspective on childhood side by side with a cherubic instance of what it scowls upon. And at the level of our own engagement with the painting's images, the faces trigger opposite perceptual attitudes: one encourages us to regard appearances as innocent, the other to consider what is hidden beneath them.

Interestingly enough, the two faces correspond in all these respects to the opposing interpretations of *Children's Games* that Bruegel criticism has given us to choose between. The iconographers, looking beneath the games for disguised meanings, view them as the inventions of "serious miniature adults"[1] whose activities symbolize the folly of mankind and the "upside-downness" of the world in general.[2] The literalists, on the other hand, argue that the games are innocent and carefree, and that they are depicted "without recondite allusion or moral connotation."[3] Indeed, the faces at the window can be seen as images of these two ways of looking at things as well as epitomes of the childhood they view. The face on the right presents the ingenuous gaze. It is obviously incapable of perceiving corruption or looking beneath surfaces. Bruegel portrays its innocence fondly but has it gaze off into space, away from the spectacle that he himself has organized. The adult mask, in contrast, peers intently on the scene below, but with a misanthropic scowl that is ingrained in its features, and with eyes that are as empty and incapable of vision as the small child's wistful gaze.

The two faces, then, not only suggest that the issues underlying the critical disagreement about *Children's Games* are thematically present in the painting but also lead one to suspect that neither of the opposing interpretations quite corresponds to Bruegel's own view of things. The mask and the child next to it grow strangely alike, in fact, in their mutual blindness to what the painting gives us to see.[4] Bruegel elaborates on what they have in common by opposing both to a girl in a swing behind them. Her active involvement contrasts vividly with their spectatorial detachment.[5] Nor can her unrestrained kinetic exuberance be assimilated to the dialectic of innocence and experience they imply. The mask shows childhood growing into ugly, predetermined adult forms, and at the same time pictures the misanthropic, supervisory point of view where such ideas of childhood

development thrive; the face on the right, for all its difference, reciprocates by picturing childhood innocence as fragile and passively vulnerable to corruption. The girl, by contrast, is the image of an empowered innocence: she could aptly illuminate the margins of Blake's "Energy is Eternal Delight."[6]

This cluster of details is paradigmatic of how meaning suggests itself in *Children's Games.* There is evidence everywhere of a sophisticated dialectical intelligence and a capacity for what Cézanne called "thinking in images" at work binding superficially unrelated incidents into elaborate structures of intent. This is not, however, a version of Bruegel with which we are likely to be familiar. The critical tradition has accustomed us to think of him as a cataloguer of contemporary customs, or as a moralist whose images possess intellectual content only insofar as they illustrate proverbs or ethical commonplaces. Thus the many studies that undertake to identify the games Bruegel has depicted gloss the face on the left as "masking" and the girl in the background as "swinging," but they refrain from mentioning the face on the right, since that child is apparently not playing at anything. The iconographers, on the other hand, concentrate entirely on the mask and make it central to an interpretation that turns the painting into a comment on human folly and "deception."[7]

As different as these approaches are, both address the problem of meaning by removing individual images from the painting's internal syntax and situating them in an external field of reference—in one case the everyday life of sixteenth-century Flanders, in the other a lexicon of conventional significations. Yet the painting's elaborate syntax (if that is not too orderly a term for something so unruly) is the medium in which its thought takes form. Within the apparent randomness of the games there is an incessant linking of antithetical details. We have already seen how the faces juxtaposed at the window are mirrored by two children looking out of the building across the street. The gently floating streamer of one of those children is balanced by the heavy basket of the other. That basket, open and precariously hanging from the boy's arm, is paired with one that is closed and tightly fastened to the wall. This opposition is embodied again in the two boys hanging from the narrow table ledge in front of the building's portico—one clinging to it tightly, the other dangling from it lazily—while behind them a girl balancing a broom on her finger takes up a position

analogous to that of the girl swinging behind the two children at the windowsill (Fig. 10).

Such patterns begin to appear everywhere as one becomes attuned to the way the painting "thinks" in terms of oppositions. And where its pairs seem most obviously to generate significance, they tend to frame questions about the place and nature of human experience, not settled moral judgments about it. An especially pointed example of how the difference-creating syntax of the painting counteracts the impulse to burden individual images with moral content can be seen in the two barrel riders in the right foreground (Fig. 11). Taken by themselves they would be quite at home in any late-sixteenth- or early-seventeenth-century emblem book, where they would no doubt signify the treachery of worldly existence. But Bruegel has paired their mount with another barrel and established an elaborately antithetical relationship between them: one upright, the other tipped over on its side; one contended with by two awkwardly cooperating boys, the other being called into by a curious girl. Seen in terms of this opposition, the two boys seem an emblem not so much of the folly of the world as a certain mode of relating to it. They and the girl present us with dialectically related ways of worldmaking.[8] One takes the object in hand in order to dominate it and undoes a given stability in order to create a man-made equilibrium; the other "lets be" and calls forth (into) the object-world's mysterious resonance. The painting works many subtle variations on this distinction, and they will be discussed later in this study. But what needs to be stressed at the outset is the presence in *Children's Games* of a shaping intelligence that tends to subsume moral issues in dialectical questions about human beings' place in a world that can scarcely be conceived apart from their bodily and imaginative participation in it.

There is also opposition *within* individual images. Time and again a detail will cause the viewer to vacillate between innocent and darkly emblematic readings. We know, for instance, that the boy running up the incline of a cellar door in the receding part of the street is only playing a game, and we can feel the fun of it; yet it is difficult to resist the adult perception that turns him into a figure of futility and despair. The children in the foreground play innocently at rolling hoops, but a sophisticated viewer must strain *not* to respond to them as evocations of human emptiness.[9] A youngster in a cowl whipping a top under a Gothic arch

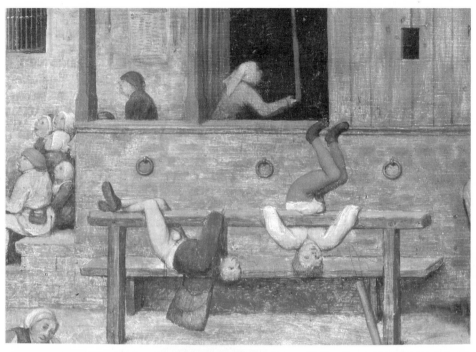

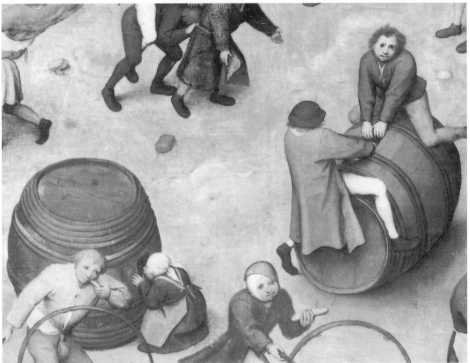

Fig. 10 / Fig. 11

17

(Fig. 12) can with the blink of an eye suddenly evoke the scriptural Flagellation or the judicial whipping post. A boy on stilts and an open-armed girl beneath him (Fig. 13) can conjure the iconography of the Crucifixion. Are such ambiguities and foreshadowings "in" the games or "in" our perception of them? Does the mask with the grimace on it represent the terrible adult countenance into which the children are already in the process of growing or the distorted perspective through which adults observe them? Is play a rehearsal for adulthood or is adulthood a loss of the spirit of play?

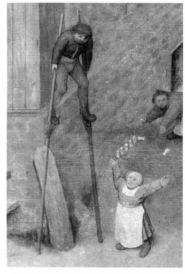

Fig. 12 / Fig. 13

Such questions have no simple answers, especially in the form that *Children's Games* poses them. They are a function of instabilities within the perception of childhood (and childhood play) that Bruegel deliberately exploits. We will be concerned throughout this study with the fields (thematic, cognitive, kinetic, cultural, iconographic) within which these instabilities operate, and with the various ways they infiltrate the act of viewing. But again, it is worth noting at the start how often emblematic and iconographic cues that at first glance might appear to fix the painting's meaning turn out to be only one facet of an unstable, overdetermined perception; and how, as a result, "references" to external conventions and contexts tend to get subsumed in cognitive uncertainty and an unanchored connotative play.

18

Moral Fixities

and Connotative Play

Bruegel uses permutations as well as antithetical pairings to weave authorial design into the apparent chaos of *Children's Games.* Consider the boy running up the cellar door and the blank-looking woman next to him throwing the contents of her bucket on two children fighting in the street (Fig. 14). The juxtaposition of these unrelated events is only an effect of perspective, but they tend to come together in the viewer's imagination as

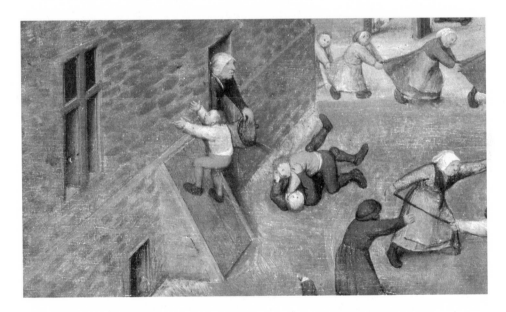

well—the spirit of the indifferent brick wall materializing in the woman who leans out of it, and her gesture becoming a displaced rejection of the boy's open-armed appeal. The feeling of intent in this overlapping of discrete incidents grows stronger when one notices how elaborately the elements of the image group reconfigure elsewhere in the painting. Against the wall of the building in the left foreground, for instance, where a group

Fig. 14

plays "blindman's buff" (Fig. 15), it is the maternal figure—here literally blindfolded rather than expressionless and unseeing—who gropes with the wide-open gesture of the boy on the cellar door (she even wears his colors), while the children who mill around her evade or refuse *her* reach. The components of this game are reconfigured again in the obscure game of covering and uncovering being played to the left of the central building's arches (Fig. 16). There the blindfold becomes a blue cloth (presumably an apron) which another maternal-looking figure (perhaps an older child)

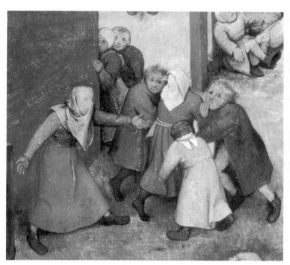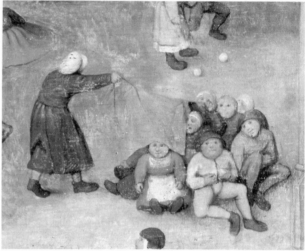

Fig. 15 / Fig. 16 reaches out to cast over one of a group of small children, who instead of running from her sit passively in a cluster, awaiting her choice with what looks like happy expectancy. This configuration, in turn, is reordered in the juxtaposition at the side of the building: the older figure's covering gesture is the benign counterpart of the blank-faced woman's dousing of the boys fighting in the street, while those boys are the antithesis of the passive aggregate waiting for the blue cloth to descend on them.

The blue cloth undergoes a further transformation to become an improvised cowl draped over the head of each of two figures who bring up the rear of a baptismal procession moving toward the lower-left-hand corner of the painting (Fig. 17). Once again there is interaction between a small child and a parental-looking figure, and once again the link between them is indicated by a reaching gesture, which appears in this case both to express a watchful solicitude and to encourage separation.

Fig. 17

What, if anything, are the ideas that correspond to this elaborate per-mutation of motifs? Carl Gustav Stridbeck is the only one of the painting's interpreters to address this question, and his answer is worth considering in detail, since it has proved so influential on subsequent commentary about the painting. Stridbeck calls attention to the motif of being covered with a blue cloth that is common to three of the games and asserts that it alludes to the "blue cloak" of folly and deception that figures prominently in Bruegel's painting of a year earlier, *Netherlandish Proverbs* (Fig. 18).[1] It follows for Stridbeck that the three incidents in *Children's Games* must also refer to lying and deception. He informs us that blue is the color of deception and folly (and that red, the other dominant color-motif in the painting, signifies ignorance, rudeness, and "related concepts"). The con-clusion of this and similar analyses of a handful of other games is that the painting is, like *Netherlandish Proverbs* and *The Battle between Carnival and Lent* (Fig. 19), a representation of "the world upside down," in which, among other things, "human existence is uncertain and treacherous, and no one can rely on his fellow man."[2]

I think it is fair to say that the quality of this argument is representative of the growing number of studies that purport to find a "moral meaning" in Bruegel's paintings. One would think that such sweeping generaliza-tions based on abbreviated analyses of a few of Bruegel's multitudinous details would be greeted with skepticism, but just the opposite has largely been the case. One of the disconcerting things about Bruegel criticism, in fact, is the way the easily remembered formulations of this approach have

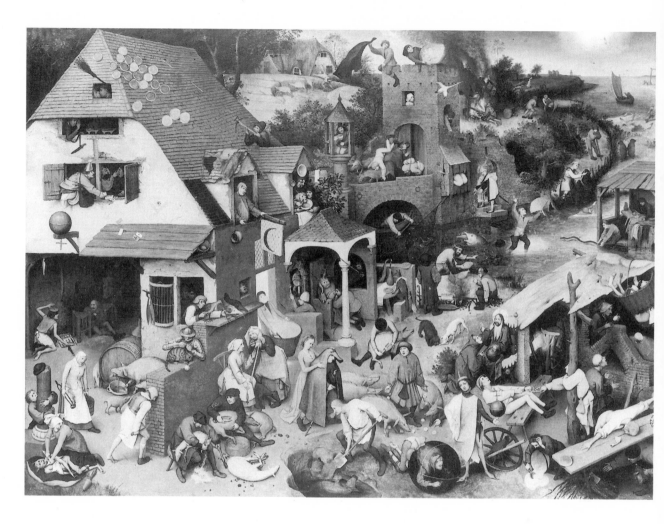

tended to become canonical to further study of the artist, regardless of how
tenuous the evidence or questionable the logic upon which they are based.
A modern study of Bruegel's landscapes, for instance, which sets out to
prove that their aesthetic appeal is a form of worldly pleasure we are re-
quired to renounce for an ascetic Christian truth, at times bases its argu-
ment almost entirely on an uncritical acceptance of the formulations of
Stridbeck and those who share his moralistic point of view: "If, for ex-
ample, we agree with Grossmann's and Stridbeck's interpretations of the
paintings devoted to peasant dances and weddings, then we see those
paintings as being 'about' lust and gluttony." Or again, at the conclusion
of an interpretation of *The Conversion of St. Paul* (1567) that relates that
painting to the engraving of Bruegel's *The Penitent Magdalene* (1553):

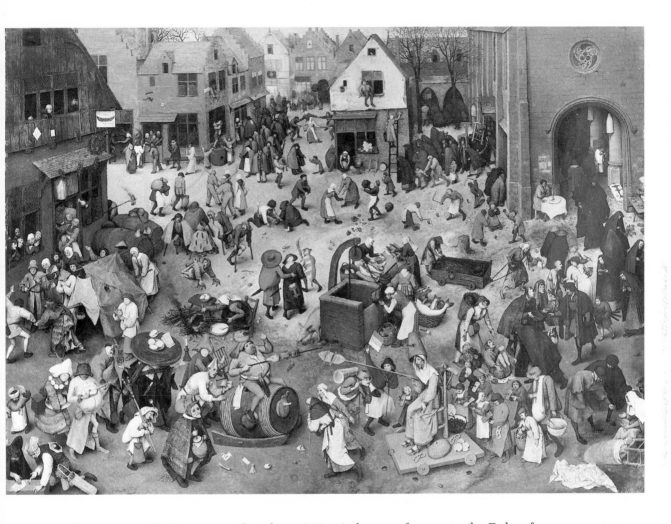

If we agree with Grossmann that the painting is less a reference to the Duke of Alva than it is "an exhortation to follow God"; if we agree with Stridbeck that analogies with Hercules at the crossroads are possible, and the painting emphasizes how narrow the way is for the true Christian; if we agree with K. C. Lindsay and B. Huppé that the painting insists that Paul—who now sees the light while others remain spiritually blind—is separate from the worldlings who surround him; if we agree with these opinions, it would seem reasonable to see the whole landscape as the world from which Paul is now as separate as is the Magdalene beneath her thorny logs.[3]

Here is an example of how an accumulating critical tradition can make it increasingly difficult to make contact with the object commentary seeks

Fig. 19. Bruegel, *The Battle between Carnival and Lent*, 1559 (Kunsthistorisches Museum, Vienna)

to explain. For *The Conversion of St. Paul* presents us with what would seem one of the least moralizable of landscapes (Fig. 20). Worldlings make their way here as best they can, through ancient rifts. The way is narrow for everyone, not just true Christians, and its fissures certainly don't present those who travel them with "crossroads." We scarcely need an exhortation to alienate us from this landscape, where trees rise like

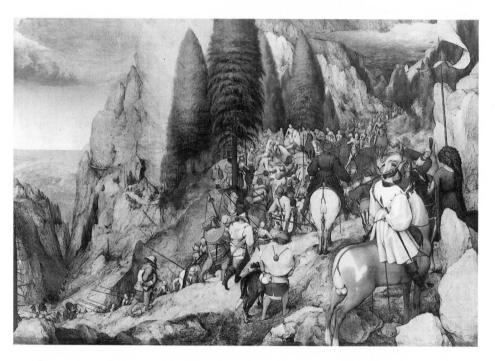

Fig. 20. Bruegel, *The Conversion of St. Paul*, 1567 (Kunsthistorisches Museum, Vienna)

mushrooms and one surrealistic cloud—shaped like a rock formation that should be pointing upward—is all there is of the horizontal world. It provides an apt setting for a conversion, but not one disposed in moral terms. We seem closer to the realm of Job than to the Gospels—as if the incomprehensible force that felled St. Paul were the same one that long ago split this world in two.

The painting does, then, seem to challenge the notion that man is at home in nature—but from a perspective not recognizably Christian. And this perspective, however we understand it, is in turn only one side of a characteristically "antithetical" view. Its pendant in Bruegel's oeuvre is *John the Baptist Preaching*, where the horizontal world prevails and nature seems actively sympathetic to human presence and the congregating in-

stinct (Fig. 21). There the Baptist's gesture directs us past an unobtrusive Jesus to a gentle, calmly inhabited river landscape that balances any desire for transcendence with the reassurance of ongoing present life. Both these paintings depend for their full meaning on subtle discrepancies between subject and setting, and on their place in the total shape of Bruegel's oeuvre; and our only real access to either of these dimensions of significance

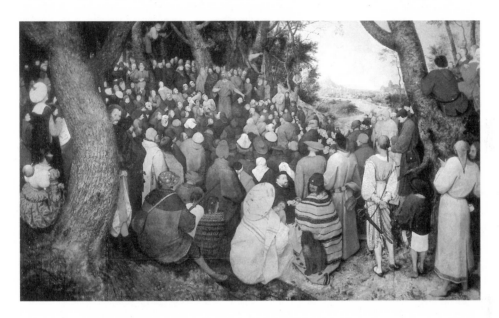

Fig. 21. Bruegel, *John the Baptist Preaching*, 1566 (Szépmuvészeti Muzeum, Budapest)

is our intuitive feel for the work—precisely that aspect of it which the iconographic approach tends to regard as either irrelevant to or at odds with its intellectual content.

References to Stridbeck's interpretation of *Children's Games* as a representation of human folly have likewise become commonplace in Bruegel studies.[4] Even Sandra Hindman's elaborately synthetic reading of the painting is based on moralistic premises it accepts as already "demonstrated" by Stridbeck.[5] Yet Stridbeck's argument, as I would like to show in detail now, depends almost entirely on generalizations held together by doubtful assumptions. If I choose to dwell at such length on a specific interpretation of the painting, it is because the questions it raises (or rather fails to raise) are so large: at stake is not just a disagreement about the meaning of *Children's Games* but issues that are crucial to any interpretation of Bruegel.

First there is the matter of children's games in general as emblems of folly. The *visual* material Stridbeck draws upon to demonstrate the existence of such a topos consists of two emblem books compiled more than fifty years after *Children's Games* was painted: Pieter Roemer Visscher's *Sinnepoppen* (1614) and Jacob Cats's *Silenus Alcibiadis sive Proteus, Vitae Humanae Ideam, Emblemate . . .* (1618).[6] No earlier extensive use of children's games as visual images of human folly has been discovered.[7] While the existence of such works implies that by the early seventeenth century there existed a habit of mind that might have been inclined to approach the details in *Children's Games* as transparently coded images, it is questionable what can be inferred from this about the visual predispositions of Bruegel's contemporary viewers, for whom emblem books would have been a novelty, not a long-standing tradition. Certainly other connections would have been more immediate. The exhaustive list of children's games in Rabelais (c. 1483–1553) would have seemed a direct precursor; the children's games in the margins of illuminated manuscripts a more remote but equally compelling reference point. And both these contexts tend to be

Fig. 22. "October," from *The Golf-Book*, early 16th century (British Library, London)

amoral and ludic in their use of children's games: the one fusing humanist *copia* and carnivalesque excess, the other filling the margins of the serious, marking off its area yet playing outside its bounds (Fig. 22).

This is not to deny the existence of viewing habits that would have encouraged a reading of Bruegel's images. Erwin Panofsky long ago showed how the apparent realism of Northern Renaissance art was from its inception "saturated with meaning," and I hope my own interpretation of *Children's Games* will suggest the extent to which Bruegel's details are designed, to borrow another of Panofsky's terms, as "corporeal metaphors."[8] But there can be a world of difference between images saturated with meaning and images coded with morality. Just how Bruegel's games exceed the realistic and how their figurative dimension operates should be considered open questions—and would have been, I think, in 1560, when the contest of images was still being played out and the cozier emblematic traditions of the seventeenth century had not yet taken hold. One needs to be skeptical of claims about the existence of visual habits that would have prompted Bruegel's audience to refer the games his painting depicts to well-known emblematic readings in which every image, regardless of its eccentricity, signifies some form of folly or *vanitas.* It needs to be stressed that (with the exception of an occasional soap bubble) no such visual uses of children's games that antedate Bruegel's painting have been discovered. If he has systematically transformed realistic-looking children's games into moral emblems, he is apparently the first artist to have done so.

But even if we grant the inference backward from the illustrations in Visscher and Cats to the context of *Children's Games*, there remains a striking difference between the setting of the emblem books and that of Bruegel's painting, especially when the games they depict coincide. One example cited by Stridbeck as support for his emblematic reading is the representation in Visscher of a boy swimming with the help of a bladder, where the activity is treated as an emblem of "mistrust" (Fig. 23). (The inscription reads, "He who relies on external means of help and support, who builds on treacherous ground: when he falls into distress, he is like a mariner who has a good line and cable but has left it lying at home.")[9] Stridbeck notes the boy swimming with the bladder in the pastoral area of *Children's Games* (Fig. 24) and infers that a similar moral attaches to Bruegel's image. But the setting in which Bruegel has placed this image suggests the very opposite of mistrust. The pastoral landscape in the upper left is the only area in the painting where human presence is relaxed and at rest. The naked children who play there give themselves trustingly to the sur-

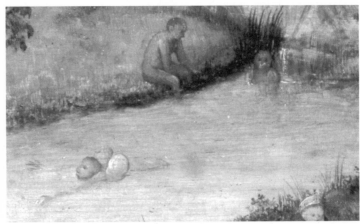

rounding element, and are in turn benignly supported by it. The two sun-darkened boys at the edge of the stream express a kind of animal, creaturely at-homeness (the one standing up to his shoulders in the water is painted to look only half human), while the third who swims in it with the aid of water wings could be mistaken for its mythological inhabitant. Bruegel's swimmer appears to be at home in his element, and reinforces a general mood of weight relieved, while Visscher's emblem conveys a sense of iso-lated, unwieldy selfhood.

Not all the games in Bruegel's painting that also appear in Visscher and Cats are so directly at odds with their emblematic counterparts, but in every case there is an equally striking impression of the absence in *Children's Games* of the aura of unambiguous moral commentary in which the emblems are inscribed. It is the same with virtually all the iconographic evidence that has been brought to bear on *Children's Games*: material that claims to situate Bruegel's images within a conventional moral context strikingly illustrates his distance from it. Consider, for instance, the images of blindman's buff which Hindman cites from later Netherlandish sources to support her thesis that *Children's Games* is about the folly of, specifi-cally, courtship and marriage (Figs. 25 & 26). It would be difficult to imag-ine representations of the game more *different* from Bruegel's (Fig. 14). Whereas the prints use the game as an ironic emblem of the marriage choice, Bruegel's painting depicts an interaction between a group of small children and a single adult-sized figure. And gender appears irrelevant to the "choice" being made: though the blindfolded figure is almost certainly

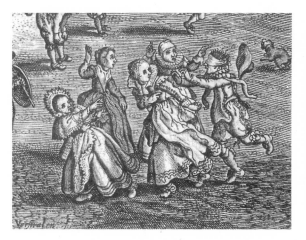

female, she gropes toward what looks like an indiscriminate mix of boys and girls, who consolidate in a group in their conspiracy to tease her and evade her reach. As an element in the painting's weave of motifs, her gesture leads in almost opposite directions—linking up with the proliferation of reaching and/or groping arms, and resembling, as a kind of negative counterpart, the gesture of the woman who shepherds the bridal procession around the corner of the fence. The components of Bruegel's image are less concerned with the marital choice than with isolation, scapegoating, the ironies of group formation, and—especially—the gap between childhood and the adult world, which a "maternal" reaching seeks to bridge.

Beyond such discrepancies of nuance and detail, moreover, the images suggest entirely different social and pictorial milieus. The seventeenth-century prints to which critics so often refer *Children's Games* depict an urban, affluently bourgeois or upper-class world and conceive of childhood as a phenomenon contained by that world and repeating in it—even when the aim is satire—its image of itself (Figs. 27 & 28). Bruegel's children, however, are depicted either outside or on the threshold of society; as a class they are associated with the peasantry, and there are vague connotations of usurpation and anarchy about the way they have—especially as iconographically marginal figures—overrun the serious central space where their games take place.[10] Nor is it so simple to locate this space. The prints set the games they depict in the town squares of actual, immediately recognizable cities—The Hague in one case, Middleburg in another, with bastions of the civic order prominent in the background—as if, in Simon

Fig. 25. Adriaen van de Venne, *Children's Games* (detail of Fig. 28)

Fig. 26. Pieter van der Borcht IV (?), *Parody of Courtship*, date unknown (Bibliothèque Royale, Brussels)

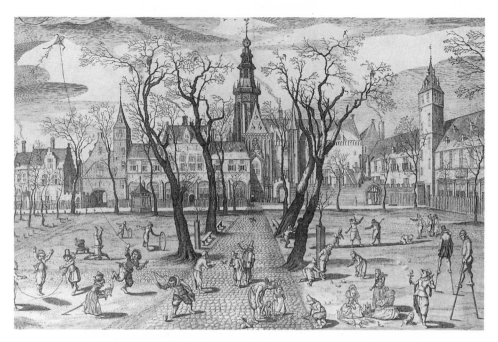

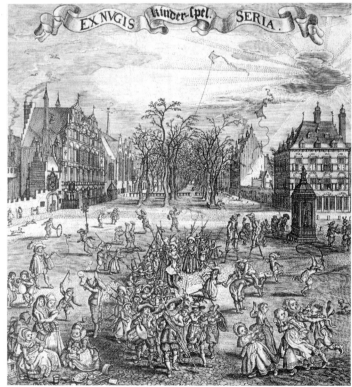

Fig. 27. Adriaen van de Venne, *Children's Games*, from Jacob Cats, *Silenus Alcibiades*, 1618 (Folger Library, Washington, D.C.)

Fig. 28. Adriaen van de Venne, *Children's Games*, from Jacob Cats, *Houwelijck*, Amsterdam, 1650 (Bodleian Library, Oxford)

Schama's words, "the children's behaviour were being scrutinized in the light of their incipient citizenship in the commonwealth."[11] Life here is a static theater where the ages act their fixed, predetermined roles, contained and overseen by a civic space that complacently suppresses awareness of any "other" or "outside." Bruegel's central region, however, gestures less straightforwardly to the civic realm. It feels less like a town square than something prior—a field of energy and unrest that seems at once cross-roads, open space, and unmapped midrealm.[12] And there is tension every-where between the energies its children embody and the civic forms that seek to accommodate or absorb them. Play here seems to occupy the realm of the presocial and/or the constitutionally incomplete, where the body reigns and "behavior" and "society" are still subject to invention, impro-visation, and chance. Only in the receding street in the upper right does Bruegel's painting resemble the geometrically ordered setting of the prints, and there—as if to place such a vision in perspective—its space grows bleak and pessimistic.[13] In the central region, by contrast, it is not clear whether what is being learned (or played with, or defied) is nature's or society's set of laws nor how compatible those laws are—with each other, with the body's needs, or with what is incorrigibly human. For every image of assimilation there is another that involves limit testing, overturning, and putting off. Even the games that directly mimic social rituals are prevented from becoming straightforward emblems of adult behavior by a spirit of play that can both mock the forms it imitates and invest them with a festive sanctity. Bruegel's children, even in their role as mirrors, remain recalci-trantly other, and everything about the way they are represented conspires to *disrupt* the modes of perception that the images cited by Hindman com-placently reinforce.

The juxtaposition of the prints with Bruegel's painting, then, insofar as it involves historical context, presents us with a *difference.* It would seem more natural to inquire from the comparison what happened between 1560 and 1610 to produce so striking a change in the conditions and con-ventions of visibility than to generalize about "Dutch attitudes" toward children. Such an inquiry might lead in several directions at once: the complex set of events that reshaped the Netherlands in the latter half of the sixteenth century; the colonization of childhood by an adult mentality increasingly preoccupied with educational programs, anthropological

knowledge, and social control; the stepped-up supervision (and cultivation) of affect and empathy by an increasingly vigilant "civil" self; the waning of the Renaissance fascination with plural meanings and with representational strategies for mobilizing them. And into this contextual swirl one would have to stir Bruegel's own authorial difference. Certainly no other images from 1560 compare with Bruegel's in richness and organized intelligence. The world, moreover, that van de Venne's print reflects—both as a certain kind of image and as a mirror of social reality—was already visible on the horizon of mid-sixteenth-century Flanders: *Children's Games* seems an act of difference on Bruegel's part, not just a guileless evocation of an earlier world or the painting's own cultural milieu.

The hermeneutic problems here are daunting: the overdetermined texture of the historical situation, together with the inescapably constructed nature of any version of it, make correlating it with either the particulars of the image or the intentions of the artist a baroque undertaking. This is not to dismiss such a project as futile. But it is to insist on difference as a fundamental element of inquiry. Both authorial purpose and "real" history are objects of interpretation, and they inhere in gaps and discrepancies that difference keeps open; the iconographic approach to Bruegel, lumping material according to a vague principle of analogy, seems ill equipped to deal with either.

Childhood and Folly

Stridbeck and those who share his interpretation of *Children's Games* attempt to compensate for the absence of relevant contemporary visual material by pointing to long-standing literary traditions that make childhood and children's play a metaphor of folly. Margaret Sullivan quotes Erasmus: "Is to be childish anything other than to play the fool?" while Stridbeck cites Sebastian Franck's repeated characterization of the worldly activities he chastizes as "Kinderspiele."[1] Hindman likewise refers to metaphors of childhood in later medieval texts and to the pejorative use of the word *kinderspel* in Flemish literature and proverbs as evidence that "a contemporary viewer of *Children's Games . . .* might have seen the entire group of games as emblematic of folly."[2] No one would deny that this metaphor was a commonplace of the sixteenth century; instances can be found in the work of virtually every major author of the period. But it doesn't follow that because condemnations of adult folly often resort to metaphors comparing it to child's play, representations of children's games are always and exclusively meant to be seen as emblems of adult folly. Shakespeare's characters often speak ironically about themselves or the human condition in language that links childhood, play, and folly; but when actual children appear in his plays, they are more often than not portrayed as preternaturally wise innocents, and often serve as foils to the world of adult corruption.[3] The same fluctuations between childhood as a *metaphor* of folly and as an *embodiment* of innocence (and vice versa) can be found in Montaigne, Erasmus, and probably every other author of the period who recorded the texture of human experience in the process of forming judgments about it. Perhaps closest in spirit to the Bruegel of *Children's Games* is Rabelais, whose hyperbolic treatment of childhood is at once a satire on adult behavior and a depiction of vital animal energies that escape the moral point of view.

Matters are further complicated by fluctuations within the concept of folly itself. Throughout the later Middle Ages denunciations of the world's folly coexisted with encomia of another, *unworldly* folly conceived of as a kind of sacred wisdom or ignorance.[4] The latter as well as the former tradition involved analogies with childishness: the Festival of Fools, for instance, with its temporary inversion of the social order and its parody of social forms, became closely linked in the popular imagination with such children's holidays as the Festival of the Innocents and the Feast of St. Nicholas.[5] What is new about the Renaissance is its organization of these contradictions as paradox and its fascination with the ways they could be both manipulated as a language and embodied, lived through, and articulated from within. Erasmus's Stultitia and Rabelais's Panurge both come to mind.[6] By the time Bruegel painted *Children's Games*, childhood and folly could attract each other not just as vehicles of the same moral judgment but as fields of paradox where such judgment could be suspended and/or depicted as problematical.

Bruegel himself explicitly links fools and children twice, in a pair of closely related prints depicting village festivals, and the results are almost antithetical.[7] In the print of his *The St. George's Day Kermis* (Fig. 29), a traditional-looking fool with a basket over his shoulders leads three children who cling to his coattails, while a fourth small girl with reaching arms is prevented from joining the procession by a dog that tugs obstinately (maybe protectively) at her dress. Little about this image suggests a departure from convention, and the configuration as a whole cries out for a "moral" reading. In Bruegel's drawing *The Kermis at Hoboken* (Fig. 30), a superficially similar detail appears in the extreme lower foreground, where a fool and two children stroll hand in hand.[8] The prominence of the site accorded these three figures suggests even more strongly than in the *St. George's Day* print that some paradigmatic comment is intended. Claessens and Rousseau, the only of Bruegel's interpreters to call attention to the detail, supply what would seem to be the called-for gloss: "The theme of the drawing is given by a group which appears in the lower part; we see there a fool leading two children by the hand. The meaning is clear and wholly in the artist's spirit: folly leads the children of men."[9] But while this "theme" might seem fitted to the *St. George's Day* detail, almost every nuance of the *Hoboken* group escapes it or undermines it. To begin with,

a closer look reveals that Bruegel does *not* depict "a fool leading two children by the hand." If anyone is leading here, it is the child on the viewer's left, who takes the fool in hand and gestures with precocious sapience,[10] while the jester—here presented as a "natural" rather than an emblematical fool[11]—acquiesces with a combination of altruistic and feebleminded affability. The child on the right seems by contrast completely bewildered in this festival atmosphere; the fool's grasp, far from leading her(?) into folly, is all that saves her from being lost and set adrift.[12] In this configuration, which is practically *all* nuance, realism overrides allegory and empathy supplants irony. Three modes of ingenuousness form a nexus of reciprocation, unrelatedness, and fellow feeling that bridges rational and generational divides. And this, too, could be characterized as "wholly in the artist's spirit." A similar mood, it could be claimed, reigns over the *Hoboken* image as a whole, where the conventional and the proverbial are largely displaced by a more impromptu visual language intent on mapping unbound social flow.[13]

Yet even if we lacked these two antithetical images by Bruegel himself, the very mention of authors as diverse as Erasmus, Montaigne, and Rabelais should make us realize that generalizations like Stridbeck's about homogenous sixteenth-century attitudes rest on extremely naïve conceptions of what historical and cultural contexts are and how one achieves access

Fig. 29. Bruegel, *The St. George's Day Kermis* (detail), c. 1561 (National Gallery of Art, Washington, D.C.)

Fig. 30. Bruegel, *The Kermis at Hoboken* (detail of Fig. 89), signed and dated 1559

to what they "say." Even if the only evidence of contemporary responses to and figurative appropriations of children's play we possessed were those in moral diatribes like the *Ship of Fools*, we should be wary of inferring from them the perceptions a sixteenth-century viewer might actually be expected to bring to *Children's Games*, much less the spirit in which Bruegel painted it. Richard Baxter's account of his 1640 ministry is a reminder of the actual place such moralism was likely to occupy even in the later, more regulated world it addressed; it can serve as an inadvertently comic paradigm for the discrepancies that so often exist in society between official cultural assertions and commonly held beliefs: "I remember what an outcry was once against me in this town, for saying, that children by nature, considered as sinful and unsanctified, were as hateful in the eyes of God, as any toads or serpents are in ours; so that people railed at me as I went along the streets."[14]

But the perception of children's games as images of human folly and corruption represents only one of several conflicting and emphatic sixteenth-century attitudes. The topos of children's games—especially insofar as it condenses the separate but related issues of *childhood* and *play*—tended to become a focal point for the ideological debates that characterized the early years of Renaissance humanism and the Protestant Reformation in Northern Europe. The basic points of reference, as Leah Sinanoglou Marcus has shown,[15] were provided by the Bible itself: the Old Testament's condemnation of childhood folly ("Foolishness is bound in the heart of a child; but the rod of correction shall drive it away from him" [Proverbs 22:15]) versus the Gospels' praise of childhood innocence ("Except ye be converted, and become as little children, ye shall not enter into the kingdom of heaven" [Matthew 18:3]); the Pauline notion (so important to both humanist educators and Protestant reformers) of putting away "childish things" (I Corinthians 13:11) and *maturing* in the knowledge of Christ versus the spectacle of King David "leaping and dancing" before the Ark of the Covenant (II Samuel 6:16–23)[16]—a gesture that became a touchstone both for the late-medieval vision of Christian life as a sacred game or "good folly"[17] (its festival observances a "playing before God" that prefigured the "endless myrthe" of eternity)[18] and later for the most radically antinomian sects of the Reformation. Add to this biblical matrix the Augustinian and Franciscan models of conversion that grew out of it—one

viewing childhood as a state of iniquity embodying everything from which the true Christian must "turn," the other regarding it as a state of blessedness to which he must find his way back—and one begins to have some idea of the number of positions from which the subject of *Children's Games* could have been viewed by its contemporary public.[19]

These various positions cover the whole cultural field. The humanist educators tended to look on childhood as a state of "neutral" innocence, an impressionability that with careful molding could be transformed into models of learning, self-supervised independence, and gracious eloquence.[20] Indeed, children, far from being ignored by the period, tended to become the focus of humanist ambitions for culture as a whole.[21] The many serious children of early humanist portraits are not (as their seventeenth-century counterparts tend to be) objects of adult sympathy or condescension: they *address* their viewer, with both a general cultural ideal and a newly vivid class distinction (Figs. 31 & 32). We are challenged to measure up to them. Holbein's imperial child-prince even seems to bestow a grace upon his audience, with gestures once reserved in images for Christ (Fig. 33). The signifying context for such depictions is the changing *civitas*, not (as will later be the case) the nurturing family bosom (Fig. 34). These humanist paragons are worlds away from Bruegel's caterwauling urchins,

Fig. 31. Jan van Scorel, *Schoolboy*, 1531 (Museum Boymans–van Beuningen, Rotterdam)

Fig. 32. Jan Gossart, *Jacqueline de Bourgogne*, c. 1522 (National Gallery of Art, London)

Fig. 33. Hans Holbein the Younger, *Edward, Prince of Wales*, c. 1538 (National Gallery of Art, Washington, D.C.)

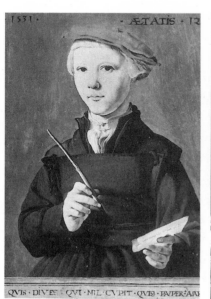

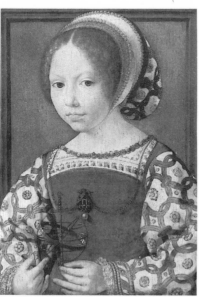

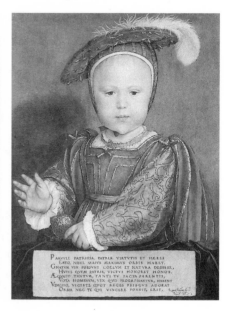

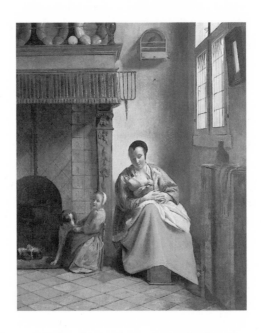

of course, but that may be the point: it might be more fruitful to view
Children's Games as a challenge to this contemporary humanist view of
children (and use of childhood images) than as a precursor of seventeenth-
century allegorizing prints.[22]

Protestant reformers approached the education of children with simi-
lar zeal, though they tended to see their goal as weeding out a fallen, in-
corrigibly willful nature before it had a chance to flower, and replacing it
with a submissive religious piety.[23] Children, in fact, became more and
more the focus of the Reformation's ambitions, as its first wave of revolu-
tionary enthusiasm waned in the face of what increasingly seemed like the
hopeless recalcitrance of adults. Luther and Erasmus would have con-
curred in the assertion of Otto Brunfels (a liberal educator and "Protestant
humanist") that "if one wants to reform the world and make it Christian,
one must begin with children."[24]

In this climate of both humanist and Protestant zeal, the "positive"
innocence of childhood could become a touchstone for resistance to both.
Agrippa's *Of the Vanity and Uncertainty of the Arts and Sciences* contains
an extravagant paean to the simplicity of children.[25] And Rabelais, from
his more capacious "Pantagruelist" perspective, celebrates in childhood a
native, instinctual resistance to the forces of seriousness and supervision

—a will-to-power that is also a will-to-play at odds with the lust for rational dominance and (self-)control:

When he [Pantagruel] was released [from his swaddling bands] they made him sit up, and he ate very heartily. Then he broke that cradle of his into more than five hundred pieces with a blow of his fist, which he struck at the middle of it in his rage, swearing he would never go back into it.[26]

These arguments were in turn manifestations of a longer-range historical shift that was taking place in the cultural perception of childhood. Philippe Ariès has argued that between the fifteenth and seventeenth centuries a vaguely formulated social attitude toward *children* as naturally immodest and uninhibited came to be replaced by an elaborately articulated idea of *childhood* as a state of innocence that was fragile and highly susceptible to corruption.[27] Ariès's claims about the history of childhood have been fiercely and elaborately contested;[28] but however flawed his thesis may be, it is clear that something *did* happen during this period in the realm of images. The poignant children of de Hooch's interiors are worlds away from the social field that the period leading up to Bruegel's age visualized. And the sources quoted by Ariès make it abundantly evident that the idea of "weak" childhood innocence was not merely a progressive, benignly altruistic one; it was also a perception imposed on children by a moralistic, authoritarian temperament, and one of its functions was to legitimize a strict supervision of the object it idealized. This new idea of childhood does not really flower until the Counter-Reformation, but it is the outcome of cultural changes set in motion by the intersection of Renaissance educational ideals (which are themselves symptomatic of a new preoccupation with both internal self-supervision and the consolidation of social experience) and the Protestant stress on a natural "tendency" in children toward sin and iniquity. The mid-sixteenth century was in this, as in so many other areas of cultural change, a period of maximum overlap.[29] Rabelais's hyperbolic assertion of the "old" view of childhood is both the expression of a "new" exuberance and an anachronistic, deliberately primitive affront to standards of decorum which the very humanists with whom he feels himself allied (*Pantagruel* also contains an elaborate educational schema for children) are causing to become current in his day. It

thus both manifests and engages the contradictions that constitute for him his historical moment. One can feel similar issues at stake in *Children's Games*, not only in such details as the arrangement of the swinging girl and the two antithetical boys at the windowsill, but in the painting's overall layout: a relaxed native landscape in the upper left opposed by a strictly channeled rational perspective at the upper right, the two of them bracketing a spectacle that can be seen—from a point of view either for or against anarchy—as an exuberant overflowing of social boundaries or an instinctive coagulation into entrenched social forms.

The religious controversies of the period stirred up similar arguments about childhood and its image. Protestant reformers attacked Catholic ritual as "child's play"[30] and condemned religious images as "toys" and "puppets."[31] During periods of iconoclastic fervor, some of the "idols" taken down were given to children to play with as dolls.[32] The Catholic response was to exploit increasingly the religious appeal of childhood innocence and ritual play. This led to a revival of late-medieval piety about childhood that culminated during the Counter-Reformation in the devotional manuals of St. François de Sales and in emblem books such as those of Hermann Hugo, Octavio van Veen, and Benedict van Haeften, which

Fig. 35. "The Soul Learning to Walk," Hermann Hugo, *Pia Desiderata*, Antwerp, 1624 (University Library, Glasgow)

picture the soul and its education by Christ in saccharine images of children (Fig. 35).[33]

The innocence of childhood also became a rallying point for many otherwise diverse objections to the harsher aspects of Reformation doctrine. The Protestant stress on original sin led to an exaggeratedly Augustinian assertion of childhood iniquity,[34] and this, as Richard Baxter's recollections testify, tended to arouse popular resistance. It was also a potential source of conflict for ardent believers. Luther himself is a case in point. His doctrinal pronouncements uncompromisingly proclaim the "natural" iniquity of children: even the Zwinglian notion of infants and small children as contaminated by original sin but innocent of the guilt of any committed evil has to be combated as a dangerous heresy.[35] Yet in his letters and table talk Luther reveals an open and warmhearted interest in children. He speaks repeatedly of the pleasure he takes in watching what he perceives as their guileless behavior and admits to being reminded of Paradise whenever he observes them at their games.[36] Though Luther never seemed to feel the apparent contradiction, it is a vivid example of the sort of discrepancy between attitudes imposed by culturally and doctrinally stereotyped images of childhood (observed, as it were, "from above") and those evoked by the spectacle of its actual presence (seen "in person" and up close) which any serious attempt to account for *Children's Games* in terms of its contemporary viewer would have to bear in mind.

As the radical Protestant sects began to multiply, they in turn tended to articulate their rejection of strict Reformation doctrine and the prevailing social order in an aggressively affirmative language of childhood, ranging from the "covenant of childhood freedom" which allowed Pieter Riedemann and the Hutterite Brethren to accept martyrdom and worldly hardships with "childlike obedience,"[37] to the antinomian theatrics of the *pueres similes*, who, according to one of their Protestant enemies,

. . . under pretense of childish innocency, played many odde pranckes: one having kept his excrements in store many days, powred them out in the street, & turned himself naked into them, saying *Unless we be made like little children, we cannot enter into the Kingdome of heaven.* Others for the same reason would ride upon sticks and hobby-horses like children in great companies, and women would run naked with them, and in pure innocency they lay together, and so in the end it proved childrens play indeed.[38]

Whether such activity really took place or is merely invented slander is not important here; what is significant is the association in the mind of a sixteenth-century controversialist between libertinism and anarchy and a certain idea of childhood "liberty." The same idea obsesses the stricter educators, who blame permissive child-rearing for the presence of so many "mercenaries, murderers, and criminals" in society and warn indulgent parents that "your children will become wanton and scorn you, and when they are grown they will be wild and malicious, harmful people, who also scorn government."[39] Such sentiments would harden into bland pedagogical commonplaces by the seventeenth century; but in the first half of the sixteenth century they were being reinforced, contested, and ironically appropriated in actual social experience, as well as in the imaginary carnivalesque of authors like Rabelais. They suggest the way in which by the middle of the century the image of childhood had become implicated in the debate about human nature that took shape during the Reformation, and in the ambivalent feelings about freedom, anarchy, and social coercion that were generated by the religious and political controversies of the age.

Peasant Dancers

This account of childhood's sixteenth-century connotative field is, needless to say, far from comprehensive. It drastically simplifies the realm of historical events and ideological controversy and omits entirely certain other contemporary disciplines in which the image of childhood figured prominently—alchemy, for instance, where the conjunction and ensuing multiplication of the *prima materia* was called both "coagulation" and "child's play," the latter because the elements were imagined as coupling in joyful imitation of the first parents.[1] What I hope it does show, however, is that the context of *Children's Games* yields neither a unified period consciousness nor a set of stable sixteenth-century beliefs. History in Northern Europe in 1560 was a shifting field of intellectual and emotional conflict that if mapped would look much like the chaotic scene which the painting itself depicts. As a result—and this is crucial, it seems to me— history cannot be invoked in any simple way as an outside control on interpretation. The net result of attempting to situate *Children's Games* in its historical context will be to multiply the questions and issues that have to be negotiated *within* the circle of interpretation.

Matters are further complicated by the way the richest texts pursue their themes through metaphoric, second-order languages embedded in seemingly transparent narrative or discursive dimensions. In Montaigne, for instance, a dialectic of the public world as flux and siege, centrifugal whirl and centripetal focus, remains almost entirely submerged in situations and images; it seldom becomes explicit, despite the *Essays'* open concern with privacy and the public realm.[2] Similarly, Rabelais's dyadic island kingdoms provide a metaphoric language with which to work variations on social equilibrium as something fraught with, perhaps even founded on, violence and opposition.[3] Bruegel's images tend to work the same way. The details in *Children's Games* are on one level simple illus-

trations of sixteenth-century behavior—so at least its fictive subtleties persuade us. But they can also be, as we have seen with Bruegel's depiction of tug-of-war, points where many themes converge. The texts of Montaigne and Rabelais would form a rich context for (or along with) Bruegel's image, but only insofar as all three are recognized as harboring languages that require interpretation to become explicit. From this point of view, subjectivity and the realm of the intrinsic only proliferate as one ventures out into the contextual field.

These embedded languages, moreover, tend to generate their own themes, which often relate only elliptically to the contextual frame, and sometimes carve out areas of "ahistory" within it. This is especially true of Bruegel's later work, which increasingly seeks conviction in what is unchanging and seems actively opposed to the forces of historical and cultural incursion. The Vienna *Peasant Dance* (Fig. 36) is an especially brilliant instance, and worth considering in detail here, since it demonstrates so vividly the degree to which connotative languages can override contextual concerns, and the power they have to make present—across distances of history and class—the world inside the frame.

Not that Bruegel, even in this late work, is indifferent to or unaffected by external phenomena. The painting reaches out blatantly to well-established iconographic conventions of dancing peasants and village festivals (both of which had their moral meanings and political uses), and through them to immediate social concerns, ranging from a new upper-class interest in peasant customs to reformist agitation against the very stratum of festive life that Bruegel's image depicts. Criticism has understandably focused on these contextual issues, arguing whether Bruegel is for or against such festivities, whether his peasants are depicted sympathetically or disapprovingly, and whether his position is conservative, tolerant, or radical and subversive.[4] One would expect whatever a close viewing of the painting discovers to bear at least indirectly on such concerns.

Rather, as one begins to explore the visual elements that organize *Peasant Dance*, an entirely different set of issues tends to emerge, for which the painting's context, however defined, seems merely the matrix or occasion. Consider all the reaching, arching, yearning, extending out, holding on, pulling back, and shrinking-in that are woven into this scene's incred-

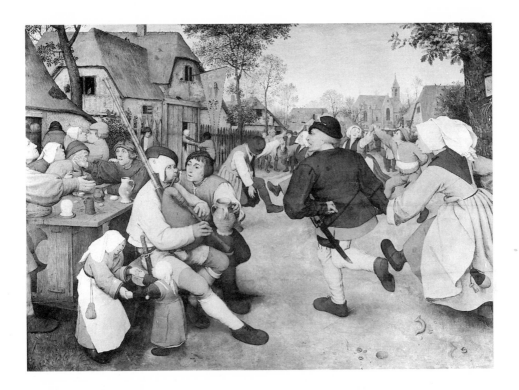

Fig. 36. Bruegel, *Peasant Dance*, c. 1568 (Kunsthistorisches Museum, Vienna)

ibly varied kinesis: the painting at this level seems to be about the way people relate across and through spaces they maintain, and about the distances—never merely physical—they have to bridge. The bulky peasant forms unite, reach out, miss their mark, resist as best they can, inhabit casually or hunker obstinately in their own impermeable worlds. Gazes try to catch up, attract, come close, cross over, fend off, or else lose themselves in reverie, blindness, melancholy, or sheer uncomplicated joy. Connectedness and disconnectedness are rendered with each stroke.

In fact, the whole painting, in spite of its massed look, is organized in terms of pairs. (In this it is very different from the Detroit *Wedding Dance* [Fig. 37], where, as Svetlana Alpers has acutely observed, large crowds are played off against solitary observers.)[5] And in almost every instance there is a threshold to be crossed or a distance to be bridged, along with a resistance that is seldom entirely overcome. Consider the couple at the doorway (Fig. 38), who are in many ways paradigmatic of the entire scene. Under the large banner hanging from an upper window of the prominent building in the middle left, they reach across an open threshold and pull against

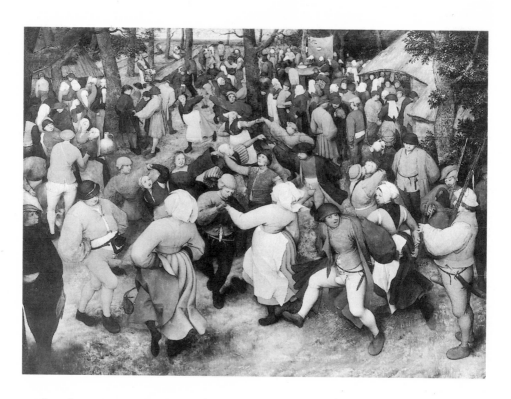

Fig. 37. Bruegel, *Wedding Dance in the Open Air*, 1565 (?) (Institute of the Arts, Detroit)

each other. Commentators who argue that the painting is a denunciation of sinful behavior take the building to be a tavern and see the woman as attempting to pull the man into it.[6] But in spite of the prominently displayed banner, the building looks more like a private dwelling than a public gathering place,[7] and it is impossible to decide whether the woman is trying to pull the man inside or the man is trying to coax her outdoors. Rather than a loose woman exerting her force on a reluctant customer, she may be a virtuous wife trying to get her husband to come home, or (even more likely?) a potential partner pulling against the man's efforts to involve her in the dance. Perhaps she merely moves to a different tempo. And the reluctance, if it *is* hers, could be a sign of either disapproval or inhibition, or perhaps just an attempt to assert her own will in the matter. All we can say for sure is that there is relation across a threshold and a resistance in one figure which the other is trying to overcome. All this makes them ironic counterparts of the upright, slack, nearly disembodied pair (nun and burgher?) pictured on the banner just above them.

The pairing of these two couples (the one on the banner docile rep-

Fig. 38 / Fig. 39

resentation, the one at the threshold stubborn corporeality) initiates a dense sequence of pairs that extends down through the bagpipe player and his intrusive companion to two children playing together in the extreme left foreground (Fig. 39). The effect is of a series of variations on the theme the banner displays. The two children, especially, reaching out to hold hands (are they having their own make-believe dance?), echo the couple in the doorway. They even relate over a similar threshold: the border be-tween the grass and the ocher ground is like a boundary line marking the two realms across which they connect.[8] No resistance maintains the space between them; in this they are opposites of the couple in the doorway. These two, in fact, seem intensely in touch with each other and almost able (in their different ways) to enter fully the other's experience. Yet they *do* reach out across that threshold, in very different spirits and from very different worlds, and the man's sword is like an ominous barrier erected just where the younger girl yearns to cross. As she stands there still com-pletely in the world of childhood, one palm turned up and wholly given, the other clutching gently a single thumb, she seems defenseless (the man's

sword seems to threaten her in this way, too) and open to relation. All she can do is express her delight in the attention she receives from her older companion and give herself to it with a fullness and absence of reserve that belong totally to this realm which she is destined to leave behind, and which even now she is being coaxed away from.

Her partner, on the other hand, is already a "miniature adult"—her costume explicitly echoes that of the wife being dragged in at the painting's right. As such she is a figure of mediation: in dancing with the young girl, she appears to be helping her over a threshold that she herself has already crossed, while at the same time returning by means of empathy to a world she has not entirely left behind. It is she who initiates and controls the relationship, but she does so as empathetic pleasure-giver, which means imaginatively crossing over into the little girl's uncomplicated happiness, even as she plays her part in weaning her away from it. The little girl, delighted to be able to imagine herself part of the complex festival that surrounds and otherwise ignores her (the bell attached to her sleeve is a device meant to keep her from getting lost), can only offer herself, not actively reciprocate; and certainly nothing in her wishes to resist. She is 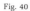 purely receiver in this relationship of future and former selves.

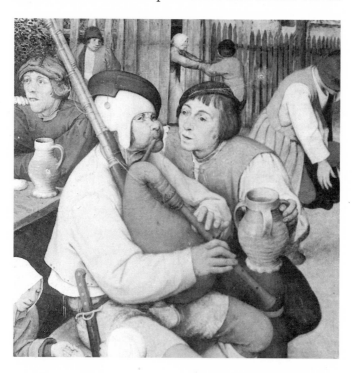

The bagpiper and his audience of one are bound in a configuration that *combines* attraction and resistance (Fig. 40). The young man with the jug is all empathy. He thrusts himself on the bagpiper with an expression that can be read as either curiosity or solicitude, and regardless of whether he is offering refreshment or just trying to see how bagpipes work (and whether he is doing so out of drunkenness, friendly concern, or a mixture of both), all his efforts seem concentrated on getting as close as possible to the other person. Such attention, however, could scarcely appear more unwelcome to the bagpiper, who does his best to remain unaffected by it. His expression may be an effect of playing, but it registers also as irritation at this "encroacher" who threatens his concentration and to whose overtures bagpipe playing makes him annoyingly vulnerable. And he would probably like nothing more than a swig from that beckoning tankard of ale. Compare his counterpart in Bruegel's *Peasant Wedding* (Fig. 41), who has stopped playing and gazes with trance-like longing at the food and drink being distributed at a table end, which the painting's composition makes seem miles away. The besieged, fiercely willed singleness of the *Peasant Dance*'s bagpipe player also links him to the artist of Bruegel's *The Painter and the Connoisseur* (Fig. 42). And the latter's vision, too, despite its rough artisan's integrity, is divided between his willed focus on his canvas (his eyes have a tendency to drift away or recede into thought) and his refusal to let the viewpoint of his nearsighted audience—always "at his back," one hand reaching into a money purse—penetrate his field.

Fig. 41. Bruegel, *Peasant Wedding* (detail), c. 1568 (Kunsthistorisches Museum, Vienna)

Fig. 42. Bruegel, *The Painter and the Connoisseur*, c. 1565–68 (Albertina, Vienna)

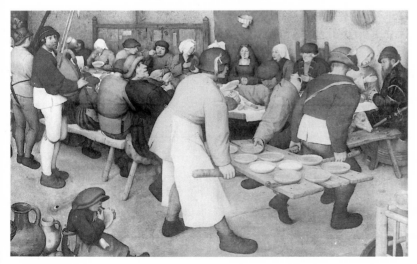

Yet the artist figure and his unwelcome "other" seem more benignly paired in the *Peasant Dance.* The two form a condensed, thickly massed unit—almost a single figure in which both seem nested. The white of the young man's right arm continues the line of the bagpiper's right arm and shoulder, so that the arc from the hand that fingers the pipe to the hand that grasps the tankard reads like a single, self-enveloping span. The jug meets the bagpipe as counterweight and complement, and the two faces respond to each other like the fresh and wizened aspects of a self in time.

So the bagpiper, whose entire concentration the dance requires, is made anything but separate, and this seems important in a painting where singleness—an almost privileged condition in the Detroit *Wedding Dance* —takes on the quality of exile. Single figures in the Vienna *Peasant Dance* tend to be cruelly isolated by compositional elements. One man stands alone against the pointed slats of the thatched house's fence, severed by the stem of the bagpipe from contact with anything on his right, and gazes wistfully, furtively, disconsolately across what seems an impossible distance toward the circle of the dance (see Fig. 40). Another unhappy gazer with red cap and vest is trapped between the head of the man entering in the foreground and the right shoulder of the woman dancing in the middle ground behind him (Fig. 43). His positioning is an especially brilliant instance of the way Bruegel fills in negative space in this painting to complicate feelings about human distances. The man's wistful, melancholy expression of left-outness is continued in the anxious gaze of the woman dancer and carried across to the distracted look of her red-capped partner, behind whose head another man in a red cap is being embraced (reluctantly?) and either kissed, nibbled at, or whispered to by an amorous partner. The effect is to bracket the dancing couple between the man in red and an ambivalent image of himself caught in what he feels excluded from. The two figures are in turn like opposites at the back of the young dancers' minds, and help to color the space between them. The dancers' arms reach out across a greater distance than the one that physically separates them and form a tenuous bond that leaves so much contact still (forever?) to be desired. Yet their raised arms form an arch like those of the church behind them, and beneath it a small child can be glimpsed trying to wrap her small arms around her mother's massive waist, the latter reassuringly there for her but the longed-for reciprocation hopelessly out of range, high up

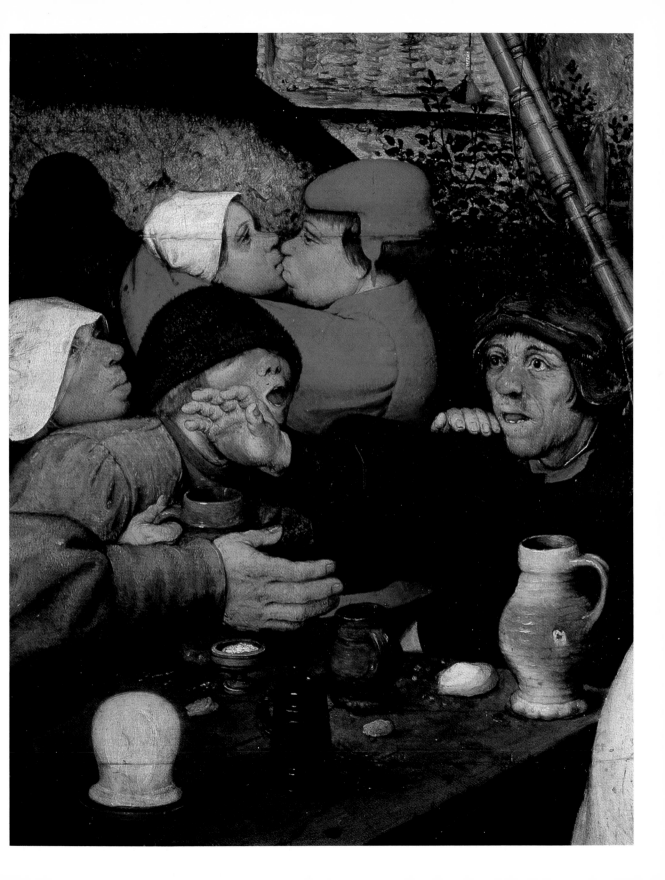

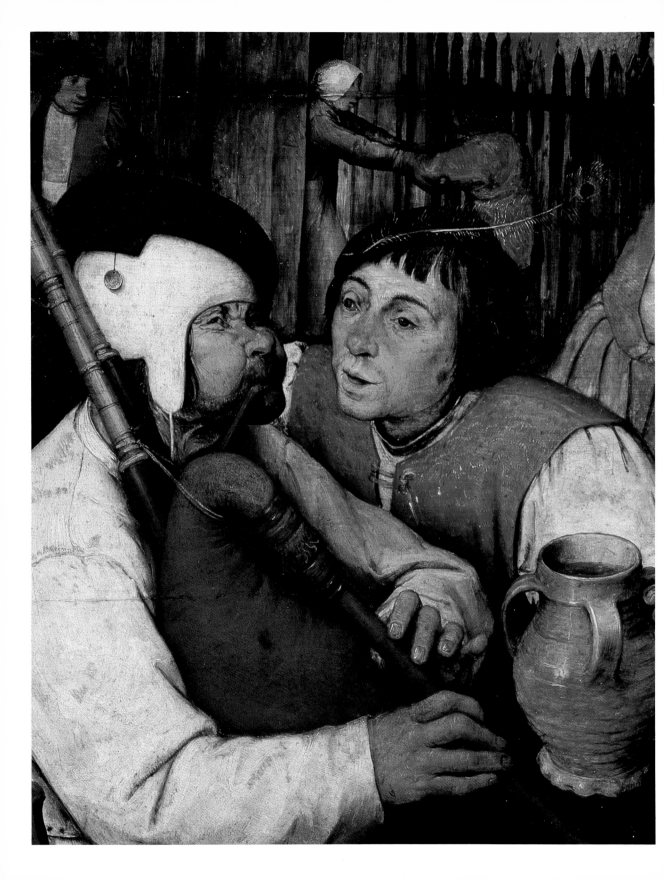

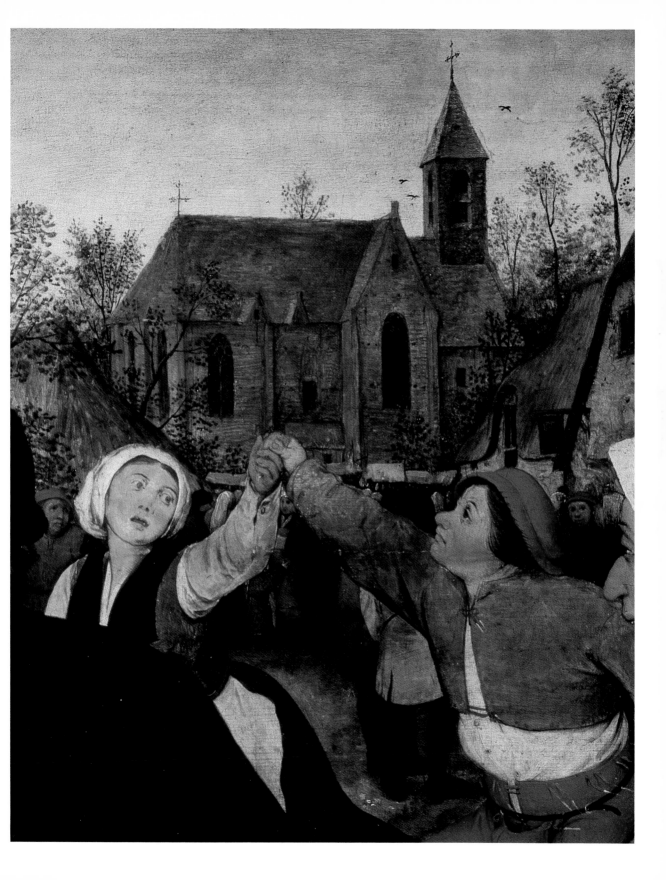

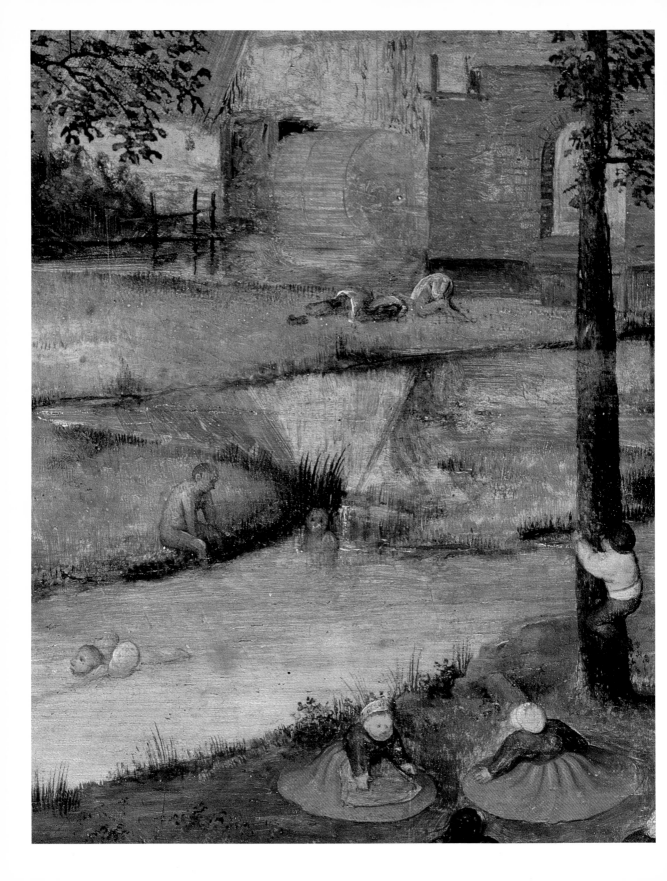

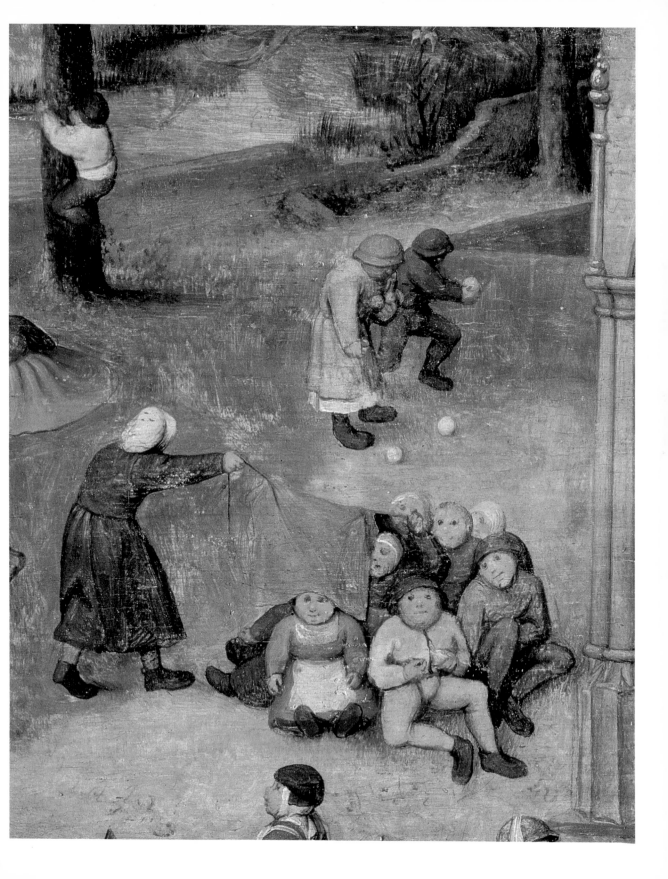

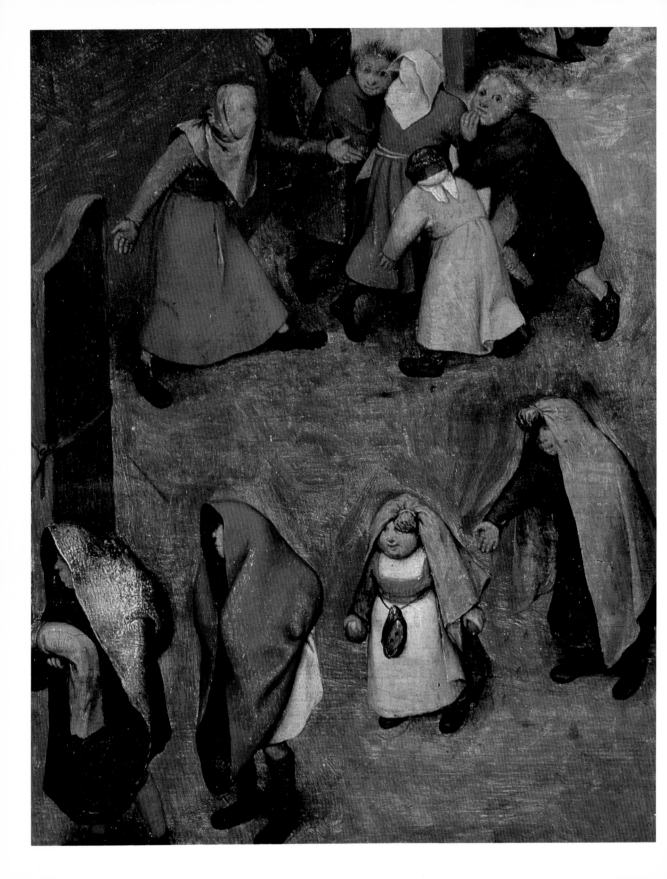

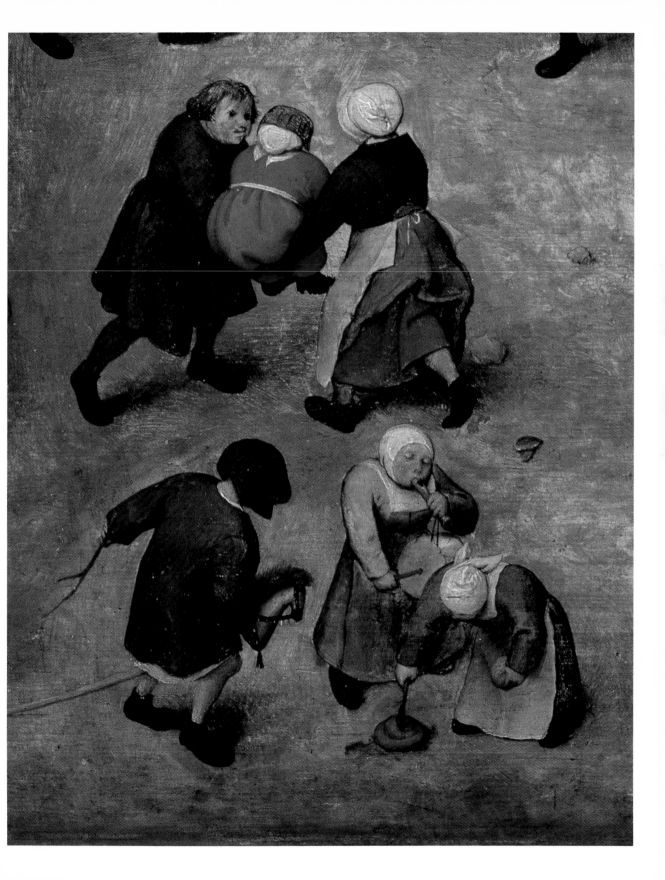

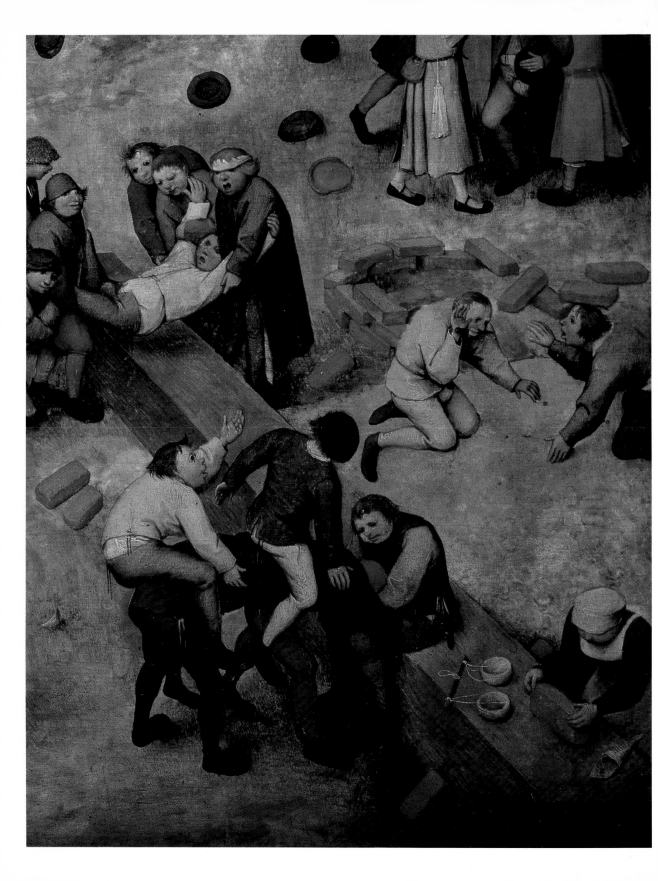

in the faraway world of adult conversation—a poignant contrast to the devotional image of mother and child attached to the tree in the right foreground (Fig. 44).[9]

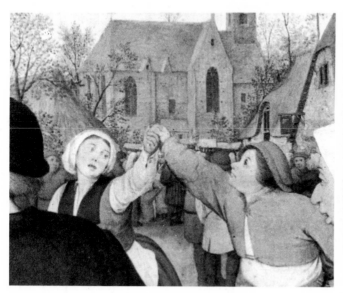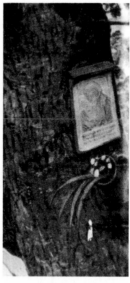

Fig. 43 / Fig. 44

 The issue of the peasant festival, then, focuses for Bruegel everything that is problematical about the human relation—and at levels that seem, if not "universal," then at least *prior* to historical or cultural transformation. And the painting's sense of variation makes any generalization difficult to come by. What might we conclude, for instance, from the three couples involved in the dance? The couple rushing in on the right (Fig. 45) appear to share scarcely anything. The man who leads the way has already entered the festive sphere, yet his harsh, weathered features cause even exuberance (if that is what it is) to register as a grimace and suggest an inner life so crude and primitive as to be almost beyond the range of empathy. His step seems impossibly awkward, and it is difficult to imagine it in tune with any musical rhythm (even the kind that comes out of bagpipes) or with the experience of community that music attempts to foster. The woman's stride, however, does not even get a chance to respond to the bagpipe's tune: all her effort is expended trying to keep up with her partner, who drags her along behind him like an extension of himself whom he has long since ceased to regard as someone separate. Hands, which elsewhere in

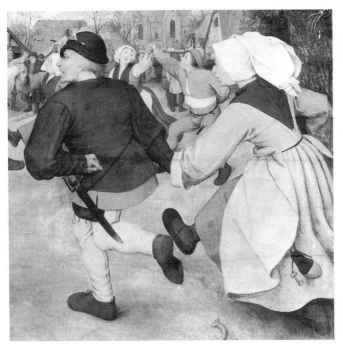

Fig. 45

Fig. 46. Albrecht Dürer,
Peasant Dancers, 1514
(Städelsches Kunstinsti-
tut, Frankfurt/Main)

the painting focus both the value and the tenuousness of relation, do not even show here. Connection is absolute, though it links (almost brutally) two partners completely out of step with each other and measures a distance across which the one behind gazes anxiously into the sphere of the other's willfulness, trying to maintain contact with the person whose mood and impulses (whatever they may be) direct her movement.

Bruegel's conception thus differs radically from the Dürer engraving to which it apparently alludes (Fig. 46). Dürer also is cunningly aware of the differences between his two dancing peasants, but he subsumes them in an elaborate interrelatedness of bodies: the effect is of separate gestures and motives emanating from a corporate mass with a single energy or drive. The legs and feet of the Bruegel couple especially gesture to the Dürer engraving, but again only to underscore differences. The legs of Dürer's dancers mingle indiscriminately—it is difficult at first to tell whose are whose—thus reinforcing the impression of separate bodies and personalities fusing in dance. The two middle feet, in fact, execute a dance step nimbler and more charming than either partner manages separately. Bruegel's perceptual ambiguities, however, reinforce the sense of two bonded

people utterly out of sync. The woman's left foot seems about to tread on the man's right heel, which on closer inspection turns out to be his *left* heel, extended into an entirely different space from hers. She takes long strides while he seems to stand storklike on one leg (given the way Bruegel has hidden her grounded foot in shadows, the whole relationship seems balanced on his one stiff leg); yet rather than racing ahead of him or catching up, she seems to be falling farther and farther behind. His attention and his direction point him toward the drinking men in the left corner, and the torque of his bent arm and raised leg is at odds with the curve of the path leading toward the dance. Yet his face is bracketed between two white-bonneted women, and he is apparently fated in spite of that opposite pull to spin round eventually toward this woman whom we *know* must be his wife.

Bruegel colors the distance between this couple by inserting into it the younger pair, who with raised arms dance in the background of the older two. Again there is a sense in the total configuration of temporal stages, of past and present selves, of poised newness and dulled habituation. The pair that intervene between the wife's face and the husband toward whom she gazes from far behind might almost be her memory of earlier dances, when her anxiety about her partner's tendency to recede still registered as tenderness and tried to keep him present at her periphery. For even these younger dancers, both with beautiful faces and probably in love, are curiously distanced from each other (Fig. 43). The younger woman's gaze also reaches intensely across the distance that separates her from her self-absorbed partner; but he appears lost in thought, not driven by brute urge, and her eyes, instead of attempting to keep up with him, seem to be trying to curve his attention back across to her. Her anxiousness is rendered in full face, while his pensiveness is given in profile, yet there is a wistfulness in both faces that makes them seem more intimately related than the matched profiles of the foreground couple. The softly clasped hands imply a more tenuous link than the "joined" arms, but they also focus a more nuanced relation. His grasp echoes that of the young child in the left foreground, while her extended reach repeats the small arm just below it—as if to imbue this adult relationship with all those childhood needs for nurture and connection and help across. Though the woman's gaze remains outside the man's sphere, she is the one who appears to lead, and in a

sense to control his movement. His extended arm reaches out for her two fingers, and its stiffness defines the circuit of their relationship. The curve of her hand and the bend of her elbow appear to draw him gently toward her, while at the same time keeping him from drifting out of orbit.

Such poignancies fit uneasily into any simple definition of the festive mood. Indeed, taken together, the aspects of the young couple recall the expression of the lover in Bruegel's *Triumph of Death* (Fig. 47), whose lute

Fig. 47. Bruegel, *The Triumph of Death* (detail), c. 1562 (Prado, Madrid)

playing is accompanied by what it tries to keep at bay. In the Vienna *Peasant Dance*, what appears to haunt the young couple is not death but a loneliness the human connection might as easily deepen as allay. Not that this necessarily makes the painting's outlook "negative." Indeed, Bruegel's feeling for how the festive impulse arises and persists in conditions that are inimical to it—material poverty, the body's weight, the self's ingrained aloneness, the inevitability of time's passing, the remoteness of both nature and the spiritual order—is largely what gives his vision here such resonance. And just in case we might be tempted to leap to an unwarranted pessimism, Bruegel includes in the dance a third couple upon whom nothing problematical intrudes (Fig. 48). For them dancing seems an uncomplicated pleasure, and the spectacle of two people holding hands, lost in their separate worlds and dancing to different tunes, becomes an image of secure connectedness. In the space between them Bruegel places another unlikely pair—a cheering fool and a sour misanthrope, standing side by side like a parody of the couple on the banner (the fool's left arm even

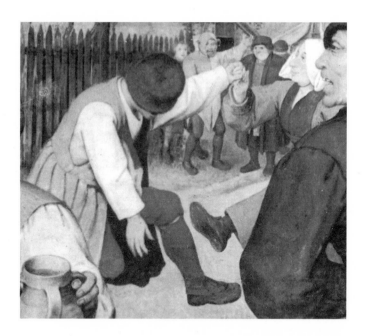

gestures like the nun's). Whether we take these two as representing op-
posite outlooks on festive behavior or coupled aspects of the moralistic
view (recall the two faces at the windowsill of *Children's Games*), the dif-
ference between them is subsumed in their common spectatorial detach-
ment from the kinetically intense, lived contradictions of the dance itself.

What might seem positive and negative in Bruegel's *Peasant Dance* is
thus caught up in a meditation on the space between human beings so
multifarious and complex as to make any moral judgment on the whole
scene seem as small and inflexible—and as close to folly—as the misan-
thrope's obstinate witnessing. Even the grimmest-looking details assume a
different cast when their place in the total design is taken into account.
Consider the four blind, gaping figures gathered around the table at the far
left (Fig. 49). It seems an image calculated to repulse. Thin, straight lips
pucker, open to a voracious hunger, and subside into a blind, searching
numbness as one moves from left to right. Hands that scarcely attach to
selves reach out from some need beyond the scope of empathy: one finds
a human shoulder, one clasps an open-mouthed mug, others remain sus-
pended in midair. Taken in isolation, the group might suggest a misan-
thropic outlook. But they exist in elaborate counterpoint—first with two
dark loners in the distant background (one swigging ale by himself just

Fig. 48

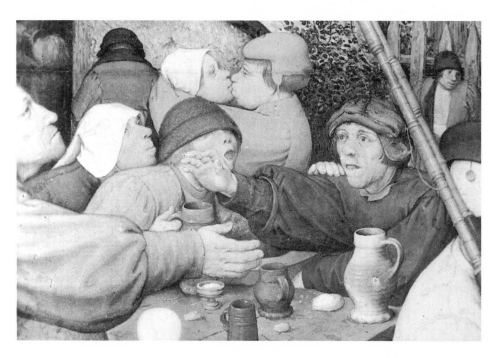

Fig. 49 inside a threshold, the other outside pissing against a wall), then with a couple embracing just behind them. It is this latter juxtaposition that stands out. Framed by the blind mouths and misdirected arms at the table, the couple's kermis-inspired kiss registers less as shamelessness and lust than as contentment securely achieved. Their satisfaction in turn tends to transform the degeneracy at the table into a swirl of failed reciprocity and unanswered need. (Note how little it takes to turn the obnoxious puckerer at the table into the sweet receiver of the man's red kiss.) If we still find the group revolting, the focus may be less on their ingrained sinfulness than on our instinct to recoil.

Not that the contented couple's kiss achieves some ideal of reciprocity. It is in its own way clumsy and tenuous. The couple's lips just barely manage to find each other, and a pensiveness shading toward melancholy can be glimpsed in the faces of both—his eye gazing down and to the side, hers drifting up and away. And again the stress is on asymmetry, as the man takes his unresisting but barely responsive partner in his arms. Yet his wonderful red sleeve secures all potential sadness and discord in a nest of bliss. The lack of realism about this detail—the way the sleeve flattens at the woman's head and requires an arm longer and more flexible

than any real person could possess—makes it seem the artist's gesture as much as the man's. It is like Bruegel's own embrace of the couple, an authorial grace he bestows on them.

———

And so where are *we* in relation to Bruegel's image? Across what threshold do *we* relate? Is it constructed by history or desire? And to what degree can we ever cross over or encompass things in *our* embrace? The historicist (old or new) might seek to uphold that threshold and take a stand this side of it: the task would be to defamiliarize the image, to recover it in its otherness (one more contradictory desire). Crossing over would be out of the question—but then so would letting go. The intuitionist, feeling so little distance to begin with and possessed by a desire for connection that feels intrinsic to the viewing self yet also engendered by *this* image, would seek to get as close as possible, with all the native faculties that allow for empathy. He might suspect at times the folly of the attempt and fear that *his* surrogate within the painting is the unwelcome bagpipe watcher. And he will never be sure if he is being met by resistance or being given help across, if he is entering Bruegel's world or pulling Bruegel's world over into his. But as long as this painting remains his passion, no one will ever convince him that there are not human constants "beneath" history, upon which history works, to be sure, but which also resist history and persist unchanged. About distances, about thresholds, about the desire for connection, he will want to say after Auden—and with stubborn naïveté—that the old masters were never wrong.

Intuition as a Control

Not that historical consciousness can safely be dismissed when viewing Bruegel. Indeed, in *Children's Games* certain formal schema only become visible within specific historical contexts. Take the conjunction of the mock altar at the lower left of the painting and the two adult-looking children playing with dolls beneath it (Fig. 50): the juxtaposition seems to construct a visual equivalent of the language of contemporary iconoclasm (see above, pp. 40–41). A modern viewer unaware of how insistently that language linked Catholic ritual and image worship with doll playing, black magic, and childish superstition would scarcely think to see the two images in relation, and the result would be a loss in signifying potential. Indeed, just this loss seems to have occurred as early as the seventeenth-century prints of children's games, which depict doll playing in bland isolation (Fig. 51). The absence of such dialectical interplay in the prints suggests their remoteness from both Bruegel's sixteenth-century world and his own signifying practices.

But it is just when one does perceive a link between the two details that problems of interpretation arise. For to "perceive" their connection is to *decide* that it is there and that as such it constitutes an "allusion"—and both decisions are interpretive judgments. (In which way does the inference proceed: are the sinister feelings that attach to the doll players *produced* by one's knowledge of the iconoclastic discourse or are those feelings already "in" the image, and does one seek out an external context in which to ground them?) And many other questions follow. Does the image conjure up iconoclastic attitudes approvingly? derisively? in some vaguer ironic sense? And to what larger end? Does the image exist as a thematic key or an overall moral pointer, or just a local comment, or perhaps one half of an antithesis? (The girl with the brick at the painting's lower right could be construed elaborately as their opposite.) And does the image *signify* the

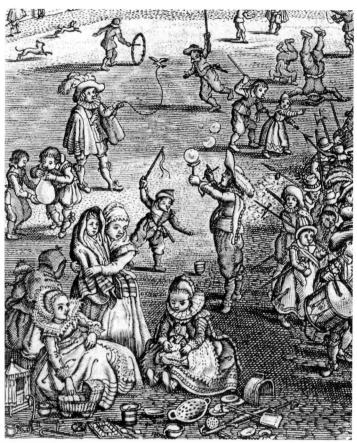

context, or is the context absorbed into the image as a more or less subliminal presence, deepening its connotative force?

Fig. 50

Fig. 51. Van de Venne, *Children's Games* (detail of Fig. 28)

Versions of this last question are especially germane to Bruegel studies, since his images so often require the viewer to negotiate between connotation and codedness, overt and embedded languages—differences that are, again, largely a matter of interpretation. Van Lennep, for instance, perceiving hidden references to alchemy in *Children's Games*, chooses to make alchemy the signified that the image denotes, the "content" that the entire painting "symbolizes."[1] The code is broken, the single meaning is extracted, and the image is discarded like a shell. But what if alchemical "references" were perceived differently: not encoded in the image but resonating in a kind of semiotic background or aura? There they would have the potential to bring all sorts of themes into play within the visible

image—coupling, coagulation, the mix of opposites, context itself as an unstable libidinal field. How *then* to judge their relevance?

One would expect such issues to arise continually within the work of iconographically or historically oriented critics like Stridbeck. Yet it is striking how infrequently in their readings of Bruegel hermeneutic questions are admitted, much less made integral to the critical process. And one should stress that even if sometimes an awareness of convention or external context allows one to formulate a question about Bruegel's work —as with the conjunction of the doll players and the mock altar—once posed those questions can be negotiated only via intuition.

Historically oriented critics, however, tend to bristle at the word "intuition." Perhaps as moderns we all have an aversion to the term, haunted as we are by the ghosts of Pater and Ruskin. But intuition is an inescapable aspect of cognition and is at least as open to self-interrogation as the contextualizing process. And it has its own claims on objectivity. Especially in the case of Bruegel, it is worth rethinking interpretation in ways that will allow us to see how intuition can be a control on necessarily speculative attempts to link the work to external contexts and not just an irresponsible impressionism that itself needs to be controlled by "history." Given the current state of Bruegel studies, in fact, real historical awareness tends to be most valuable as a guard not against wildly anachronistic interpretations but against spurious historical assertions about what Bruegel could *not* have meant—such as Stridbeck's claim that no ironies could have been intended in Bruegel's *Justicia* (Fig. 52) because "for [his] contemporaries there was nothing problematical about the enforcement of the law's judgments."[2]

Let us stop and ponder this statement, since it epitomizes the voice of authority that resounds so often in writing on Bruegel. When we remind ourselves that "Bruegel's contemporaries" included those who lived through the wholesale questionings of authority brought on by the Reformation, witnessed the torture and execution of countless dissenters and men of good conscience,[3] and read authors like Montaigne ("Savages do not shock me as much by roasting and eating the bodies of the dead as do those who torment them and persecute them living") and More ("[The English] first create thieves and then become the very agents of their punishment"),[4] the assertion begins to sound less like informed historical

SCOPVS LEGIS EST, AVT VT EV̄ QVE̅ PVNIT, EMENDET, AVT POENA
EIVS CAETEROS MELIORES REDDET, AVT SVBLATIS MALIS CAETERI SECVRIORES VIVAT.

Fig. 52. Bruegel, *Justicia*, 1559 (National Gallery of Art, Washington, D.C.)

awareness than willed ignorance of it—a denial in almost the Freudian sense. Authority here seems to manifest itself as an anxious aversion to the image.

In fact, when one looks at Bruegel's *Justicia* in detail, the sources of such anxiety readily appear: the print is rife almost to the point of comedy with elements waiting to be taken ironically once "interpretation" is allowed.[5] Consider Justicia herself: her headdress looks distressingly like a courtesan's, and Bruegel has crowned it with an invisible soldier's iron helmet. Surrounded by armed soldiers, she can appear either held captive by them, in their employ, or both. Her blindfold can suggest disheveled helplessness rather than impartiality, especially given the awkward way she wields her attributes. Her scales (held so much lower than her sword) appear to weigh down in the direction of the torturer who kneels busily at the rack (which has replaced the traditional bed of mercy),[6] while her sword—which fits in so well with the raised pikes all around her—is suspended above him, as if ready either to slice randomly or to dub his

61

hunched shoulders. The gallows and gibbets that stretch uninterruptedly across the far horizon are made to seem continuous with a huge monumental cross upon which someone may or may not be crucified—as if to suggest either Christianity's complicity in the carnage or the martyrdom of the law's victims.

It is the same with the small crosses held by the criminals marked for execution (two have just received judgment, the other is about to feel the sword's blow): that detail, too, could be taken ironically either as singling them out as Christ's true surrogates in this scene (the robed priest is conspicuously without a crucifix) or as commenting again on religion's complicity in the judicial apparatus. ("Christ's cross shall be used as an excuse for executing criminals" is Blake's gnomic prophecy.) These two condemned men are clearly depicted as peasants, and throughout the print there is an awareness of how class differences structure the judicial scene. Men in furred cloaks and swords enjoy the privilege of the raised platform, where they either busily administer justice or safely observe a choice of spectacles. (The cocked hat and casually crossed legs of one of the three well-heeled spectators at the balustrade contrast vividly with the forced contortions of the legal victim hanging just above him.) These same spectacles, meanwhile, organize those below into masses of passive conformity who observe, transfixed and numbed, victims with whose plight they might otherwise identify.

Even the absence of any sign of either malice or protest, which is sometimes taken as evidence of Bruegel's "approval,"[7] can be viewed ironically. The clerks absorbed in their record keeping (the noting down of everything in good order), the torturers engaged in their tasks—a delicate art for the one who drops flaming pitch into the open wounds of the accused from high above, a labor like any other for the knaves who fill him up with water or turn the rack—everything suggests the administration of justice reduced to just that, all system and procedure, devoid of affect, with no one in charge, acknowledging responsibility or answering to some higher (or lower) moral authority. Likewise, the lack of protest or struggle on the part of those who accept their punishments so passively: it contributes to a picture of a social world where detachment reigns and all capacity for resistance has been eliminated, a realm of "docile bodies" that have been completely colonized by the governing apparatus.

And then there are all the scattered oddities: the skewed shields of the seventeen provinces, the hanging antlers, the sleeping dogs, the ornamental beasts which, especially in Bruegel's drawing for the print, look more like monkeys or large vermin than the lions of Solomon, and the strangely out-of-place, isolated, half-cropped onlooker who witnesses the execution from one side. It is difficult to establish precise meaning (ironic or otherwise) for any of these elements, but their very presence injects an element of hermeneutic disquiet into the print's otherwise documentary-like atmosphere.

All these details accumulate to make *Justicia* potentially one of Bruegel's most fiercely sardonic images. But the same elements are open to "straightforward" interpretation. Barnouw, for instance, sees the monumental cross as validating the entire scene: "The cross of Christ, raised on a pedestal on top of a hill, rises high above this scene of woe as a guarantee that justice thus administered has the sanction of the Supreme Judge."[8] One might argue with this interpretation on several grounds: its innocence of other possible readings; its failure to take into account how Bruegel's composition makes the cross not only small and remote but level and continuous with the instruments of death and torture on the far horizon (the last gibbet even leans toward it, as if to ensure the link), or how the image as a whole makes an *issue* of detachment and the stance of overlooking; or the sheer sanctimonious presumption of the reading, which reproduces faithfully how the order Bruegel depicts uses Christianity to secure and validate its power.

But such arguments, however acutely focused on specifics, would still hinge on "feelings" and would wind up sounding a priori and political, especially to someone predisposed to the non-ironic view. Indeed, that is precisely what needs to be stressed here: the argument between the ironic and the non-ironic, even when the issue is a clear visual element, is largely a matter of predisposition and—even when it isn't—can never be settled outside the circle of interpretation, regardless of the weight of evidence assembled on either side. Even visual links between the print and other depictions of the legal scene in Bruegel—the census taking in *The Numbering at Bethlehem*, for instance, or the depersonalized carrying out of the law's edict in *The Massacre of the Innocents*, or the channeling of masses (so reminiscent of *Justicia*'s left background) in *The Procession to Calvary*,

or that same painting's two terrified, uncomprehending peasant-thieves, marked again with small crosses and being consoled by a pair of insidious-looking monks (Fig. 53)—have to be constructed and described, and to acquire meaning they require emotional investments and interpretative leaps that are equally present in every discussion that pretends to treat "what Bruegel believes" as a matter of critical consensus, iconographic convention, and/or social context.

It *is* possible, then, to dispute the ironic reading of *Justicia*, but not on grounds less interpretative than those on which the reading itself rests. Both assertions (ironic and non-ironic) have the same (questionable) epistemological status, both are vulnerable to argument, and both lack any ultimate authority outside the image. What *cannot* be legitimately claimed, on the grounds of something falsely called history, is that the print "could not have been perceived" as ironic, and that to see it ironically is to be perversely modern and anachronistic. Any context constructed for such purposes can always be exposed as both partial and motivated, and—history being what it is—can be either interpreted differently or countered by another context. Even in the apparent absence of any precedent for a meaning or an irony, the image itself can be claimed as a datum of history, and as such as open to interpretation. And the image's *relation* to any context will remain in question. Whatever the "facts," the viewer will always be left asking, In what sense are they to be taken?

Bruegel's Bodies

The general argument for Bruegel's games as emblems of folly, then, not only ignores important discrepancies between metaphor and reality, language and image, the didactic and the imaginative, but depends on an oversimplified view of the historical moment and how it relates to pictorial context. There remains, however, the matter of the blue coverings in *Children's Games* and their apparent reference to the proverbial "blue cloak" of deception pictured in Bruegel's *Netherlandish Proverbs.* I want to try to show now that the interpretation of these objects as emblems of folly involves a misunderstanding of the signifying process that binds images in *Children's Games* not only to one another but to images in other Bruegel paintings. The argument will again take us beyond specific questions about *Children's Games* to the issue of meaning in general in Bruegel, and to related issues about the development of his oeuvre.

To begin with, Stridbeck's comments about the emblematic use of color in *Children's Games* need to be qualified. The color iconography at a Renaissance artist's disposal was so polyvalent that scarcely ever is the prominent use of a certain color sufficient in and of itself to establish meaning. Interpretation usually works the other way around: given a context whose significance or "tone" has been provisionally established, an iconographic precedent can usually be found to explain the use of a certain color in that context. It is especially misleading to assert without qualification that blue is the color of deception and folly. To the degree that blue does possess intrinsic iconographic significance—and of all Renaissance colors it may come closest to doing so—just the reverse is true. Blue is the color of the Virgin (her cowl is a rich blue in Bruegel's own *Adoration of the Magi* [Fig. 54]), and it will always connote hope, truth, or faith in a signifying context unless special circumstances subvert its usual associations.[1] In the Flagellation scene of the *Très Riches Heures*, the discarded

Fig. 54. Bruegel, *Adora-
tion of the Magi*, c. 1564
(National Gallery,
London)

garment lying at the feet of Christ is blue, and that color's associations
intensify one's feeling for the body's vulnerability (Fig. 55). (Although the
scribe, two of the flagellators, and Herod himself also wear blue.) A few
pages later, in a brilliant composition depicting the scene of Judas's hang-
ing, another discarded blue mantle lies cocoonlike in the foreground, and
its blueness—the symbol of a rejected but ever-present hope—draws both
the hanged man's gaze and ours like a magnet (Fig. 56).[2]

· Even in late medieval and early Renaissance love poetry, blue is the
color of fidelity,[3] and as part of Gargantua's childhood livery it stands for
"anything to do with Heaven," though in order to employ it in this way
Rabelais is forced to engage in a mock-argument with his readers, who all,
he knows in advance, will insist that blue actually means "steadfastness."[4]
At the end of *Lycidas*, Milton's swain, cheered by a vision of his friend's
heavenly recompense, puts on his "mantle blue," and though critics dis-
agree about the significance of the color, no one yet has suggested that the

poem ends with its narrator covered in folly and self-deception.[5] These positive connotations are probably still operative in the proverb to which Stridbeck refers. Being covered with a blue cloth can serve as a metaphor for deception or the state of being deceived precisely *because* blue connotes truth so emphatically: even in the proverb, that is, blue signifies not so much deception per se as the false appearance of fidelity.[6]

Someone who thinks that *Children's Games* envisions childhood as a state of innocence "covered" by a special grace can thus make use of the same images that for Stridbeck serve as evidence that the painting is an allegory of man's folly.[7] There would even be iconographic support for such an interpretation. Representations of the Virgin of Mercy, which, according to Michael Baxandall, was "an ancient image of protection" that "had been an established picture in the European imagination since the thirteenth century," show her with her mantle held open to shelter a humanity that huddles inside it like small children (Fig. 57).[8] The mantle is

Fig. 55. Limbourg Brothers, *The Flagellation*, before 1416, *Les Très Riches Heures du Duc de Berry* (Musée Condée, Chantilly)

Fig. 56. Jean Colombe, *Judas Hangs Himself*, c. 1490, from *Les Très Riches Heures du Duc de Berry* (Musée Condée, Chantilly)

Fig. 57. "Maria die ist
unser beschirmeryn und
bütteryn," *Heilsspiegel*,
1473 (Warburg Institute,
London)

almost always blue in painted representations: the beautiful painted sculpture by Michael Erhart that Baxandall analyzes renders the lining rather than the exterior blue, which suggests how strongly the color itself was associated with the feeling of being inside the sphere of mercy the Virgin extends. The passage Baxandall quotes from an early-sixteenth-century spiritual meditation indicates the connotations of maternal grace the image carried:

I will suppose the Mother of God stands before me with outspread mantle as large and wide as the whole world, and waits constantly for the sinner. And if the sinner flees to her with trust and good intention, in repentance and horror for his sins, with firm and strong faith, she receives him under her mantle of grace and mercy.[9]

A distant recollection of this tradition may survive in Bruegel's image of the group of small children clustered happily under a blue apron held over them by a female figure on their left (Fig. 16). Yet even if such a reference were admitted, Bruegel's *differences* would key his meanings: nature would become the realm from which the maternal figure extends her blue cloth, and the image as a whole would address the issue of protection in terms of our mundane human being-here.

But a brief scan of the activities across which Bruegel's colors range in *Children's Games* makes it evident that they cannot be consistently correlated with moral attributes at all, regardless of how iconographically sug-

gestive their presence may seem in individual details. If the red skirt of the blindfolded woman marks her (as Stridbeck claims) as an emblem of worldly ignorance, what are we to make of the two small girls who sit by the edge of the stream with *their* red skirts spread out around them? The motif may indeed link the two images, but their difference remains critical. The difference, moreover, suggests not moral judgments but deeper feelings about the human situation: the woman is an image of lostness and isolation, while the two girls blossom together in an oasis of well-being. The same holds true for the blue coverings: the blindfold on the face of the woman creates an image of groping, disoriented aloneness, but the apron held over the passive cluster in the background bestows a collective happiness, and the improvised cowl draped over the small child in the baptismal procession covers her not in deception but in delight.

These motifs are linked by complicated permutations and inversions, not by simple repetition. They imply an authorial sensibility more inclined to make distinctions than to generalize, and inclined to make them more in experiential than in moral terms. The blue coverings of *Children's Games*, in fact, are in one sense visible signs of a liberation from fixed moral judgments and narrowly referential points of view.[10] No longer anchored by the proverb to which they may seem to refer—and once *did*, in an earlier painting by Bruegel—they are free to enter into a play of images that has more to do with our experience of being "in" the human world than with any commonplace wisdom that can be extracted from it. It crosses images of covering and uncovering with images of being exposed and either sheltered or secure (note how the two flower girls at the head of the bridal procession manifest these aspects), associates them with states of vulnerability and security, happy satisfaction and unanswered need, and makes the presence of a maternal-seeming figure a related motif. And the value of any single image is conveyed at the level of affective nuance. If one feels that the blue cloths covering the group in the background and the small child in the foreground are "positive," it is because one can empathize with the delight of the children under them—and even, perhaps, sense the fondness with which Bruegel has rendered their experience.

The sensation of unmediated access to experience thus tends to involve access to its lived significance in Bruegel, and in both these respects

Children's Games is a key work in his development. What is new in the painting becomes immediately apparent when its top spinners are compared to those of *The Battle between Carnival and Lent*, painted only a year earlier. Seen in the light of the figures in *Children's Games* (Fig. 58), those in *Carnival and Lent* (Fig. 59) seem crude visual constructs. They are rendered more or less conceptually—from the outside only, as it were.

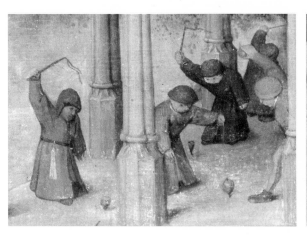 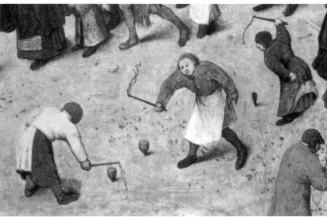

Fig. 58

Fig. 59. Bruegel, *The Battle between Carnival and Lent* (detail)

But the figures of *Children's Games* are lived images. We experience them with an utter visceral particularity. The top spinner on the right, especially, is a self-conscious tour de force of motor-visual representation. All Bruegel gives us is a head, a raised arm, part of a shoulder (all in red), and an isolated portion of one leg (an unrelated blue); yet our imagination assembles the *whole* body and experiences its stance and gesture from the inside out. The top spinners of *Carnival and Lent* are loosely distributed throughout an open space on an otherwise crowded canvas; those of *Children's Games* inhabit the physical world, and in spite of their almost demonic self-absorption, they are held together by the edges of the porch in a kind of force field which their exertions (and our investment in them) generate.

This motor-visceral empathy with the human figure appears fully developed in Bruegel for the first time in *Children's Games*, and one tends to experience it as something intrinsically positive, however violent or autistic the images it generates may sometimes feel.[11] It involves a *representational* faith in the goodness of the body, both as the basis of experience and the vehicle for one's contact and identification with other selves. Fritz

Grossmann has remarked that "Bruegel's conception of the human body
. . . was essentially a moral one," by which, unfortunately, he means only
an object viewed and judged from a moral perspective, and hence "marked
with sin and folly."[12] (He opposes it to the "aesthetic conception" of the
Italian Renaissance.) We might be able to accept this as a generalization
about the *Seven Deadly Sins* of 1556–57, and even (though I think not)
The Battle between Carnival and Lent, but no statement could be more
misleading for an understanding of *Children's Games* and the works that
follow it. In *Children's Games* and after, the body is an ontological given,
the place of lived experience. Consider the man stretched out under the
tree in the New York *Harvest* (Fig. 60). He sleeps from physical exhaustion,
not sloth, and his body's presence feels as primary as the tree's—not
merely grafted to it but part of its root system or its horizontal complement
and stabilizer. Note how Bruegel involves the tree and its sleeper in an
elaborate system of proppings. (The leaning sheaves crystallize this motif.)
The twisting tree rights itself against the man's unbudgeable lethargy. (The
slim pitchfork is an equally strong visual stabilizer.) The man, in turn, is

Fig. 60. Bruegel, *The Harvest*, 1565 (Metropolitan Museum of Art, New York)

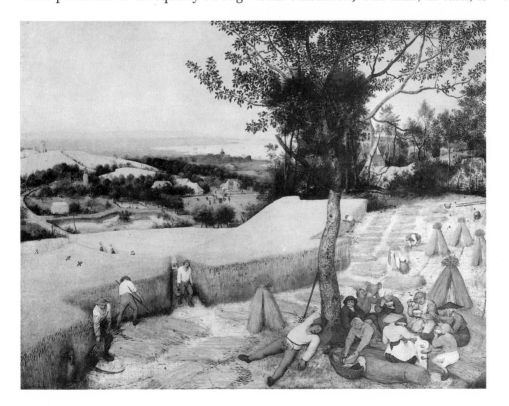

71

secured within the frame—he alone of all the image's space-contained figures seems subject to "slippage" off the painted canvas—by his attachment to the tree (the pitchfork helps here, too). Meanwhile, his heavy stupor counterbalances the communal experience that clusters on the tree's other side. Access to his worn-out body's sleep feels like access to a dimension of shared experience as fundamental as the painting's heightened sense of time and space.

We tend to migrate like this into the bodies of *Children's Games* even when the activity depicted is not obviously kinetic, and in many cases there is a similar feeling of access to what (for lack of a better word) we might call "primary" levels of experience. The small girl crouching at the barrel of *Children's Games* (Fig. 61) appears to be a recollection of the woman drinking from the well near the center of *Carnival and Lent* (Fig. 62). Both are even linked to barrel riders by compositional devices. The connotations of the image in *Carnival and Lent* seem strongly ironic. Although the woman draws water up from a source of replenishment beneath

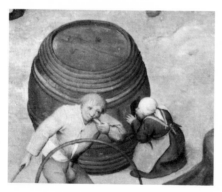

the surface of things (the well is the only opening in the otherwise closed, infinitely reversible social field of the painting) and is surrounded by baskets of food with eucharistic connotations, she herself tends to become a wry emblem of human self-preoccupation, thrusting her head into a shallow void that shows her own image at the end of her nose, gazing back at her like an absurd Narcissus. But the image in *Children's Games* goes deeper. As we turn from the one to the other there is an enlargement and intensification of being—a sensation that has to do both with the activity represented and the way the image works on us. The little girl's curiosity

creates a primal relatedness: she calls into a mysterious space at once "inner" and "other," making an emptiness resonate with her voice and feeling herself amplified in return. We in turn are transported into the image, or made at least to feel a creative empathy with it, instead of looking on as ironic observers.

Allusions to earlier works are frequent in Bruegel; they constitute a kind of internal mapping of the oeuvre. And as the previous examples suggest, the more overt such references are, the more likely they are to indicate a change in vision than the simple reiteration of an idea. *Netherlandish Proverbs* and *The Battle between Carnival and Lent*, especially, seem to have functioned for Bruegel as touchstones for measuring his movement *away* from the perspective of his beginnings. *The Blind Leading the Blind* and *The Cripples*, both painted in 1568, near the end of Bruegel's life, return to images in the two early paintings (Figs. 63 & 64), and the

effect in each case is to call into question the context in which they once appeared. Enlarged to monumental proportions and thrust starkly into the foreground, the figures of *The Blind Leading the Blind* exceed the proverb they call to mind and leave the viewer suspended between realistic and emblematic modes of perception (Fig. 65). Is the painting a depiction of moral corruption or an absurd universe? of man's folly or nature's indifference? Bruegel deliberately refuses to answer these questions. His almost inhuman objectivity creates a void where a stock response once existed, and makes pity, sarcasm, revulsion, black humor, curiosity, and a kind of tragic dread all vie to fill it. Nor is the church in the background allowed to control our interpretation (as we might expect, given the origin of the

Fig. 63. Bruegel, *The Battle between Carnival and Lent* (detail)

Fig. 64. Bruegel, *Netherlandish Proverbs* (detail)

Fig. 65. Bruegel, *The Blind Leading the Blind*, 1568 (Museo Nazionale di Capodimonte, Naples)

proverb). The painting crops its steeple just where a cross might otherwise appear and makes its dim apertures mirror the blind men's eyeless sockets.

The tightly knit group of *The Cripples* (Fig. 66), removed from the everyday setting of *Carnival and Lent* and thrust into the viewer's consciousness, also calls into question the notion of a moral universe and challenges even more radically than *The Blind Leading the Blind* the viewer's capacity to respond. The usual art-historical interpretation of these figures as emblems of moral corruption restores contexts that Bruegel has conspicuously removed. In such cases, the attempt to situate is a refusal to see:

Bruegel . . . has isolated these human wreckages from the carnival atmosphere and portrays them with apparently little compassion. Their coarse, animal-like faces and mutilated bodies seem almost as monstrous as Bosch's devils, and the resemblance is perhaps not fortuitous. By Bruegel's day, beggars had long been regarded as cheats and scoundrels who often faked their deformities in order to attract public charity. In an engraving of cripples and beggars . . . the accompanying poem characterizes them as servants of the Cripple Bishop who gladly lives on false charity to avoid work. The Cripple Bishop was also included by Jan van den Berg

Fig. 66. Bruegel, *The Cripples*, 1568 (Louvre, Paris)

among the wastrels and deceivers in his *Het Leenhof der Ghilden* (*Court Register of the Guilds*). Bruegel's *Cripples* is, therefore, less a record of contemporary carnival customs than a timeless image of human deceit.[13]

Of one thing we can be sure: the deformities of Bruegel's cripples are *not* faked. No figures could have less to do with deceit, except insofar as they confront us with our own capacity for self-deception in the face of what threatens our complacency. Nor do they appeal to us for pity. Bruegel's presentation makes denouncing them as frauds and offering them charity seem merely two different ways of turning away, drawing back from a disruptive experience of otherness into modes of "reasonable" seeing. Hence the shrouded background figure's ambiguity—has she just distributed alms to the cripples or is she walking by oblivious to their plight? is she wrapped in complacency or alone in her own destitute world?—and the feeling of that ambiguity's irrelevance. What Bruegel does instead is paint his subjects in their own world, as they appear in their absence from us, before they disperse to assume the postures calculated to elicit from us our stock responses to their suffering. Such "objectivity" is itself moral, though it involves a refusal of all readily available moral sentiments. And

as such it is always on the verge of turning its critique upon itself. For all its apparent detachment, *The Cripples* is one of Bruegel's most personal works, fraught with conscience. The viewing consciousness does nothing here, takes no steps either to touch things up or to intervene. Instead, it takes radically upon itself the burden of its object, not by offering sympathy or acting on its behalf, but by refusing the frames of reference the ordinary world has devised for coming to terms with it. And for all the strength of the gesture, we are still made to feel that it is not enough, that it does not escape complicity, that it, in fact, makes us sharers in the general blame. Beyond this it isolates us in a relation with the one cripple at the rear whose back is turned: we both become solitary, far-off viewers of, in Rilke's words, "the hopelessly open gate."

Retrospect

What I have tried to do in Part One is suggest the outlines of a certain reading of *Children's Games* and at the same time address issues of meaning that tend to get lost in specific interpretations of Bruegel and the disagreements they inspire. In particular, I have tried to show that Bruegel's images—especially in *Children's Games* and after—tend to work as a primary means of expression, not just as signs of preformulated verbal ideas. Bruegel's thinking, that is, is to a great extent inherent in the image-making process, not somewhere "behind" it manipulating the medium to suit its ends.

Two last ventures into the painting's weave may help to illustrate this point. Consider first the treatment of bodies in *Children's Games*. On the one hand, they are givens of the painting's world and thus matter-of-factly require representation. But they are also enlivened by a kinesis which comes out with special force in children's games and which thus presents a special challenge for any artist who takes up the motif. Indeed, one of the things that distinguishes Bruegel in *Children's Games* is the immediacy with which he renders this kinesis—so strongly that the body itself tends to generate an ethos.

But the rendering of bodies in *Children's Games* goes even further. In addition to "coming alive," bodies are scattered through the scene like some arcane alphabet, marking a primal ebb and flow, yet only sporadically readable as "meaning." Consider a key detail: near the right corner of the central building, amid a varied group of children with hunched, tensed-in postures, a single girl arches her body and flings her arms wide (Fig. 67). Isolated in such a context, her stance seems to release the energy being stored up and held in all around her. Such an interplay between "outflungness" and "indrawnness" recurs throughout the painting and seems capable of endless variations. Given its intricate weave, there can be little

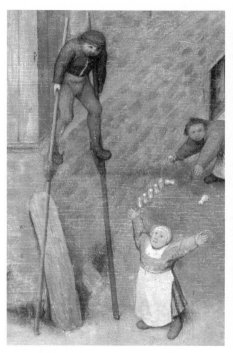

Fig. 67 / Fig. 68 question of Bruegel's awareness of it: note how cleverly he arranges these two postures on the area of the canvas marked by the red fence, fitting a boy doing a headstand directly on top of a boy who ties himself into a knot in the same area (Fig. 68). Sometimes this interplay becomes the site of a specific theme: the hunched stilt walker and the girl with outflung arms, for instance, are one of the painting's many pairings of male and female postures of experience. But more often the ebb-and-flow works more diffusely to energize the canvas, suggesting (almost subliminally) the coagulations and dispersals, "the gatherings and releases of tension,"[1] that libidinize the pre-symbolic field.

Or consider the profusion in *Children's Games* of straight lines and circles, angles and gentle curves. One finds these forms everywhere, often ingeniously marked and juxtaposed. Note the round hat on the roof at the far left and the rectangular handbill pinned just above it: neither seems to have any rationale beyond helping to underscore this play of motifs. Likewise, the training potty in the extreme foreground: its rectilinear top conspicuously frames a round hole. Sometimes these forms are combined to effect elaborate conversions of energy. Consider the pair of jousters in the

left middle background, who wield long sticks to which pinwheels are attached. As the two move forward, apparently about to clash, the pinwheels convert this linear momentum into circular movement, and a game involving what looks like phallic aggression and imminent conflict is transformed into the pleasure of making things spin around. Bruegel, as we shall see, is elaborately interested in this conversion of linear into circular energy: it even becomes what might be called one of his "themes."[2] But the dominant impression all these lines and circles create is of elementary forms (the unworked raw material, perhaps, of structure and significance) caught up in an overall random play. Even the large-scale lines and curves that traverse the canvas seem overdetermined and provisional, less formal patterns that give us the structure of the painting than momentary configurations held in an instant of arrested perceptual flux.

This last impression may be the closest thing the painting gives us to a Weltanschauung. We see a play of transcendental forms in the process of organizing experience, first finding embodiment in social patterns (the circle of hair pullers, the line of leapfroggers), then further taken in hand by individuals (the hoops, the knotted belt, the endlessly appropriated sticks, the blindfolded pot smasher's raised pole). But we observe this process from an unlocated perspective that leaves the purpose of it all in doubt. The painting testifies vividly to the instinctive human will to turn barren and impoverished circumstances into a multifarious and imaginatively grasped world. But it also intimates a universe governed by an anarchic play that reappropriates such world-making activities in much the same spirit that bricks, brooms, barrels, and other stalwarts of the practical world are swept into the flux of children's games. The painting may even make us feel that human activity participates in some cosmic process,[3] but it offers such intimations from a perspective that makes human significance all the more difficult to believe in and hold secure. Not that we necessarily look down from far above, sharing the attitude of gods who deride us for our vanity. But we may feel—with ambivalence, exhilaration, or dismay— a sense of what it is like to inhabit a world where "a child reigns as king."

———

What follows in Part Two is an exploration of certain details of *Children's Games* for which the previous discussion might be thought of as a

preparation. But the first part is not meant to frame the second, or in any hermeneutic sense control it. (Indeed, either section could precede the other.) Part One is more a jumping-off place than a frame, its contextual material the account of a connotative fund from which the details treated in Part Two may be felt in varying degrees to draw. In one sense what is most important is the gap between the halves. As pendants they should underscore the leap, the mental shift that attending to details involves, *especially* when something like a context has been assembled. Even when material from Part One seems to bear most obviously on an aspect under discussion in Part Two—the iconographically "marginal" place of childhood games in illuminated manuscripts, for instance—I have usually chosen to treat the connection in a footnote or else allow it to remain implicit. In handling the relation between the painting's "inside" and "outside" this way, I have tried to convey a sense of how context itself is often intuited or *felt* at work in an image, and of the more oblique, intermittent, even uncanny ways that context can color a perception.

Part Two's exploration of *Children's Games* begins and remains in medias res. In it I choose certain games or areas of the canvas, and in the process of attending to them closely attempt to make connections and coax meaning out of nuance. The titles of the individual sections I offer provisionally as guideposts or structural cues. The first five—"Nature and Culture," "The Middle Realm," "Opposition," "Coagulation," and "Violence"—move forward with a loose sequential logic and their trajectory may convey something of the painting's outlook. But the remaining sections—"Gender Difference," "The Sexual Relation," and "Assurance" —track themes that are disseminated in the painting as if to elude coherent views. A sense of the painting's overall "aboutness" should gradually form for the reader in the interstices and at the outer edges of the analysis: my claim is that meaning is *there* in Bruegel, and that it lucidly inheres. I'll attempt no explicit formulation of the meaning the painting reaches, primarily because none seems feasible. The book will end where it began, immersed in the painting's details, with a strong sense of Bruegel's scope and clarity, yet persuaded more than ever by his fineness and variety that "all knowledge is particular knowledge."

PART

TWO

Nature and Culture

When the eyes scan *Children's Games* for the sign of a unifying idea, what they first tend to notice is the opposition between the pastoral area at the upper left and the receding street at the upper right (Figs. 69 & 70). The two areas bracket the central region like the moralized landscapes in the backgrounds of so many religious paintings of the early Renaissance.[1] What they depict, however, is a more secular and contemporary-feeling dichotomy between nature and culture, or rural and urban life. The effect is to situate the marginal world of childhood play—which has already spilled over into the realm of serious adult activity—within one of those "antithetic *mise-en-scènes*"[2] that define the central human region. Childhood here (like life itself) is a charged intermediate space, framed by con-

Fig. 69 / Fig. 70

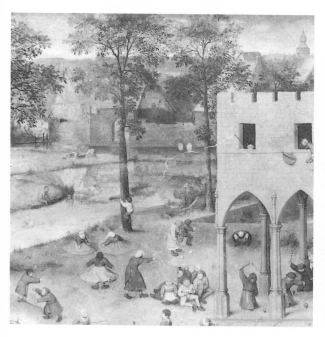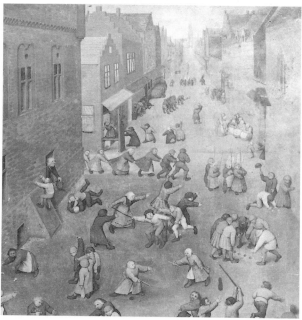

83

flicting allegiances and by ancient schemata that pose dereliction against grace.

Several apparently casual details reinforce the parallel between these two areas. The outline of the grassy plot that grows away from the stream resembles that of the shadow which the building casts onto the street. Two isolated patches of grass that attempt to flourish in the building's shadow find their counterpart in a low piece of wall that lies in ruin at the edge of the stream, equally out of its element there.[3] The vaguely Boschlike spire that rises incongruously in the background of the pastoral area seems necessary to match the cathedral that looms at the end of the receding street.

The two latter structures resemble landmarks on the often-depicted horizon of sixteenth-century Antwerp (Fig. 71).[4] The building on the right

Fig. 71. Melchisen van Hooren, *View of Antwerp in 1562* (Cabinet des Estampes, Brussels)

Fig. 72. "Mystic Attributes of the Virgin", *The Grimani Breviary* (Bibliotheca Marciana, Venice)

suggests the city's famous cathedral, while the building on the left recalls (more distantly perhaps) the lantern-topped spire of the Abbey of St. Michael. Their positions relative to each other imply an inland view of the city, seen from its rural outskirts, thus reinforcing suggestions of the painting's central region as somewhere "between" nature and culture, *rus* and *urbs*. But iconographic allusions complicate geographic cues and interfere with any attempt to fix the painting in actual historic space. The tower on the left, for instance, gestures as strongly toward the structures of Bosch as toward those of Antwerp, and resembles an emblematic tower in the *Grimani Breviary* more closely than either (Fig. 72). And the spatial layout of the painting defies any horizon that might stretch "in reality" from one

building to the other. The cathedral seems at an infinitely greater—and qualitatively different—distance than the lanterned tower. The two areas seem metaphysically unbridgeable. Nothing appears to extend behind that central building, which imposes itself as both impenetrable mass and sheer façade.[5]

One of the most pregnant of the correspondences between the two background areas is that between the tree climber on the left and the boy running up the cellar door on the right (Figs. 73 & 74). The resemblances between the two figures—both facing in the same direction, left knee bent and arms outstretched, attempting not very successfully to climb—make their differences all the more striking. The boy climbing the tree, like so many of the children in the painting, is playing a game that expresses an impulse to rise and aspire—he is a distant cousin, for instance, of the budding young Icarus perched high on stilts. Yet one could scarcely imagine a less convincing image of transcendence. He has made very little progress up the tree and seems unlikely to make much more. Unlike the trees in *John the Baptist Preaching* (Fig. 75), which seem *made* to accommodate

 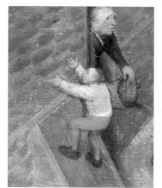

human presence, the one to which he clings is all uprightness. Though it epitomizes something in nature that rises and then flowers, it remains indifferent to the human impulse to climb.

Yet the tone of the image is not ironic. The tree may not support the boy's efforts, but its presence answers his embrace. It provides him with what the cityscape refuses to the boy with empty arms running up the cellar door. The tree climber clings to the tree, in fact, as if he were one of nature's children, still attached to the nurturing source. The wall to which

Fig. 73 / Fig. 74

Fig. 75. Bruegel, *John the Baptist Preaching* (detail)

his counterpart appeals, by contrast, presents a sardonic negation of the nurturing impulse: out of it a woman with an expression as blank as the wall itself materializes, and empties a bucket on two children fighting in the street (Fig. 76). The tree climber, possessed by vertical urges, embraces

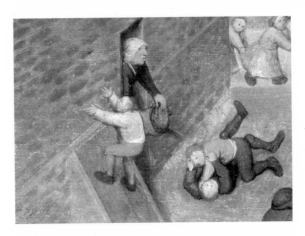

Fig. 76 a stable, rooted order of things. The geometry of the street, however, encloses life within an oppressive mental construct. The children enveloped by the shadow of the building seem to lack all sense of direction. Like the figures gathered around the table in Bruegel's Vienna *Peasant Dance* (Fig. 49), they grope blindly as if to make contact with something outside the self.

The use of different modes of perspective to render the two areas (''natural'' on the left, ''artificial'' on the right) makes the contrast between the scenes they enclose inseparable from the psychic organizations whose ''views'' they are.[6] The linear perspective exaggerates the monotonous succession of buildings that border the street and turns the entire area into a surrealistic vista where few instances of the dwelling instinct survive (Fig. 77). A mood of both frenzy and enervation attaches to the games that take place there. The children who play them seem trapped—their condition is epitomized by the boy who runs up the cellar door, his empty arms held out to the blank unanswering wall. All are unwittingly caught in a funneling movement that absorbs individual children and their separate energies into patterns of conformity and channels them past the burning stake—a last vestige of resistance to the social and religious law—toward the hazy spire. They seem to recede in time as well as space, toward a

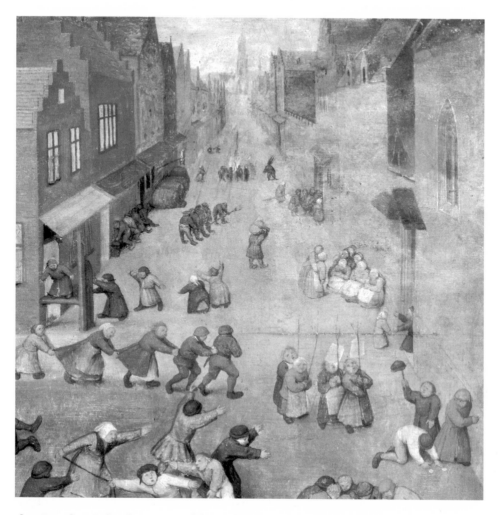

destiny that is both inescapable and infinitely remote. The festive St. John's Fig. 77
fire in the distance—it is the apocalyptic counterpart of the pastoral area's
baptismal-like stream—is like a last huddling together for warmth and hu-
man closeness in a space that becomes more and more barren as it recedes.
Yet at the same time it is an emblem of martyrdom and a reminder of
religious persecution, and as such, an ominous harbinger of the cathedral
that seems to levitate in the far distance, barring the opening at the end of
the street.

Such exaggerated linear perspective is rare in Bruegel and usually car-
ries with it a negative charge, especially when it creates a channeling effect.
The thick window of *Two Monkeys* (Fig. 78) and the receding walls of *The*

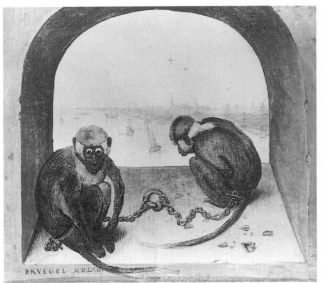

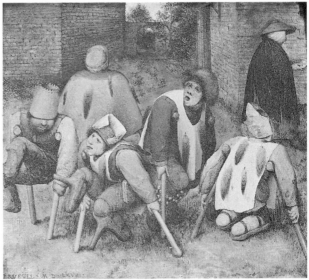

Cripples (Fig. 79) are especially vivid instances; both frame conditions of imprisonment or entrapment and channel the view toward a prospect of freedom that is empty and/or cruelly delusive. Linear geometry prevails in Bruegel's *Virtues* series, which Tolnay has interpreted as ironic depictions of a world from which nature has been eliminated.[7] In the background of *Justicia* (Fig. 52), the most plausibly ironic of Bruegel's *Virtues*, there is an association of ideas that seems especially relevant to the upper-right area of *Children's Games*: a heretic being burned at the stake, a channeling of individuals into masses of passive conformity, and a rigorous control of event and viewpoint by linear perspective. This work, as we shall see, seems to have been especially on Bruegel's mind when he painted *Children's Games*.[8]

If one does look for solace in *Children's Games*, one tends to find it not in the authority centralized in the remote and vaguely forbidding cathedral but diffused throughout the pastoral scene at the upper left (Fig. 80). Whereas the linear perspective of the street suggests imprisonment in an artificial viewpoint, the aerial perspective on the left pictures a sustaining order that is *in* nature, and includes humans in the same way it does trees and streams. The naked children who play there express a kind of creaturely at-homeness. The cottages in the background, constructed from the materials of the immediate environment and fitted to its

scale, are similar indications of a dwelling impulse that is in harmony with nature, not imposed in its absence. The thatched roofs, the waterwheel, and the reflection of the cottages in the meandering stream all suggest a realm where patterns of reciprocation govern in the absence of linear imperatives. Even the exotic tower in the background, which might seem out of place in this idealized vision of what it is like to live close to the earth, in contact with nature, seems oddly at home here—an imaginative flourish crowning a scene that appeals as much to utopian fantasies as to one's realistic sense of life.

This pastoral ideal that is so accessible to the viewer's imagination is less so, however, to the children playing in the central region. To reach it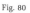

from the foreground of the painting a narrow, maze-like path must be negotiated, and at the crucial turn a menacing-looking boy with a knife blocks the way. Its scattered inhabitants seem to have found their way into it either by accident or by grace, and their connection with what is going on elsewhere in the painting remains problematic. Practically the only thing that unites all the randomly intersecting movements in the painting is a common flow *away* from the realm in the upper left: the gauntlet runners, Fig. 81 the leapfroggers, the hoop rollers, the hobbyhorse rider, the bridal and

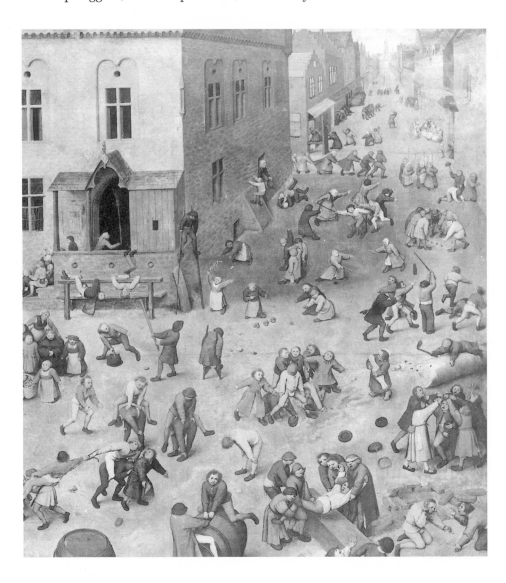

baptismal processions, the hats being tossed at the far right, the vector imparted to the fence by its riders: all point away from it. The only exception is the windblown banner that ripples from the window of the central building, and though it might draw the reverie of the boy who holds it toward the pastoral area, it indicates no means of getting there.

The upward flow into the street on the right, however, is broad and unimpeded (Fig. 81). This arid, walled-in space clearly seems the destiny of the children playing in the foreground, although not many of them are pointed in its direction either. The lines of force that channel them into it represent a process that appears independent of individual wills and the local configurations into which they enter. It seems, in fact, to *suppress* the physically exuberant, riotously imaginative form of life that overruns the foreground. Yet at the same time one senses a purely inner momentum at work. No visible agents of coercion are necessary to shepherd the flow across the threshold marked by the building (in the way, for instance, that an adult must guide the wedding procession around the corner of the fence), and the relationship between foreground and background registers as one of continuity as well as loss. The socialized space in which what is urgent and valuable in the games seems unable to survive is made to appear the inevitable extension of something to which they themselves give vent. The frenetic disorder of the one and the paved solitude of the other somehow answer to each other and distinguish both from the open calm of the pastoral scene.

The Middle Realm

Midway between the tree climber and the boy on the cellar door, two boys dangle upside down from a wooden railing (Fig. 82). They've been weaned from the world of nature but don't yet experience the social order as unanswering and alien. Their support is one of a group of wooden objects (each with a human attachment) that scatter points on the nature-culture continuum throughout the central region: from the rooted tree to which the tree climber clings, to the felled tree on which a child stalks flies, to the squared beam across which a boy is being bounced up and down, to the simply built railing from which the two boys hang, to the artfully constructed red fence with its line of riders. The wooden railing locates the midpoint of this continuum: it announces the building impulse in its most unsophisticated form and heralds those rectilinear constructions (unknown to nature) erected by the human order.[1] Though it lacks the aura of the trees still growing near the stream, its derivation from them is still a quality of its presence. And unlike the red fence—whose finish masks its origin in nature—it doesn't yet function to mark off and enclose. Though it doesn't really fit the arms of the boys who hold on to it, they enjoy a margin of freedom and an openness of view that the tree climber's attachment deprives him of. They more than he experience *human* nature, however improvised the forms it takes.

The two rail hangers are played off against each other as well as the figures to their left and right. The one on the left hangs free, luxuriating in the feel of the earth's pull against him (the dangling satchel emphasizes the sensation). The space his arms enclose is a place of reverie, an inner region. His more aggressive counterpart pulls the railing tightly to him and raises himself, perhaps twirling, in defiance of gravity. The boy on the left loses himself in the sheer physical sensation of hanging there; the one on the right stares out at the world and takes in an upside-down view of it.

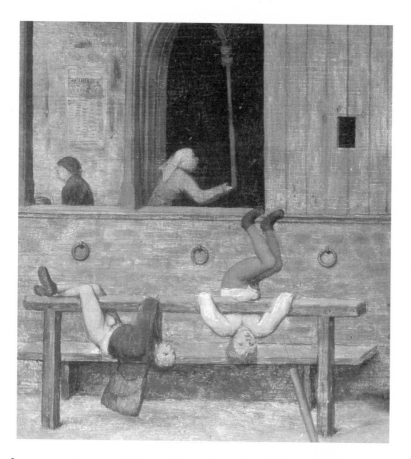

They thus repeat, in a different key, the paired faces at the two window-sills. Both, in the process of trying out their physical skills, develop in themselves a capacity for subjective freedom: one nourishes an imaginative potential, the other a muscular ability to alter his perspective.

Fig. 82

The boy gazing upside down was singled out long ago as a sign of the painting's "moral meaning" and ever since has figured in interpretations of *Children's Games* as the depiction of a topsy-turvy world.[2] But the boy inverts the world as he pits his body against the laws that rule it: his visceral understanding of point of view seems worth possessing. He is the opposite of the misanthropic mask at the windowsill: one looks down, like a Reformation moralist, from a place of godlike detachment with fixed, predetermined disapproval; the other, more an Erasmian paradoxicalist, is implicated in the world's inversion, and views it with ludic curiosity.

Behind the two boys a girl balances a broom on the end of her finger

at the threshold of the entrance to the central building. Her position there matches that of the girl who swings behind the two children at the windowsill in the painting's upper left (the identical headdresses underscore the connection). But while the upper story in which the one swings holds helping arms, the building where the other plays frames a gaping void. Its anthropomorphic façade threatens oblivion almost as surely as the hellmouths of Bruegel's *Dulle Griet*, though as a bastion of the social order rather than as an alien metaphysical presence (Figs. 83 & 84). Commentators usually identify the building as a town hall or guild house, but this seems too literal a response to its socially representative or official look.[3] Bruegel has constructed it more as a pastiche of different institutional aspects or cues—civic (the notice board, the portico with all its public trappings), ecclesiastical (the Gothic arch with its monklike flagellator), even the private in its fortresslike, Italianate form (the crenellation, the maid at the side door). Comparison with contemporary Flemish architecture—the old Antwerp town hall, for instance, demolished by 1564 (Fig. 85)—emphasizes the extent to which Bruegel's building *estranges* native forms. The

Fig. 85. Old Antwerp Town Hall in 1561. H. Causé, after a painting by Mostart (City Archives, Antwerp)

monotonously rectilinear design, the fortresslike quality, the anthropomorphic façade, and above all the oppressive sense of mass and weight are all features of Bruegel's image.

The girl with the broom positions the two rail hangers—and by extension all the children—with respect to this gaping structure. The directional thrusts of the red fence and the long squared beam fix her at the apex of the central region and channel the foreground activity toward the dark opening behind her (Fig. 86). Poised at the entrance of this walled-in darkness, she locates the point of exchange between herself and the external world at the end of one finger and holds an object lightly suspended there. And not just any object: the broom is an emblem of her society's obsession with order and an attribute of her own destined role as that society's domestic custodian.[4] The game inverts this object and, in doing so, "suspends" practical function, conventional meaning, and social fate all at once—a rich claim for the moment of play. It is a gesture that can strike us, like the entire foreground spectacle that converges toward it, as either audacious or poignantly guileless—flaunting the playful, carnivalesque at-

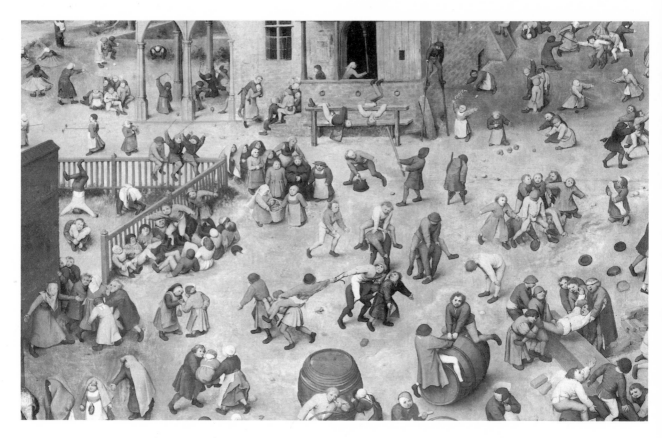

Fig. 86 titude toward the world (in this the broom balancer is a kind of inverse
Atlas-figure or ironic upholder) at the very threshold of the institutionally
housed order that is alien to it, or oblivious to the darkness into which the
girl and what she stands for are on the verge of disappearing.

Opposition

In the center foreground of the painting, the two contending piggyback riders hold on to opposite sides of a knotted belt and strain against it with all their might (Fig. 87). The forces that act on this stretched circular form have a powerful focusing effect: it tends to become a still point around which not just the tug-of-war but the entire central region turns. At the same time, the area the belt encloses is charged with energy and importance—the impression of urgent, concentrated space is underscored by its counterpoint with the large, vacant-looking hoops rolling by in the extreme foreground. It is as if the purpose of the game were to locate and pry open the human connection—which never really succeeds in overcoming separateness in Bruegel and here seems *constituted* by the forces pulling against it.[1]

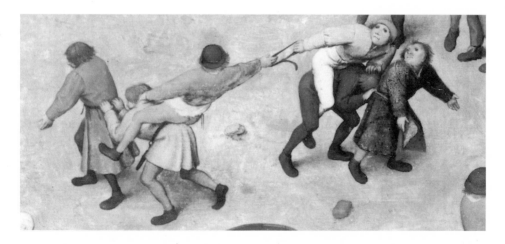

The centrality of the tug-of-war is more than just a vague impression. Bruegel has cleared a large space around the game and arranged the vignettes at its periphery into another stretched circle (from the top moving

Fig. 87

clockwise: the boy crouching at the overturned pot, the blindfolded figure with the stick, the stilt walker, the group tossing caps, the boy being bounced on the beam, the three children at the barrels, the couple carrying a girl, the two figures playing odds and evens, the gauntlet runners, and the bridal procession) (Fig. 88). The spaces around and between the warring groups describe two more circles pulling toward the upper right. One of the two rocks that mark the game's boundary line even acts as a visible center for these concentric rings. The effect is of a dense "hub" around which the games in the central foreground turn. A line of leapfroggers tangent to the tug-of-war cuts through the outer wheel, masking the circular design and at the same time combining with it to form a giant hieroglyph of linear and circular motifs. As such, the conjunction can be read in opposite ways, as a figure of either blockage or facilitation—the spoke jamming the wheel or the wheel moving the spoke. The two elements of this visual idea separate out in two closely related works by Bruegel. In his drawing *The Kermis at Hoboken* (Fig. 89) a large horse-drawn wagon fills the center of the composition with the hieroglyph in its "mobile" aspect, while its linear and circular components weave their way through the entire design. By contrast, a wheel with a spoke thrust through it in the lower-right-hand corner of *Netherlandish Proverbs* illustrates "poking a stick into the wheel," i.e., thwarting someone's plans (Fig. 90).

Fig. 88

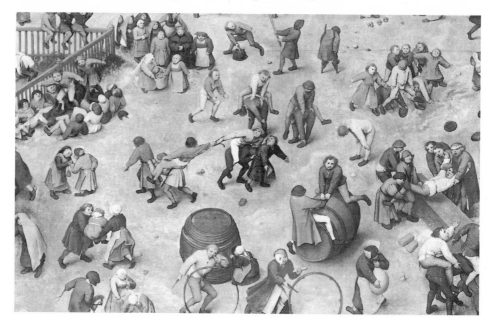

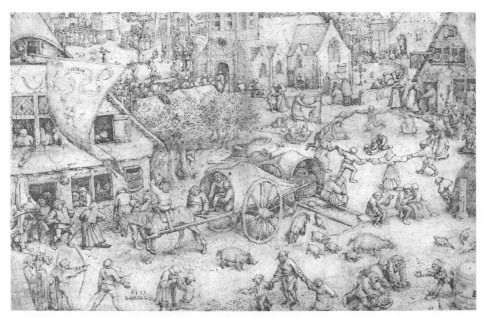

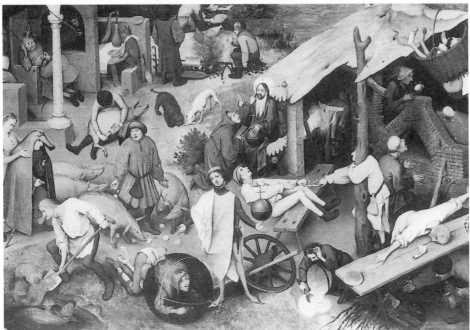

Fig. 89. Bruegel, *The Kermis at Hoboken*, 1559 (Courtauld Institute of Art, London)

This lower-right-hand region of *Netherlandish Proverbs* is worth pausing over, especially since it contains two pretzel pullers who are obvious precursors of the piggyback riders in *Children's Games*. The proverb illustrations in this area of *Netherlandish Proverbs* are more densely interactive

Fig. 90. Bruegel, *Netherlandish Proverbs* (detail)

99

than elsewhere in the painting and generate what amounts to an ironic discourse about the haves and have-nots. The peasant who "can barely reach from one loaf to another," for instance, turns himself into an image of self-crucifixion through his futile attempt to make ends meet and offers his head up as if on a chopping block. The young lord who "spins the world on his thumb" and the peasant who "must squirm if he wants to get through the world" form a single configuration of blithely dominant and abjectly subservient classes. The gestures of the standing aristocrat contrast sardonically with those of the seated Christ (who, however, in his indiscriminate beneficence is being "bearded" by a hypocrite monk), while the young lord's boot stands in the way of the peasant trying to make his way through the world. We are left to wonder whether the result will be the one's blocked progress or the other's crushed foot.

The two figures who "pull for the larger half" generate more complex ironies. The bulging red purse of the man on the right turns the contest into another struggle between the haves and have-nots.[2] His purseless counterpart pulls with greater zeal and therefore may look like the eventual winner; but then again, how hard one pulls has nothing to do with who winds up with the larger portion, and the one thing the figure on the left can be sure of is a nasty fall. The man with the purse, by contrast, can afford to pull more lackadaisically, since his grasp on the "structure" gives him extra leverage and assures that when the pretzel breaks he will remain anchored and unmoved. But this assurance may in turn prove hollow. If we follow his tree-like support down to its base (an authorial-like figure with a lamp directs our attention there), we find its roots exposed and an ax laid in among them. Whatever the proverb, it almost certainly derives from Matthew 3:10: "Even now the ax is laid to the root of the trees." There is the chance, then, that the poor man's exertions may bring the whole withered structure tumbling down, while the rich man keeps obstinately clinging to it to ensure his advantage.

The sense of ironic social commentary persists in the tug-of-war at the "hub" of *Children's Games*, where we observe a struggle between privileged individuals being sustained on the backs of laboring pairs.[3] But the charged kinesis of the image reaches down beneath social conflict to elemental forces of attraction and repulsion. The tug-of-war is less an illustration of how the world goes than a depiction of the self in primitive

relation to other selves. The piggyback rider on the left is the relation's visceral focus. He is stretched between opposing forces, but unlike the victim being bounced up and down on the wooden beam (Fig. 93), he obviously thrives on conflict. He is an image of the exhilaration of being stretched out all along the body's span, reveling in a capacity for extension and reach. Cooperative and aggressive impulses appear secondary here to an urge for self-heightening that just happens to require other human beings. Nor can the exhilaration conveyed by the image be understood simply in terms of the thrill of dominance or the will to power: it registers most vividly in the rider who, having been pulled almost completely over into the space of contention, is on the verge of *losing* the game. (Though here too there are contradictions: down below where the "horses" strain, the boys on the *right* appear imminent losers, since they are only inches away from the game's boundary line.)

As an image of the social bond, moreover, the game is elaborately ambivalent. The belt links two bodies, yet encloses a space that separates them. Each rider pulls the other toward him, yet pulls away from the other's designs on him. The mounts strain in opposite directions, but in the process the riders are forced inward toward each other. The members of each group act in concert, but only because they are united in the "fun" of opposition and strife. Although both groups pull with a sense of determination and purpose, neither seems to be getting anywhere, and the energy they generate between them all but cancels itself out.

The equilibrium that momentarily holds between the two groups, however, is as intense as it is unstable. The current that leaps across the gap inside the belt and flows through all six bodies at once is like the life force itself; it is precisely what is missing in the line of children who play follow-the-leader in the rigidly channeled civic space of the street above. (*They* recall the blind leading the blind in the *Netherlandish Proverbs*.) And although the two tug-of-warriors pull in opposite directions, their efforts force them into orbit around a common center: the game feels more like a vital nucleus than a war of opposites. There is something triumphant about the way that connecting link is *grasped* and made palpable, even though it looks as if it may be torn open at any moment by the energies that strain against it. What is positive about this version of the human link again becomes evident when one compares it to the groups in the street above,

where the centrifugal and centripetal forces held in equilibrium by the game of tug-of-war separate out into bleakly conceived social aggregates. The figures who dominate that area reach out across vacancies or move in circles that seem to be flying apart, and many of them grope as if for a lost connection (two who have found it are locked in furious strife); or else they are drawn magnetically to centers that involve chance, blindness, greed, and random violence (Fig. 81).

Just behind the piggyback riders, a game of leapfrog occupies almost as prominent a place in the center of the painting (Fig. 91). It, too, seems to offer an emblem of human motivation and the social order, and a rather

Fig. 91 sardonic one at that. The "frogs" encounter the "jacks" as obstacles and turn them into objects, means to their own end. The immediate impression is of two distinct classes, one of which rises and enjoys mobility at the expense of another, which remains passive and stationary, its horizons limited to the ground beneath its feet. But eventually each frog will take his place at the end of the line after he has vaulted over the last back offered to him, and each jack will become a leaper in his turn, as the game makes its way through the central region much like the two rolling hoops. As with the tug-of-war, what looks like a game of pure opposition harbors a "circular" impulse, which conspires to recycle linear energy and make fixed hierarchies revolve.

There is thus a discrepancy between the inner dynamism of the game and the tableau into which Bruegel has frozen it, and this discrepancy poses succinctly the ambiguities of childhood and play that are scattered through the painting. The participants can be regarded either as already driven by the impulses that produce dominant and submissive classes or as embodying a democratic counterimpulse that converts patterns of dominance and submission into reciprocal relations. And this opposition within the game mirrors another within the act of viewing: on the one hand, a detached, purely optical perception of frozen images that lend themselves to emblematic meaning or at least lack the means to resist it; on the other, a kinetic, memory-charged participation in images that are embodied and in motion, and whose momentum keeps undoing simple moral tableaus.

But the kinetic aspect of the image is invested with an instability of its own. For even when one's eyes manage to view the game in motion, they still have to wonder how long the "recycling" process can sustain itself, and to what effect. One problem lies with the isolation of the foremost jack. Bruegel has adjusted this boy's distance and angle from the others just enough so that, as he waits to be vaulted over, his link with the group tends to fade, while he drifts down into the realm of self-withdrawnness that claims so many of the painting's figures (Fig. 92). Pattern and color reinforce his separation. His light clothes distinguish him from the other two jacks and make him blend with the ocher ground, while the

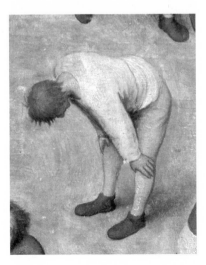

thrust of the piggyback riders wedges in on him at the same sharp angle embodied by the fence. As he crouches down he closes over an inner space—Bruegel highlights the effect by making the shadowy, contained area of his pale shirt deepen to a rich orange—into which he inadvertently sinks as he waits. And even if one's imagination manages to keep him attached to the game and makes the foremost frog vault over him, one promptly encounters the opposite horn of the individual's social dilemma. For Bruegel has aligned the game with the long wooden beam jutting out from the lower-right-hand corner, so that the momentum of the leapers terminates in the hapless figure being bounced between contending groups (Fig. 93)—an image of what it feels like to be part of society that is less easily recuperated by seeing it as only a game.

Fig. 93

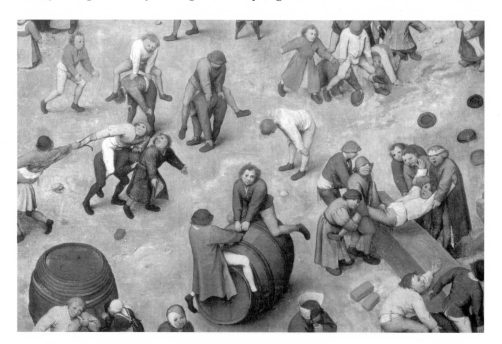

Coagulation

At the right edge of the painting five boys gather in a circle around a sixth, playing a game that is always identified as "pulling hair" (Fig. 94). It is tempting to regard them as epitomizing the spirit of violence and aggressive coupling that grows so dense toward the lower-right-hand corner of the painting. Actually, though, the presence of cruelty in such unsublimated form makes the game something of an anomaly even in this area. Wherever else the impulse to victimize or persecute is the basis of a game (and that it often *is* is one of the painting's many insights), another impulse is at work, binding aggression in forms of make-believe and providing compensation to its victim. (We might wonder, in a deconstructive mood, whether "play" is the latter of these impulses or the field of both.) One of the things that make a unified perception of the painting so difficult to achieve—and so dubious a goal—is the way Bruegel shifts the emphasis from one to the other of these components in the various images where

Fig. 94

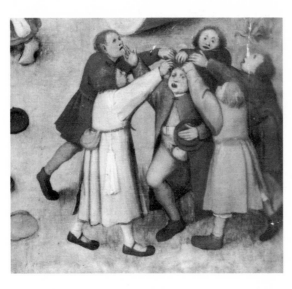

they most overtly contend. It is obviously *fun* to be the gauntlet runner (Fig. 95), for instance, and from the looks on the faces of the children who supply the kicking legs, their pleasure has little or nothing to do with

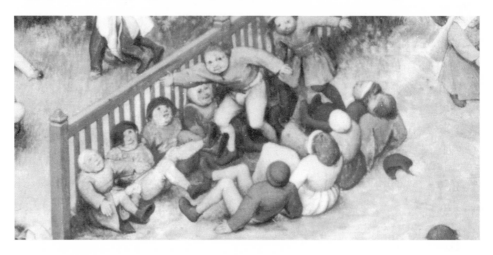

Fig. 95

Fig. 96

Fig. 97. Raphael, *The Entombment*, 1507 (Galleria Borghese, Rome)

inflicting pain. In the game in which the boy is being bounced up and down and stretched across the wooden beam (Fig. 96), by contrast, the pleasure principle's compensatory strategies seem barely in effect. Yet even here Bruegel depicts a certain solicitude in the way the victim is being manhandled by his friends—an effect that is enhanced by a submerged reference to imagery of the Entombment (Fig. 97). And he in turn experi-

ences an inverse exhilaration. He is in many ways the opposite of the girl who swings inside the upper story of the shed with the aid of helping arms, but his distress is still a recognizable variant of her elation. For both, the sensation of charged bodily existence is raised to the highest pitch. There is even a strange transcendental sense in which "giving" this experience to the boy seems the purpose of the game.

But it is difficult to imagine what could be very exciting or ontologically exhilarating about having one's hair pulled, or what would distinguish it as play from unadulterated cruelty. Indeed, on the evidence of this one image, a viewer might be inclined to credit the painting's moralistic interpreters, who predictably hone in on the game: "When five [of the children] pull the hair of a single victim and when they kill flies, they act more savagely than normal children would."[1] Yet the longer one looks at the image, the less certain one becomes that pulling hair is really (or simply) what it depicts. The boy in the middle, far from crying out in pain, strikes the pose of a statesman and appears to declaim, all but oblivious to the figures who surround him. And his persecutors appear to be covering or crowning his head—from which he has obligingly removed his hat—rather than pulling his hair. Only the hands of the two boys in front are closed (gently so, from what we can tell), and they seem to be suspended slightly in front of his head, not directly over it. The three hands that are in position to grab some hair are limp and open—one thumb is even pointed straight up, as if to create the unlikelihood that pulling hair is what its hand is doing. It would almost seem more plausible to suppose from the details of the image that the game involves a laying on of hands, as if the surrounding figures were either ritualistically legitimizing an "orator" or vicariously participating in the charisma that emanates from him.

It may be that some such game involving an orator and his audience was actually played by sixteenth-century Flemish children and no record of it survives. Or the game may be purely Bruegel's invention. Or he may have deliberately constructed an image in which the two possibilities—"oratory" and "pulling hair"—coexist, as opposite poles of a single contradictory perception. The game's closest analogue in the painting (structurally speaking) is the bonfire blazing in the distant street, and the latter image is similarly ambiguous, since the figures who gather in a circle around the burning stake can be seen as doing so either to warm them-

selves or to persecute a mock victim. And however we interpret the game, we may see in it another allusion to Passion imagery, this time the deriding and/or crowning of Christ by his tormentors (Fig. 98).[2] An image that causes the viewer to see the persecuted victim in the charismatic leader (or vice versa) would certainly not be out of place among the group formations that dominate the right foreground. Even the ironic conferring of aura may have iconographic precedents: in one fifteenth-century *Betrayal of Christ*, a hair puller's curved arm makes a halo for Christ's head (Fig. 99).

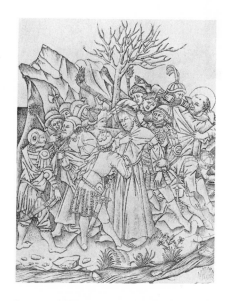

Fig. 98. Master E.S., *The Crown of Thorns*, c. 1450 (Albertina, Vienna)

Fig. 99. Master of the playing cards, *Betrayal of Christ*, c. 1440 (Albertina, Vienna)

Gestures similar to those of the "hair pullers" appear at least three other times in Bruegel, and each instance reinforces the impression that several themes converge in the image from *Children's Games*. At the extreme left of *Fides* (Fig. 100), three hands reach out similarly to bless a couple being married, while just above them a gaping mouth receives Communion. Reaching hands and open mouths also dominate the foreground of *Caritas* (Fig. 101), where bread is being distributed to the poor. Closest of all to the five surrounding figures in *Children's Games* are the five scrawny, half-starved men who sit at a round table in *The Poor Kitchen* (Fig. 102), reaching out spoke-like toward a large bowl of clams—while down below a child crowns himself with an empty pot.

Whatever the game's basis in reality, its emblematical feel is imme-

Fig. 100. Bruegel, *Fides* (detail), 1559 (National Gallery of Art, Washington, D.C.)

Fig. 101. Bruegel, *Caritas* (detail), 1559 (National Gallery of Art, Washington, D.C.)

Fig. 102. Bruegel, *The Poor Kitchen* (detail), 1563 (National Gallery of Art, Washington, D.C.)

diate and complex. A solipsistic declaimer surrounded by gaping figures who reach trancelike for his illusory mana, like a concentric version of the blind leading the blind: one of the themes the image seems to address is what draws the crowd to the rhetor, and the ironic symbiosis that obtains between them.[3] (Their empty hands are what his crown is made of.) From this point of view, it and the game nearby in which the boy is being stretched across the beam can be seen as pendants. In one the group unites

around a victim, in the other around a rhetorical flourish, with incidents of Christ's scapegoating subliminally present in both—certainly not a very sanguine view of what makes for social cohesion. Flanking these two games above and below are games in which separate bodies interlock in bizarre configurations, further suggesting that an issue in this region is the social body and what makes it cohere.

The bricks scattered in the lower-right-hand area serve as counterpoint to this theme (Fig. 103). (Note the coloristic links between the bricks and the children: one boy's red stockings repeat an angled pair, another's red cap mingles with flanking ones above and below.) For all their apparent disorder, the bricks define key points along a human continuum. First, at the extreme lower left, a single leaning brick is propped against the wooden beam and juxtaposed with a leafy, cabbagelike plant growing vigorously beside it. Brick and plant bring together the nature-culture opposition and subtly reinflect it. The plant, an exotic survivor in this region, paradoxically blends in, while the single brick, a common object, stands out. The

Fig. 103

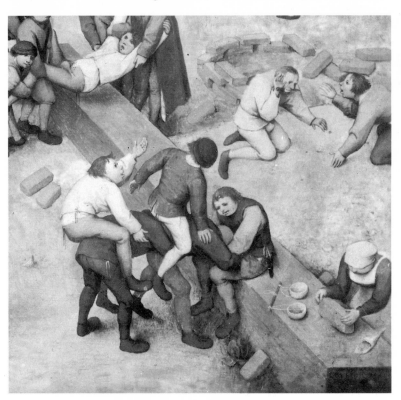

plant is rooted, while the brick requires propping—one recalls the leaning sheaves in *The Harvest* as well as the progression of wooden objects with their human "attachments" in *Children's Games.* Over against the naturalness of the plant's flourishing, the single leaning brick feels strangely arbitrary and provisional, even unexplained—some hand has placed it there, to be used who knows when or how.

From the single isolated brick there is movement past a tangle of boys to a "contented" pair. The larger of these two lies straight and stalwart, while the smaller angles in at its side. The anthropomorphizing impulse here is especially strong: the formation evokes a gestalt of human assurance deeply inscribed in the transcultural imagination, as Erving Goffman's work on such imagery has shown (Figs. 104 & 105).[4] The pair even resolves

Figs. 104 & 105. From Erving Goffman, *Gender Advertisements*, nos. 445 & 448

the propped brick's tensions, by separating out its conflicting aspects—singleness and the "leaning" impulse—and recombining them in a stable form of twoness. Here, as in *Peasant Dance*, the couple seems a privileged unit in Bruegel's thinking.

But the paired bricks are not a stopping place: they form a vector that points on toward a third configuration, a more problematic grouping on the beam's other side. (Another intervening brick strengthens the directional thrust.) This primitive construction tends to make its first impression as another ironic emblem of the attempt at social cohesion or collective effort: a pathetic Tower of Babel, scarcely begun when it was abandoned and left in ruin. But as a mobile *line* of bricks the figure reads more complexly. Bruegel has situated it exactly at the boundary between the growing grass and the ocher ground, so that, as a kind of unit or morpheme of the constructive impulse, it bulges out into nature and then curves back over

into culture, as if attempting to incorporate the green world into the built order of things as it proceeds.[5] Its opposite is the finished, sharply angled red fence across the way, which is also constructed along the line between the grass and the ocher ground. The fence's angle *marks* this boundary and functions to enclose. The curve of bricks, by contrast, suggests a more primitive yet dynamic urge to expand across and incorporate as it unfolds. The line it traces is virtually a Bruegelian signature. Instances proliferate in his oeuvre, from the gentle dikes and ecological contouring of the earliest landscape drawings[6] to the dynamic curved pier of his *View of Naples* (Fig. 106) and the spiraling ramps of his *Tower of Babel* (Fig. 107)—both of which transform inert rectilinear sources[7]—to the sweeping curve of

Fig. 106. Bruegel, *View of the Harbor of Naples* (detail), 1562 (?) (Galleria Doria, Rome)

Fig. 107. Bruegel, *The Tower of Babel*, 1563 (Kunsthistorisches Museum, Vienna)

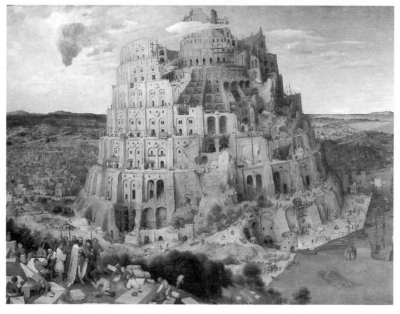

The Harvest and the whole felt world of *Landscape with the Fall of Icarus* (Fig. 108), where furrows, coastline, unfurled sails, and grazing sheep all inscribe its presence. Seen in this light, the brick curve in *Children's Games* evokes a basic shaping impulse in Bruegel's world, and the pessimism that still attaches to it has to do with how it collapses when it exits nature. Even viewed as mere childish construction, this short-lived wall of bricks, with its partial overlappings and connecting gaps, may seem preferable to the secure monolithic façade of the central building. In the latter the dynamism of the curve and the beautiful Bruegelian rose red disappear along with the outlines and differences of individual bricks. And the walls themselves, rather than incorporating some vestige of the green world, enclose a darkness in which nothing could possibly grow.

Fig. 108. Bruegel, *Landscape with the Fall of Icarus*, undated (Musée des Beaux Arts, Brussels)

Violence

Beneath the arches of the central building's loggia, five boys are spinning tops (Fig. 109). Four boys are clustered under the arch on the right in elaborately linked postures; they are separated by a column from another boy, who stands alone under the arch on the left, dressed in what looks like a monk's habit and holding his lash high above him. Crossing over the threshold marked by the central column is like passing from one psychic realm into another.[1] Physical presence, emotional charge, and mode of representation all change in these adjoining spaces. It is as if Bruegel wanted to make a certain difference visible, to chart the barely perceptible metamorphosis of one animating principle into another, almost its opposite.

Fig. 109 The top spinners on the right are portrayed realistically, and elicit

from the viewer an immediate visceral response. Whether they throw, whip, or watch transfixed,[2] they seem possessed by what looks like pure instinctual energy—the activity that issues from them appears to satisfy a bodily need as basic as that of the girl sitting against the wall in the background relieving herself. Yet in spite of the violence with which the boys impose their will on the objects of their attention, it would seem needlessly sour to deduce a "sadistic" instinct from their behavior. The energy that possesses them seems more innocent, more spontaneously extrovertive. They feel the exhilaration of being able to concentrate the will and focus it on an external object: the top is less an object of aggression than a visible symbol for that feeling of centered power into which the game converts the energy that drives the boys to play it. Though it is difficult to see how the object relation the game creates could translate at the social level into anything altruistic, the relation itself is not what motivates the boys; it is more as if their energy of self spills over into it. And though this energy may appear too violent and compulsive to supply the impetus for purposive behavior, its ontological grounds appear neutral, not destructive.[3]

But all this changes when one passes to the single top spinner on the other side of the central column (Fig. 110). A mental element intrudes into the boy's activity and one's perception of it, and at both levels the result is something like a loss of innocence. The stiff, hieratic pose into which the boy is frozen robs his body of any sense of animation and turns it into a container of controlled *psychic* energy. Suddenly there is a question about what is hidden inside the self and what motivates its need for an object. The top spinners on the right are caught at the peak of their gestures by the instant of representation; but the hand of the boy on the left seems to pause of its own accord. He appears to eye his top from a greater distance than the strictly pragmatic arm's length that separates the boys on the right from theirs. The net effect is a space of measured reflection in which the boy "administers" the lashing of his top and at the same time stands back and observes the effect of his blows. We can read his attitude as either brutality or detached curiosity—indeed, it is the strange, affectless combination of the two that makes the image so unsettling.

These aspects of the boy's posture combine with his monklike habit and the framing arch to make the spontaneous motor-visual empathy we have with the top spinners on the right virtually impossible in his case. It

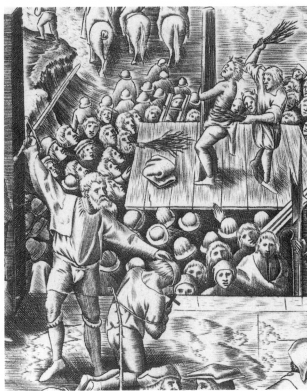

Fig. 110

Fig. 111. Bruegel, *Justicia* (detail)

is difficult *not* to "see through" the boy's activity to the iconography of the Flagellation, or to the current practices of the Inquisition, or to the legal punishments Bruegel himself had depicted less than a year earlier in his *Justicia* (Fig. 52).[4] Indeed, the boy's gesture seems a direct allusion to that print's executioner and flagellator. The posture of the girl hunched against the wall behind him similarly (if more distantly) recalls the two heads bowed beneath raised swords in *Justicia.* Her presence, also, succumbs to the emblematic mode of perception triggered by the isolated top spinner. Realistically perceived, she is an instance of uninhibited curiosity about sexuality and the body's natural functions. Her lax "incontinence" contrasts vividly with the tight fixity of the boys' postures: between them they suggest issues of "control" and complex ontological differences between holding in and letting go. But at the same time she tends to *read* as a figure of abject passivity. The arch couples her with the boy in such a reading and installs her in the mental space above him. There she can function—

again, at the level of a "reading"—not only as a fantasized object but as a subjective complement: either a cast-out (or in Kristevan terms "abjected") passivity by means of which the single top spinner's active mastery is secured or an abused inner state where his sadistic impulse originates (and upon which it works).[5]

The image's reference to *Justicia* suggests, then, among other things, a meditation on the internal objects of violence and repression. Indeed, the top spinner, with his raised whip and his monkish garb, "condenses" the executioner and the priest who bracket the peasant about to be beheaded in *Justicia* (Fig. 111). And condensing these two figures internalizes what lies between them: both the criminal/victim (that is, the guilty object of retributive aggression) and the distance civilized Christianity maintains from the violence it sanctions. This latter distance—gauged by the priest, no doubt, from long experience in how far blood travels—is one of Bruegel's most negatively rendered intervals: note how the mindless gaze of the armed soldier falls into it, and how the work of the flagellator presides over it. There is also, in the relationship between *Justicia*'s torturer and the victim being stretched beneath him on the rack, a linking of impersonal, measured cruelty and abject submission similar to the one framed by the painting's arch. But in *Children's Games* the coupling opens on darker energies: besides acquiring an internal, purely subjective aspect, it is polarized in terms of male and female and given sexual connotations by the boy's monkishness and the girl's open legs.

The isolated top spinner, then, is the one image of childhood in the painting that evokes a potential for something we might be tempted to call "evil." But instead of attributing this potential to human nature, Bruegel's imagery frames a complex question about its derivation. The body's urges remain innocent, or at least neutral. It is only when the physical impulse embodied in the boys on the right is clothed and framed in the emblems of religion and brought under what looks like mental control that it assumes a menacing aspect. The boy's monklike appearance generates an especially vicious circle: it makes the attitude into which he is frozen suggest both repression and a channeling of the repressed energy into the agency that administers its repression.[6] Yet the spontaneity of the boys on the right is too demonic, and the isolated figure's connection with them too strong, to allow us to be satisfied with the notion of childhood as a

state of innocence destined to be corrupted by the forms of adulthood. Clearly it is something *in* those boys on the right that gets transformed in the top spinner on the left.[7] One can imagine Bruegel, having in *Justicia* catalogued the institutionalized forms of violence with which society enforces order in the name of virtue, turning to the spontaneous disorder of children's play with a sense of relief, only to discover the capacity for violence there from the beginning, animating the body and organizing the whole of things into a kind of Heraclitean strife.[8] Yet to encounter it in this form is itself the discovery of a kind of innocence, albeit an innocence that the moral sense with its rage for order is bound to find unsettling. It clarifies what the vision of Bruegel's *Justicia* implies—that evil springs not from an innate, anarchic violence but from the human capacity to detach oneself from it and administer it in the name of order.

Gender Difference

It might seem unlikely that Bruegel, of all artists, would be much interested in the difference between the sexes. The horizons of his paintings are too vast and their concerns too far-reaching. They confront us with both our common lot as a species and our isolation as solitary individuals, and in either context whether we are men or women would seem a secondary distinction. Nonetheless, in *Children's Games* there is a marked tendency to distinguish between male and female versions of the developing self and its imaginative hold on reality, and in terms far more complex than conventional notions of the sexual hierarchy (our own as well as those of Bruegel's age) might lead us to expect.

Consider, from this point of view, the boy on stilts at the right corner of the central building and the little girl who stands beneath him with widespread arms (Fig. 112). Everywhere one looks one finds some variation

Fig. 112

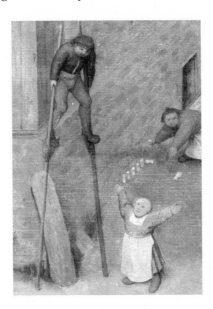

on one or the other of this pair (climbing and balancing on the one hand, outstretched arms on the other): their juxtaposition is a key to the painting's anthropology. The human creature rises precariously on two feet (whose cumbersome black boots provide both immunity from the earth and anchored contact with it) and as a result has to devise for itself the world of functions and purposes which in nature seems merely given. One result is a paradox that the boy on stilts neatly illustrates: the device by which he goes about acquiring a sense of balance and a feeling for the laws of the physical universe nurtures in him both a fantasy of transcendence and a preoccupation with downfall and ruin. It is difficult, in fact, to know which is host and which is parasite in this symbiosis of adaptive and transcending urges.

And having planted itself on two feet—the girl and the painting's many variations on her gesture are emblematic here—this same creature finds itself with a pair of leftover arms which can reach, cling, grasp, contend, devise, exult, assist, despair, drop sadly, register isolation and connection, express fullness of being and emptiness of self. Deprived of their "natural" function, they are freed to signify the entire *human* world of care unknown to those rooted trees in the upper left whose calm uprightness moves us so.

Primarily, then, the pair at the corner of the building—one towering, the other grounded; one wavering, the other firmly planted; one hunching in, the other flinging out and open; one seeking to scale heights, the other longing to be taken up—suggests a dialectic of human being in general. But it also provides an emblem for the difference between male and female horizons. The boy enjoys a privilege in the realm of transcendence that the girl is denied, but his position there robs him of stability and forces him to gaze anxiously at the ground immediately beneath his feet. The girl, on the other hand, denied the means to rise or strive beyond herself, paradoxically stands firm and opens her arms to the whole of what encompasses her. Even if we perceive her gesture as an address to the boy, it reads less persuasively as desire for what he has than as elation at his enterprise. It is ironic, in fact, that a sense of expanding horizons and the encompassing whole register in her open arms, not in his risk-taking. She rather than he seems the ontologically adventurous one.

The two barrels in the foreground are, as we have seen, the focus of a similar difference (Fig. 113). One sits upright, a stable, maternal-seeming

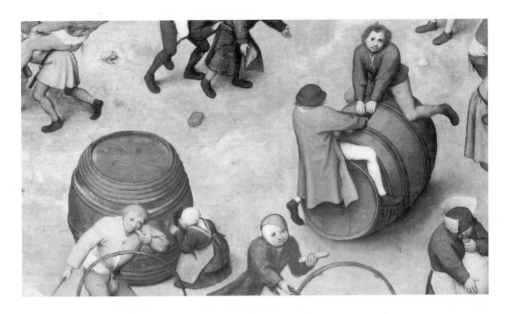

object into which a single girl calls. The other has been tipped over on its side and transformed into a precarious surface with which two boys awkwardly contend. There is something archetypal about the presence of these barrels: they are like surrogates for the world's body, that "first" object of the incessant human dialectic of attachment and separation. The games they have inspired embody antithetical ways of appropriating the given and experiencing the self in relation to it. And once again the difference is expressed in male and female terms. Fig. 113

The boys are indifferent to the self-sufficient, oddly answering presence of this given object; it interests them only insofar as they can surmount and master it. To do this they must first convert it into something they can struggle with, something in opposition to which they can establish a more precarious equilibrium of their own making. The hole in the barrel's side, which for the girl opens into a resonating inner realm, becomes for them a means of taking hold and achieving dominance. Their game, then, like that of the fence riders, manages to transform a container into a conveyance—in this it asserts a precious human capacity—but only by treating the object's original equilibrium and sufficiency of being with disdain. Although they are perched atop something whose most obvious properties are depth, inwardness, and circumference, they have appropriated it as an external surface and use it as a neutral ground upon which to play out a version of the human connection that even in joint ventures

projects a sense of being opposite. It is difficult, in fact, to be sure whether conflict or cooperation is the game's primary element. From the stance of the boy with his back to us, it would appear that the objective is to rock the barrel from side to side, with both players pushing first off one foot and then off the other. But the uncertain perch of the boy who faces us suggests that the goal is to balance the barrel or keep from falling off it. Whatever the case, Bruegel characteristically stresses a *difference* between the participants: the one nearest us exerts himself violently against the barrel, while the one farthest from us holds on for dear life.

The girl's curiosity counters the aggressively appropriative instincts of the boys. The barrel is for her an openness to be sounded. Her activity may be less obviously inventive than the boys' and lack the "social" instinct theirs expresses, but it also suggests a more primary relation. She appears, like the tree climber at the edge of the stream (Figs. 114 & 115), to still be in touch with the world's largely obliterated maternal aspect and to draw

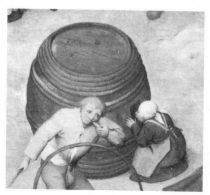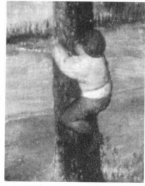

Fig. 114 / Fig. 115 nourishment from it. Though she doesn't seek to transform her object, she does fill it with her voice, which the barrel amplifies and returns to her. The image has to do, like so many in the painting, with the filling of vacant, unrealized spaces (the hobbyhorse rider and the boy peering through the oversized mask are more problematical variations on the theme). It evokes an imaginative desire to grow bigger that is incidental to the actual maturing process and that the passage into the adult world seems to stifle: witness the diminution that takes place in the receding street and the hollow silence that seems to reign there.

It takes only a brief scan of the painting to become convinced that the contrast between these two kinds of experience is one of its primary in-

terests and that their embodiment in boys and girls respectively is not fortuitous. Indeed, the painting's many intricate variations on this difference are compelling signs of its intelligence. The sandpile just in front of the stream at the far left, for instance, is the site of a similar contrast (Fig. 116). On its slope two small boys are playing some version of "king of the castle"—a game that involves competitiveness, visceral struggle, and a will to dominate. At the same time, a single girl kneels at its base, making something (a sand castle, perhaps). Here, especially, nuances seem to valorize the difference. Bruegel has portrayed the boys not even locked in struggle but failing to connect, as if they had migrated from the shadowy area of the street at the upper right. The girl, however, is quiet and self-absorbed, and her arms (unlike the boys') are happily occupied. She appears connected and contentedly in place, while the boys seem lost and blindly driven.[1]

A precise though more neutral variation on this set of images appears in the lower-right-hand corner of the painting. There two boys playing mumblety-peg are juxtaposed with the single girl below them making red powder with a brick (Fig. 117). The boys, whose gestures mirror those of

Fig. 116 / Fig. 117

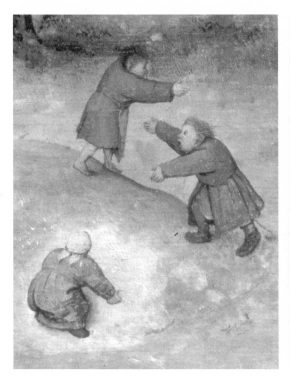 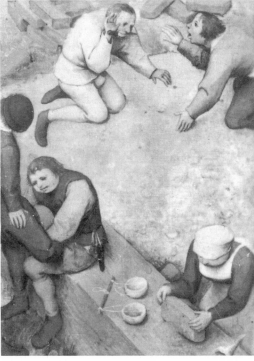

the boys on the sandpile, relate across a gap their game again turns into a charged space of contention, and the knife the player on the left holds between his teeth injects an element of violence into it. (He recalls "armed to the teeth" from Bruegel's *Netherlandish Proverbs* [Fig. 118].) The girl,

Fig. 118. Bruegel, *Netherlandish Proverbs* (detail)

however, is another instance of solitary, quietly absorbed inventiveness. The large brick she grasps lightly as she grinds (she is apparently "playing apothecary") contrasts benignly with the vacancy over which the boys' hands are tensely poised.

One would search in vain for a sixteenth-century context adequate to the subtle distinctions these paired images delineate. To be sure, the difference between the sexes was being discussed more and more in Bruegel's time, and the assumption of male superiority was growing into a heated philosophical and literary "quarrel."[2] It would even be possible to employ the ancient hierarchical oppositions that still propped the Renaissance understanding of the sexes—strong/weak, active/indolent, hot/cold, perfect/imperfect, generative/nurturant, etc.—to articulate Bruegel's images. But to do so one would have to ignore the painting's visual nuances and its play of differences, both of which so extravagantly exceed the text-bound limits of the contemporary debate as to remain virtually innocent of it. It is not so much that Bruegel's images mysteriously encode ideas "ahead of their time." If they have an iconoclastic aspect, it is because of the way they seek out the realm of vital impulse that underlies culture, and that cultural perception seeks to influence and control. They attempt to speak the body's language, unpossessed by the mind's understanding. To the degree that

they succeed, they are as likely to call into question our culture's accounts of gender difference as they are those of Bruegel's time.

Consider Erik Erikson's classic study of children's play, which purports to show that the imaginations of boys and girls are structured according to different spatial modes—one dominated by "height and downfall and by strong motion and its channeling and arrest," the other by "static interiors which [are] open or simply enclosed, and peaceful or intruded on"—and that these modes correspond to differences in the way the sexes experience "the ground plan of the human body."[3] The pairings in *Children's Games* clearly depict differences related to the ones proposed in such passages, and Erikson probably would have found in Bruegel's images straightforward support for his observations.

Yet if this artist and this psychoanalyst observe similar phenomena, they see with very different eyes. Bruegel's images, in fact, provide material for a critique of Erikson. For one thing, they highlight the stereotypically male quality of Erikson's perspective and the extent to which his observations domesticate his female subjects. The girls in *Children's Games* may be vulnerable to Erikson's notions—which after all address *something* in reality—but their bodies are animated by active selves, not hollowed out by vacant "interiors" that can be imagined as "static," "passive," or "expectant"; and the activities that issue from them have to do (as we shall see in greater detail later) with creation, exploration, and self-expression, and only in a secondary sense with bearing, caretaking, and containment. Erikson concludes that "the girls emphasized *inner* and the boys *outer* space."[4] Bruegel's images, on the other hand, suggest that every game involves both inner and outer space, and that a more important difference may lie in the way one experiences the interchange between those realms.

The primary effect of this contrast between Bruegel and Erikson is not to make us feel historical difference (much less just two equally valid ways of looking at things): on the contrary, Bruegel's sixteenth-century images seem to restore complexities that Erikson's modern observations occlude. The painter's images seem less culture-bound, less overlaid by sexual stereotypes, than the psychoanalyst's observations. And Bruegel's observational frame seems more open and unrestricted than Erikson's. Understanding for this painter involves inhabiting what is grasped, imagining bodily experience from the inside out. Erikson's account of the sexual dif-

ferences underlying children's play projects the fantasies that structure his empirical observations: "Here sexual difference in the organization of a play space seems to parallel the morphology of sexual differentiation itself: in the male, an external organ, erectible and intrusive in character, serving the channelization of mobile sperm cells; in the female, internal organs, with vestibular access, leading to statically expectant ova."[5] What Bruegel's images propose as most irreducibly real, however, is the transaction between self and world (a transaction in which self and world take form); sexuality seems a metaphorical dimension of this transaction, not what it unconsciously symbolizes. We can at least say that Bruegel shows us a "prior" realm where sexuality is subsumed in ontological imaginings. The child who is inflating a bladder while gripping it as if it were his or her own belly (Fig. 119), for instance, may be indulging, consciously or un-

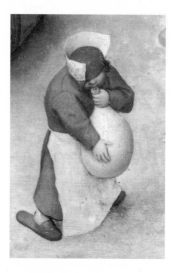

Fig. 119 consciously, in a fantasy of being pregnant (Bruegel obscures the signs of gender, as if to emphasize that either sex can *play* at this),[6] but the primary dimensions of the game have to do again with filling empty spaces and "growing bigger"—it provides a portable, body-centered version of the relation the girl calling into the barrel creates.

Even in the games that are more concerned with the energy that animates the body than with its ontological horizons, Bruegel's focus is on the process that channels that energy into an expressive relation with the world. The painting treats this as something common to both sexes, but

also as something that differentiates them. A good example is the juxta-position of the hobbyhorse rider in the foreground with the two girls playing in his path (Fig. 120). There is something almost demonically in-troverted and compulsive-looking about the boy. As he goads his imaginary horse by striking his whip against his own bare leg, he experiences himself

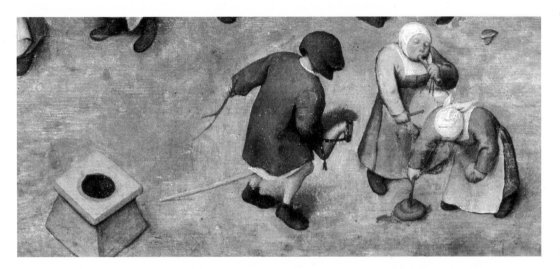

as both the driven animal and the rider who dominates it. He exacerbates
Fig. 120
in himself a violence that thrusts him compulsively into the outer world, but in a way that appears to lead him only farther inside fantasies of dom-inance and control. The two girls in front of him are equally absorbed in what they are doing, but their activity seems to issue casually from them —unlike the boy's, which he whips up and channels into a kind of phallic will, as if anxious to put distance between himself and the training potty behind him. One girl plays a pipe and tabor, while the other pokes a stick into a dung cake and perhaps, under the influence of a creative impulse, stirs circles into it. What the boy gallops away from, she probingly returns to. Her curiosity and the musical expressiveness of her companion are like two aspects of an extrovertive principle whose opposite is the driven sol-ipsism of the hobbyhorse rider. The girls are portrayed, in fact, as if they were complementary aspects of a single figure. Certainly they form one of Bruegel's happiest images of unchecked human instinct and the motives that issue from it.

The girl who leans over the pile of dung resembles a boy in the upper

center of the painting who crouches over an upside-down pot and bangs his knife against it (Figs. 121 & 122). The visual link again poses contrary feelings of what it is like to inhabit a body and be inhabited by its energies. The girl is all roundness and circles. The ball she holds in her free hand,

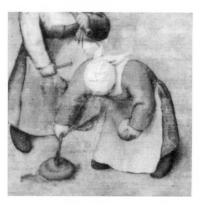

Fig. 121 / Fig. 122 the outline of her white kerchief, and even the rings of the dung cake underscore the centered, spherical feel. Not that Bruegel consigns her, in the manner of Erikson's observations, to an immanence: an ego-less curiosity issues instinctively from her. But as she reaches out discreetly with an exploratory gesture, she remains planted in her own separate physical space, and the gentle curve of her probing arm is what more than anything else creates the sense of self-containment. All this tends to make her an instance of well-being reminiscent of the rounded, self-absorbed shapes that contribute to the peaceful atmosphere of Bruegel's *Landscape with the Fall of Icarus* (Fig. 123), where all motion outward and away ultimately curves back toward its beginning. She especially resembles the fisherman in the lower-right-hand corner of that painting, who reaches out into the destructive element from the security his own ponderous body provides.

 The boy, on the other hand, is all discordant angles and vectors (his legs resemble those of Icarus as he plunges awkwardly into the sea), and his presence has a fugitive, menacing quality about it. It is not just the knife and the masklike face but the body itself. Forces seem to be pulling it in opposite directions, twisting it into a posture that resembles the torque of the peripheral figures in Bruegel's *Procession to Calvary* (Fig. 124) who are being pulled almost in spite of themselves into the impersonal momentum sweeping things toward the site of the Crucifixion. The result is

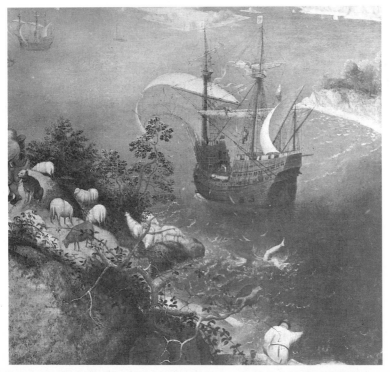

Fig. 123. Bruegel, *The Fall of Icarus* (detail)

Fig. 124. Bruegel, *The Procession to Calvary* (detail)

129

a tense, coiled energy, produced (unlike the girl's curiosity) by forces acting as much from without as from within, and more likely to explode in violence than to find its way into the rhythms of creative experience.

The boy, like the girl, is part of a twosome. He is playing "blind pots" with the nearby boy with his hat pulled over his face, who brandishes a long stick as he walks (Fig. 125). The coupling parallels that of the two girls: one upright, the other bending down, with sticks banging round ob-

Fig. 125 jects and noisemaking involved in both pairs. But the energies are opposite. The crouching boy is signaling to his blindfolded companion, whose goal is to smash the overturned pot with his stick. (Here the visual analogy shifts to the girl stirring dung as the hat-faced boy rides blindly toward her on a stick.) But the crouching boy tends to "read" more ominously than this. He seems almost to be lying in wait for his companion, luring him to his doom, sharpening his knife rather than giving helpful clues with it. One critic has even perceived him as "resembling an executioner."[7] And his blindfolded partner appears haplessly in orbit rather than approaching closer to his target. Seen in this light, the game becomes a bleak image of center and circumference akin to those that form in the receding street. The two girls are so closely twinned that no space seems to open up between them; separation, relation across distance, seems not yet under way.

It is as if the boy on the horse will be the wedge that splits them apart. But the space between the two boys has widened and skewed into a kind of no-man's-land. Their game, instead of marking off a territory for itself, threatens to set loose a principle of blind havoc that might strike anywhere.

These differences between male and female territory are refigured in the three girls twirling skirts in the grassy area bordering the stream (Fig. 126) and the top spinners nearby (Fig. 127). The tops are, in effect, a metaphoric displacement of the inner gyroscope that so many of the games are

 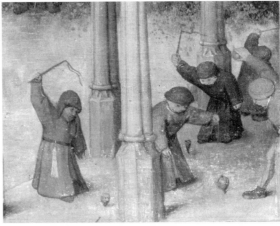

ways of discovering and developing. (The fence riders show the stages of this process.) Top-spinning externalizes the gyroscopic mechanism and makes it subject to the will. As such it can be animated by external violence and either continually exacerbated or watched transfixed as its energy decays. The top spinners convey the excitement and sense of power in being able to focus all the body's energy on a single, willed point outside the self (in contrast to the girl who sits hunched against the wall behind them, the image of a body with only itself and its natural functions as its object); yet at the same time they suggest an immobilizing, trancelike compulsiveness. Although they participate as a group, they all seem locked inside their near-identical gestures, alone together, as it were, hypnotically preoccupied with making the objects of their separate wills perform at their bidding.

The two girls with red skirts are by contrast one of Bruegel's most engaging images of togetherness. Although they don't act out the human

Fig. 126 / Fig. 127

bond or its tensions with the direct visceral intensity of the barrel riders or the boys playing tug-of-war, their mirroring of each other seems more fundamental and reassuring. Amid all the games of opposition and conflict, they evoke the happiness of an identity based on sameness. The pleasure one can sense that each takes in her own red skirt is inseparable from its agreement with the other's, and the same appears to be true of their bodies and the selves that inhabit them. Like the boy who embraces the reality of the tree behind them, they are emblems of an assurance that the skeptic despairs of—in the boy's case, that things *exist*; in the girls', that experience is shared, that the other can be present to the self not as an opponent or an enigma but as its complement, the source of its experience of itself as outward and manifest.

The game the girls play involves spinning in place (it looks like in opposite directions) and then plopping down on the grass so that their skirts spread full around them. It thus counters the activity of the top spinners not only with a different bodily experience but with a different teleology as well. The girls are portrayed in this final state, sitting at the edge of the stream like two red flowers blooming there. The metaphor may be fanciful, but the sense of compatibility with the natural setting is not; Bruegel has even emphasized it by coloring the apron of the girl on the left with the same rich blue the stream deepens to at its most intense point.

Both the skirt twirlers and the top spinners are arranged so that a single figure is detached from the shared activity. But unlike the isolated top spinner, the girl who stands alone, still twirling her skirt, seems continuous with the red-skirted pair, even though she is active and alone while they are together and at rest. And she is similarly "opposite" the top spinners. Instead of manipulating an object, she whirls on her own axis, and her centrifugal exuberance makes *surroundings* of the exterior scene. The purpose of her game, ontologically speaking, is to fill the body with the self's energy, not inflict that energy elsewhere. Unlike the isolated top spinner, who makes us think of the hidden and repressed, she is an image of the self as whole and free, centered yet open and radiating outward.

———

I have been especially aware in these last comparisons of having to restrict an unmanageable plurality of images in order to stabilize an object of analysis. The comparisons are marked by the painting, but they are also

subsumed in a play of differences in excess of whatever idea can be constructed to contain them. The skirt twirlers, for instance, contrast as obviously with the tree climber as with the top spinners, and the doublet they form with him can be seen as a variation on the pairing between the boy on stilts and the girl with widespread arms. The girl with the broom likewise complements the skirt twirler, projecting the balance point which the latter activates within. The equilibrium that exists for the one in a vertiginous dependency of the self and its surroundings is experienced by the other as a delicate balancing act performed at the end of one finger. This relates the broom balancer to the boys spinning tops—like them, she projects outward and concentrates her will and attention at an external balance point—in a way, to be sure, that locates another difference, but a *different* difference from the one between the top spinners and the skirt twirlers. The girl's broom also inverts the stilt walker's enterprise, and both connects and contrasts with the many similarly raised sticks held in boys' hands and associated with the fun of violence and the will to power. (Though even here there are exceptions: the raised lash of the foremost fence rider is an aid to balance that has become an expression of exuberance, just like the spinning girl's outstretched arms.) The broom balancer also triangulates two other girls who bracket the paired rail hangers below her with what can be perceived as companion emblems of a woman's social fate: one gesturing empty-armed beneath the boy who towers over her on stilts, the other bearing the weight of an inert-looking boy on her shoulders, while a fascinated crowd looks on (Fig. 128).

Fig. 128

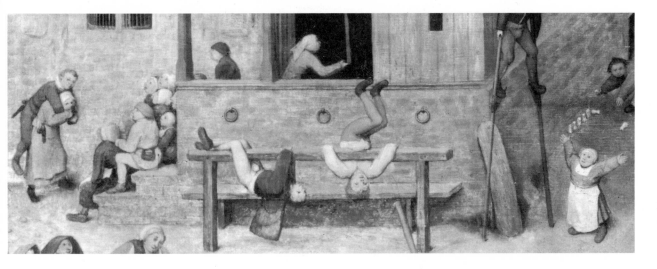

Such examples could be multiplied. The skirt twirler and the piggy-back rider are similarly *alike* in the way they fill the body to its farthest extent (the one in an open relation to her surroundings, the other in a struggle against an opponent), while the girl who stirs dung into circles is like the boys who lash their spinning tops. And finally: though the single skirt twirler is the image of a "centered" self, her game—this surely must be the fun of it—induces instability and vertigo and serves to *dislodge* the world. *Like* the boy on stilts, she is playing with downfall, and from this point of view the difference is in the way her two companions blossom in their fallen states.

As such gender-marked disjunctions and connections multiply through the painting, they are continually being absorbed and reformulated by a play of differences that is always on the move and can neither be reduced to gender differences nor considered wholly apart from them. Take the girl watching herself urinate and the boy balled up inside the angled fence: the two can be seen as *similar* images of singleness taken to its near-autistic extreme—as paired opposites of the children in the central region possessed by the connective urge. But looked at from the perspective of gender difference, they suddenly become *antithetical* images and encourage us to rethink "indrawnness" in differential terms.

Given the intricacy of this play, one might expect the overall structure of *Children's Games* to produce a marriage or intermingling of male and female modes. But this isn't really how the painting works. Instead, when one steps back and attempts to take in the painting as a whole, the "female" images almost disappear. Both the linear patterns that thrust across the painting in all directions and the general mood of restless, driven activity tend to dominate the overall view and suggest a world attuned most obviously to the energy that manifests itself in the boys' games. In this respect female difference is present in the painting much as it is present in the society whose formations the painting explores. But reflected at the level of unsupervised play rather than socially regulated activities, this marginality feels a matter less of forced exclusion than of voluntary indifference. There is something virtually asocial (given how the "dominant" view defines sociality) about the contentedness of the skirt twirlers, the girls at the barrel and the sandpile, the pair with the fife and drum and the dung cake, and the girl at the lower right with her improvised brick crusher. All seem

too happily immersed in primary activities and relations to be concerned with coagulating into larger patterns and power centers. But Bruegel appears to celebrate rather than feel threatened by this asociality: these images are among his most affectionately rendered and the ones with which as an artist he seems most happily to identify. Their apartness underscores, on the contrary, what is problematic about the social order itself. For the painting makes the violence that undermines social stability appear intrinsic to the social impulse, not alien and opposed to it. The overall impression is of human order emerging from a matrix of unrest and driven by the energy it supplies. For the most part, this insight is conveyed neutrally, even exuberantly. And to the degree that the painting does look askance at the generative instability it depicts, the values that underlie its critical perspective appear not in images of the well-ordered society (the receding street suggests what Bruegel thinks of that ideal) but in the peacefulness of the pastoral landscape at the upper left and in scattered pockets of solitary female activity—the very areas of experience that tend to become inaccessible to society in its walled-in, smoothly functioning form.

The Sexual Relation

The games Bruegel's children play may construct a sexual difference, but the plethora of children playing reminds us that there is sexual relation as well. Or rather it teases us with its mystery: the question of where children come from is posed by the scene almost as if it were a primitive *adult* mystery, subsuming endless visual postulates. (Sometimes the training potty in the extreme foreground seems an Aladdin's lamp from which the entire horde has sprung.)[1] But however elusive the painting may be on the

Fig. 129 subject of origins, the generative act is everywhere implicit in it, even in

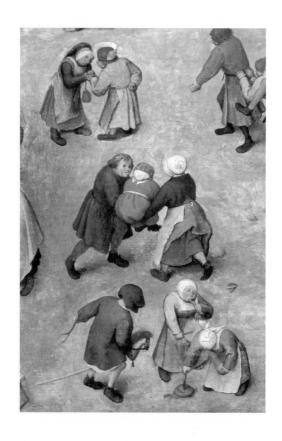

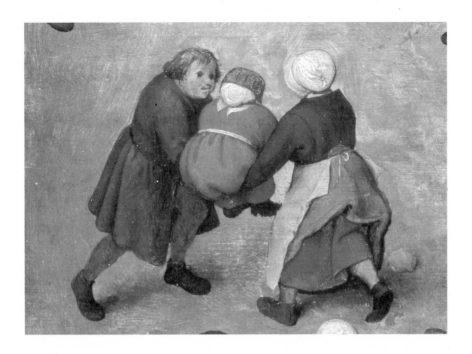

Fig. 130

the autogenous-seeming energies that command its central region. It should not be so surprising, then, to come upon a small, out-of-the-way area of the painting devoted to the *convergence* of the sexes.

In the left-center foreground, a nearly upright diagonal leads from the boy riding the hobbyhorse and the two girls playing in front of him, through a couple carrying a child in red, to the small pair above them playing "odds and evens" or "guess which hand" (Fig. 129). It is one of the clearest thematic structures in the painting. All three groupings depict the human relation as a convergence of separate, heterogeneous spheres. And in each case (though ambiguously in the third) what comes together is gendered male and female. This tiny series is a masterpiece of tact and condensation: it is difficult to imagine how more could be said in so little space about what lies between the sexes.

At the center of the diagonal a man and woman make a bridge of arms for a child and suspend her between them (Fig. 130).[2] The little girl oc-cupies, as shall be seen in the next section, one of the painting's privileged regions of assurance. But the couple who lift her enter into a vital relation of their own. Only the man's face is visible, and from it we can see that his attention is invested solely in the child. He is in a sense as alone in his joy as she is in her contentedness: the image is a beautiful rendering

of the adult's vicarious reliving, through the role of "nurturer, pleasure-giver, empathetic wish-granter"[3] of childhood's imagined delights. Yet even though his partner scarcely exists for him in this moment, the image also affirms his link with her. In order to lift the child they join hands, and though they don't consciously regard each other, their arms are full of a life they hold between them. Their carrying gestures are rendered, in fact, as if they were simultaneously offering and receiving from each other what they separately invest in the child. Though they pull away from each other in order to hold the child aloft, the child's weight responds by drawing them closer. In this they are like the barrel riders and the two groups playing tug-of-war; only the tension between them is sustained by care, not strife, and they pivot around an enduring bond rather than a momentary, precarious equilibrium. So many of the games require a victim or an object of persecution to transform opposition into unified effort; *Justicia* and *The Procession to Calvary* are more direct elaborations of this theme. But the little girl mediates as an object of affection. She and the girl beneath the boy on stilts address each other from opposite sides of the central region, bracketing what unfolds there with matching assurances: one standing free and branching on barren ground like an irrepressible Bruegelian tree; the other full and unfallen, held aloft in the arms of a secure relation.

In the extreme foreground, just below the parents and their child, the small boy straddles his hobbyhorse (Fig. 131). He, too, stands at the threshold of the central region, on the verge of entering it. We can see in his

Fig. 131

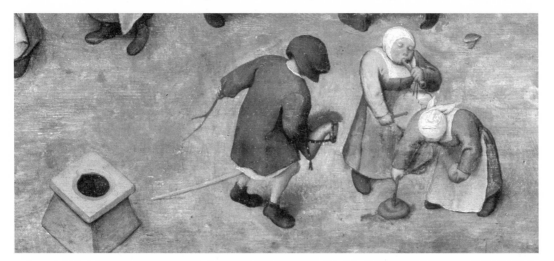

activity the tentative emergence of a male principle that blossoms exuberantly (and riotously) in the space ahead of him. He is a prototype, for instance, not only of all the riders in the painting, but also of the boys who are so fanatically engrossed in whipping tops. He seems to have just stepped off the training potty behind him (is that the reason for the absence of pants?) and into the more active, phallic stage of the imagination—Bruegel has gone out of his way to portray the hobbyhorse's head as if it were an extension of the boy's own bare leg. Whip poised, knees bent, weight tensed on the balls of his feet, he awaits the forward thrust of his horse. His clothes all but swallow him, and the broomstick is pitifully inadequate to the massiveness it is supposed to represent. All his being is concentrated on the task of filling these as yet unrealized spaces, as he exacerbates and at the same time harnesses the inner violence needed to bring his mount to life and make it leap forward at his bidding.

His activity seems to destine him for the world of the leapfroggers, the barrel riders, and the tug-of-warriors; yet it places him on a direct collision course with the two small girls playing just in front of him. The two sexes, equally absorbed in their respective activities, are about to encounter the opposition that bears fruit in the configuration of parents and child above them. But its results here promise to be anything but creative. The girls stand in the boy's way as obstacles to the uninhibited filling out of his "phallic" self; he in turn descends unwanted on them as some inadvertent, centaurlike marauder.

At the top of the diagonal, two small children come together over an issue posed by a closed fist (Fig. 132). In the two lower groups it is the sexes that converge, but here one can't be quite sure. The child on the left is definitely a girl (there is even something old and cronelike about her); the one on the right appears to be a boy, but his(?) gender is deliberately kept hidden and in doubt. In a sense this sexual ambiguity *is* the mystery being held out to (and withheld from) the girl. Their game embodies—latently for them, representationally for us—a threshold where the difference between two separate human beings is on the verge of becoming a sexual difference.

In contrast to the threat of conflict evoked by the hobbyhorse rider's convergence on the pair of girls, these two children come together in almost conspiratorial intimacy. They are totally engrossed in the obscure

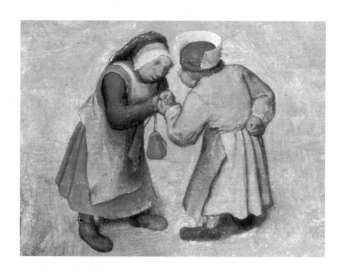

Fig. 132 transaction that passes between them. We see a first unconscious venture into the space that flourishes between the adult couple above. (The girl's bright purse is a reminder of the child in red.) Yet what draws this couple together is more wryly conceived. The girl on the left reaches out with the same enthusiasm as the "husband" below (her wide-eyed, intensely focused look is the barest transformation of his), but she does so in order to pry open her companion's closed fist, the mate to which he(?) keeps held behind his back. What is given to her in this relationship she must guess at, and what (if anything) she gains from the exchange will no doubt wind up in her own tightly drawn purse.

The "concealer" observes intently the girl's absorption in what he(?) keeps from her. He seems as fascinated with what is going on inside her as she is with what is hidden inside his fist. His gesture (unlike the woman's below, which reads as total, selfless giving) appears to offer something to her as a way of cunningly drawing her out of herself, into the space between them and the mystery it conceals. They are attracted to each other in terms of a secret each holds out to and keeps back from the other. What they share is a reserve, an unknown quantity founded in their separateness. That the unit of exchange can be closed in a fist and bargained over like this seems an obvious irony (one of Bruegel's satiric prints depicts a war of moneybags and strongboxes); yet there is still the feeling that somewhere in the transaction between that closed fist and that tightly drawn purse is the potential for the child below all bundled up in red.

Assurance

Anna's soul was put at peace between them. She looked from one to the other, and she saw them established to her safety, and she was free. She played between the pillar of fire and the pillar of cloud in confidence, having the assurance on her right hand and the assurance on her left. She was no longer called upon to uphold with her childish might the broken end of the arch. Her father and her mother now met in the span of the heavens, and she, the child, was free to play in the space beneath, between.

—D. H. LAWRENCE, *The Rainbow*

The man and woman who make a bridge of arms for the small girl in red carry her forward on it like some precious object (Fig. 133).[1] A wonderful mix of security and indrawn poise radiates from this plump, heavily encumbered body. The equally corpulent body of the girl who swings inside the shed above and to the left expresses the elation of flying through the air, defying gravity, but the child in the foreground is an image of contented weight. Parental arms lift her free of the earth, but it is the sag of her own body, which hunches forward and pulls in around itself, that turns her into a center of gravity and ensures the stability of her perch. She remains absolutely still, trusting yet instinctively counterbalancing what supports her. Only in the pastoral realm in the upper left is there a similar

Fig. 133

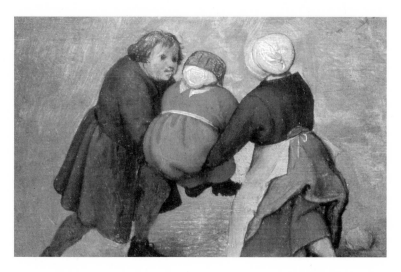

sense of supportive context, a surrounding element into which human presence can settle and feel contained and at home (although there the dominant note is *dis*encumberment). Elsewhere in Bruegel's painting, human ingenuity must grapple with an indifferent setting and a poverty of means: the leapfroggers, fence sitters, stilt walkers, rail hangers, and tree climber must achieve through improvisational feats the elevation and poise that are given to the little girl as benign preconditions of experience. It is as if their goal were her starting place.

Such radical self-containment is more often than not treated problematically in Bruegel. His vision of the human condition is too preoccupied with the body's restlessness and the demands of the connective urge to accord states of withdrawn self-sufficiency a privileged status. The balled-up boy inside the fenced yard and the girl urinating behind the top spinners are equally extreme instances of singularity (Figs. 134 & 135), and both seem to be satisfying basic needs: the look on the face of the boy, in

Fig. 134 / Fig. 135 spite of the contortions into which he has forced his body, is one of omphalic bliss. But they tend to *read* as images of refusal, of a nearly autistic indifference to the charged transactions that dominate the central region. Their antithesis is the piggyback rider stretched to his full extent by the tug-of-war: he feels what it means to be a bodily self in terms of reaching, resistance, and the pull of a counterpart. Yet in spite of the little girl-in-red's kinship with the withdrawn figures, her quiet presence seems as open and connected as the piggyback rider's violent straining, and it conveys in its own way as palpable a sense of strength. The game lifts her into a dimension (is it imaginary or real? self-engendered or bestowed?) that underlies the will and its exertions, where the self exists not as the product or producer but as the nucleus of its world.

142

A scan of *Children's Games* does not encourage much trust in such a dimension. Assurance is not something this painting seems anxious to provide. In its Heraclitean central area, especially, everything seems at risk: open, unfinished selves abandoned to their own devices; a fixed civic space transformed by play into a multifarious instant. One can scarcely imagine what it might mean to be at home or have a place in such a "world."

Yet even in so provisional and improvisational a context, Bruegel finds ways to inquire about what upholds and supports. Scattered through the painting are a group of subtly linked details, all of which have to do, like the little girl in red, with the existence of a "prior" dimension where things abide. These images exist in plain sight, but they are not likely to attract the generalizing gaze. In a sense they are *all* nuance and detail and thus may seem irrelevant to large-scale unifying concerns. Yet in many ways they are the images in the painting that go deepest: they delineate key Bruegelian assurances, even as they question whether those assurances can survive in the frenetic *present* world.

———

One of the richest of these images involves a game of covering taking place to the left of the central building (Fig. 136). An older-looking figure reaches out across a distance to hold her blue apron over a cluster of

Fig. 136

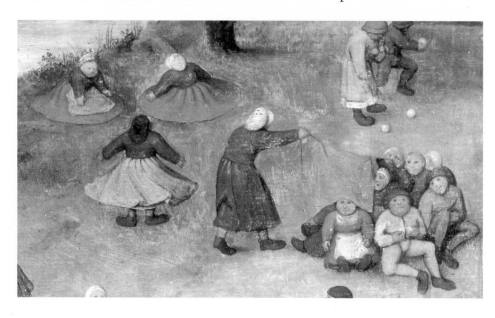

smaller children, one of the brightest of whom is a little girl in red who peers out from underneath it, looking for all the world like the doppelgänger of the girl suspended in parental arms. Although the function of the blue cloth is apparently to single out, it seems to bestow a collective happiness.[2] It is as if clustering together like this was sufficient in itself to conjure up the feeling of being "covered" and was a primary reason for doing so. (The cloth holder reaches out almost as if she were a magician bringing the surprised and delighted group into being.) Bruegel emphasizes the imaginary quality of this shared sensation by having the game's pleasure register in a threesome at its periphery, all with their backs turned to what is going on. The three children have a look of blissful satiety about them—the boy in the middle seems to have drunk especially long and deep. Their opposites are the boys crowding around the illusory mana of the rhetor, their mouths gaping like birds crying to be fed (Fig. 94). The two games, in fact, invert a common paradigm: in both there is clustering around a privileged experience and a singling out by the covering of a head. The children clustering on the ground seem completely unmoved by what compels the boys on the right to collect around a charismatic center. And yet it is the former who have what the latter seek.[3]

The girl in red and the two brightly colored boys on her left stand out from the rest of the group, scarcely present to one another but near-companions in the artist's eyes (Fig. 137). The idea that unites them has to do with how the sameness of their expressions contrasts with the different ways their bodies accommodate themselves to the game. The boys do not appear "knavish," as one commentator has suggested; they have the same look of blank contentment as the girl beside them (though hers warms to something like active delight). It may be difficult to name the feeling this expression communicates—it seems to preclude the need for speech —but all three share it, and as far as it is concerned, there seems little difference between them.

Their bodies, however, are *all* difference. The fit of the girl's compact little body to the requirements of the game agrees with the happy, will-less expression on her face. Feet outstretched, arms dangling at her sides, she seems perfectly content simply to rest where she is, receptive to whatever might descend on her from without. The boys, however, have already crossed over into what looks like a subsequent stage of childhood and find

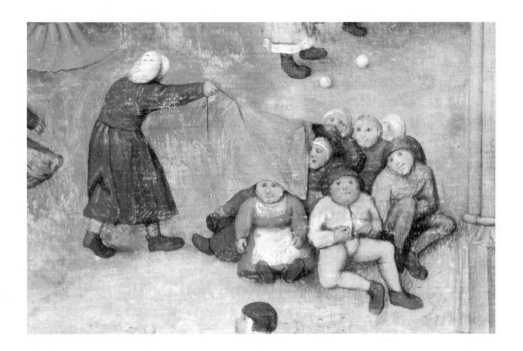

Fig. 137

themselves with gangling, pre-adolescent limbs to contend with.[4] Arms have grown too long to hang freely from shoulders and must be tucked in or pressed against bellies. Sprawling, froglike legs remain hopelessly recalcitrant to the oceanic feeling in which the faces still participate. These legs would obviously be more at home in the strenuous exertions taking place in the center and lower-right-hand corner of the painting. Those of the boy in the middle, especially, seem ready to leapfrog, ride piggyback, straddle barrels, or even have caps tossed between them—do anything but rest quietly and comfortably in place.

It is difficult to know whether what separates the two boys from the girl is an innate distinction or the onset of puberty, but it is a difference imposed by the body where in spirit there is none. That is what makes the image poignant as well as tenderly comic. It seems only a matter of time (and a short one at that) until the boys split off from the group and become part of the hyperactive, strictly male games in whose direction they are pointed. They, unlike the girl, are already outside the covering sphere the apron provides. Yet they linger past their time, still happily susceptible to the feeling of being under it; and this itself seems a gentle sort of grace. Under the aegis of the cloth they postpone—or imagine away—a difference

that both their bodies and social conventions impose upon them. Their opposite is the hobbyhorse rider near the lower edge of the painting: he would fit perfectly into this cluster of small children, but instead he goads on his phallic mount, already occupying in spirit the realm into which he has scarcely begun to grow as he bears down on the two small girls playing in his path.

Bruegel deepens the connotative force of the gesture that extends the blue cloth by having it bridge separate realms as well as separate figures. As with blindman's buff, except benignly, a single, adult-looking figure (probably an older child) reaches across a space that separates her from a group of smaller children who cluster in relation to her gesture. The single older figure is positioned exactly at the boundary that divides the grassy area of the upper left from the ocher ground of the central region, and her distance from the children is exaggerated by the way she appears to reach out from one area into the other in order to cover them. She has been painted almost entirely against the green background of the pastoral area; her green stockings (one still in the grassy region, the other striding out of it) reinforce the suggestion that she in some charged sense "comes from" that realm and that in reaching toward the children she is carrying it over into theirs. The cloth thus acquires the nuances of a transitional object (to use D. W. Winnicott's term), mediating the separation from nature and extending the sphere of primary nurture into the trodden area where human beings collect.[5]

The left edge of the cloth begins exactly where the grass leaves off— so that it literally extends that region. The cloth has even been painted the same color as the grass and then painted over with broad strokes of blue that leave most of the underlying green visible. Even the hasty-looking brushwork may "signify" here. It is as if Bruegel wished to paint a blue that transformed an underlying green, or else a green visibly raised to the power of blue. One suspects, in either case, a subliminal reference to the Virgin's blue cloak of mercy, lined with green in countless Renaissance paintings and statues.[6] There is a grace, the detail suggests, that nature, in its maternal aspect, extends—but how far, and for how long?—into the human realm, a grace that in certain moments can be intuited as still sheltering and making present the collective body that clusters in its absence.

Bruegel makes the girl in red the focal point for what the cloth be-

stows. Touched by it, she emerges from the undifferentiated mass behind her into bright-hued uniqueness, yet continues to enjoy the backing of the more amorphous collective self. The conventional moralistic interpretation of the painting takes the state in which Bruegel has portrayed her negatively: she and the children next to her become "puppets who do not act from their own volition," and thus satiric emblems of mankind in general.[7] But this seems an egregious instance of imposing moral categories precisely where they are in abeyance. The affective charge of the image is overwhelmingly positive: it suggests an oasis of pre-volitional well-being where distinctions between "active" and "passive" have not yet come into play.

The cloth singles out the little girl as both a chosen object and a perceiving subject. Its front edge is centered on her eyes and curves up as if to accommodate her line of sight, so that the two aspects coincide at a place of happy expectancy where she sits. She is positioned there in a kind of ideal Bruegelian state, her separateness (unlike the knotted boy's inside the fence) still an outgrowth of community and her gaze (unlike the windowsill's hovering, disembodied mask) securely grounded, facing outward toward an open world that seems to come in, unresisted, through innocent and delighted eyes.

———

Over against this image of the individual self as "reached" by grace and still secured—whether by nature, maternal assurance, the collective body, or an unwilled imaginative openness—the girl beneath the boy on stilts presents a companion image of abandonment and apparent isolation (Fig. 138). Though no obvious structure links her to the girl being carried or the girl under the blue cloth, she almost exactly triangulates them— along lines that mimic the acute angle of the red fence. She, too, seems to find herself in a "prior" realm. Lacking objects or companions, outside any sheltering context and unassimilated by the rules of any game, the girl beneath the boy on stilts has only her own empty arms (which remain unanswered) to declare her place in the surrounding whole. (*Her* opposite is the girl perched atop fatherly shoulders in the receding area of the street, looking benignly out of place amid the desolation there.) The gesture seems at first glance to emphasize her bereftness. It even alludes (especially conjoined with the boy on stilts above her) to the iconography of the Cru-

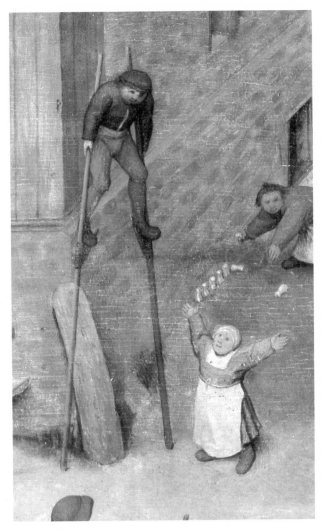

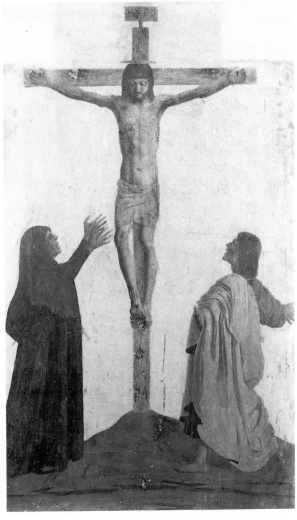

cifixion and the Lamentation, where gestures like it function as signs of
uncontrollable grief (Fig. 139).[8] And yet the girl's gesture conveys a kin-
esthetic elation. It somehow communicates the opposite of despair. Bruegel
compels us to read it as an address to the boy above (does the girl feel
grounded and left behind, or full of wonder at his perilous height?), but
then projects it forward toward something unspecified and limitless, and
stretches the girl's arms open—*past* the limits of abjectness, as it were—
to become a wide embrace. The knucklebones extending straight back from
her right hand pull her arms open even wider and punctuate the extrava-

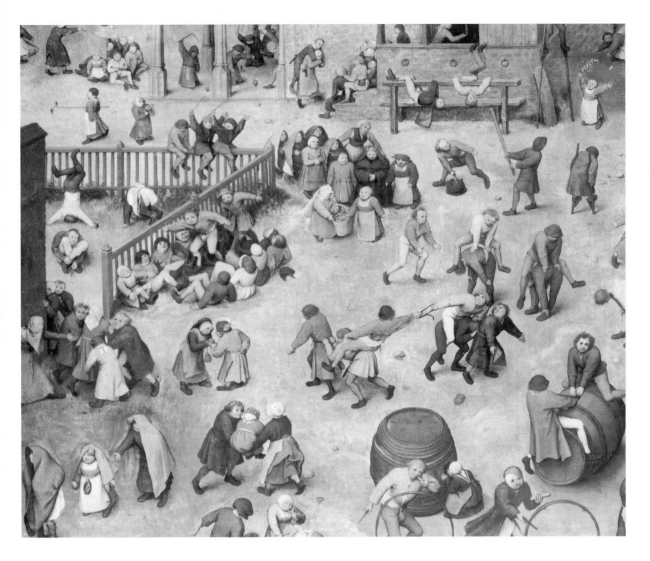

Fig. 140

gance of her span. Though the gesture belongs to all the painting's reaching arms, it stretches their emptiness into an affirmation—an extravagant "Here I am" that simultaneously opens up to and proclaims the surrounding "There is."[9]

———

As one's eyes follow the vector initiated by the little girl's wide address, they come upon a second and then a third similarly aproned figure with arms extended at their sides (Fig. 140). The effect is to make them

seem variations on the theme that issues from the first girl's gesture. The first of these figures to appear is a flower girl at the head of a mock bridal procession rounding the corner of the fence (Fig. 141). She and her fellow basket carrier contrast states that might loosely be called "absorbed" and "exposed": indistinguishably twinned as far as their task is concerned, the

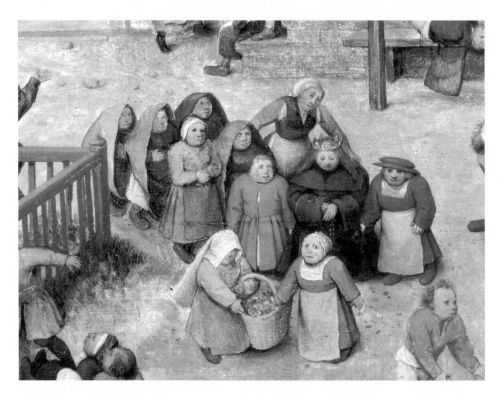

Fig. 141 two girls are almost opposite existential poles. Everything about the basket carrier on the left emphasizes her inclusion in the ceremony. Bundled up into herself, one arm holding the basket snug against her while the other arm reaches around it for a flower, covered by an ample headdress that conceals everything about her face except an expression of happy involvement, she conveys the unselfconscious well-being that comes from being functionally and/or ritually absorbed in the collective life (even when cloaked, as many of the bridal processioners literally are, in spheres of separateness). The group as a whole, in fact, suggests the contentment of being gathered up in the roles and conventions with which society creates a common life. There is something especially happy about the way the

procession hugs the curve of grass that grows beyond the red fence: it suggests that social forms in general, and marriage in particular, happen in accord with the natural order of things. Yet at the same time Bruegel shows that an adult figure is required to shepherd the process, and that the course laid out by nature is an outgrowth of the arbitrary constructed angle of the fence.

Amid all this covering and enfolding, however, the basket carrier on the right stands alone and completely exposed. She seems to have strayed into a condition of isolation just beyond the invisible boundaries of the ritual that contains her fellow participants. Such "straying" is a constant prospect in Bruegel's world, especially in *Children's Games*, where play tenuously suspends the entrenched forms of social life. Recall the foremost jack in the game of leapfrog (Fig. 93): his loss of mooring within his group is like an introverted version of the basket carrier's exposed isolation.

The flower girl remains connected, but her function has ceased to absorb her. She grasps the handle of the basket absentmindedly and at the same time almost desperately, as if it were the last thing anchoring her to the common life. (Recall the children and fool in Bruegel's *Kermis at Hoboken* [Fig. 30].) While the rest of the procession turns the corner, she appears to be immobilized by opposing forces: the countercurrent of leapfroggers threatens to pull her away and sweep her into the chaotic vale of self-making at the center of the painting. She stares forward like the girl in red under the blue cloth, but what appears to register in her eyes is the gap that has opened up behind her, separating her from the collective body. It is less a look of perceiving than of feeling exposed to view. Whatever may be going on inside her, she tends to become for the spectator an image of a self-consciousness that intrudes when the common life and the anonymous cover it provides inexplicably fall away. The space into which she has blundered is the same one in which the girl beneath the boy on stilts takes her stand: the near-panic of the one is the obverse of the other's extravagant reach. And while the piously complacent bride marks the center of the procession—she is the center, in fact, of the painting as a whole—it is this stranded figure and her experience that most directly address the painter's vision.

———

The third aproned figure appears in the middle of the baptismal procession nearing the doorway in the lower-left-hand corner of the painting (Fig. 142). The thematic flow toward her is facilitated by the momentum of the gauntlet runners and by the reflection of the basket holders in the

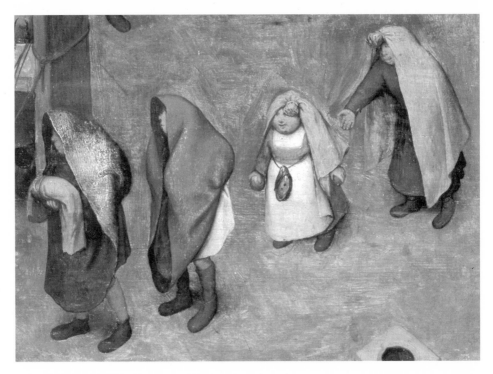

small intervening couple playing "odds and evens"—the girl on the left, especially, recalls the "absorbed" flower girl. The two figures at the head of the procession have pulled their dark cloaks over their heads to improvise the religious coverings that create an anonymous collective identity for the worshippers in Bruegel's *Battle between Carnival and Lent* and *Fides* (Figs. 143 & 144). But the effect here is nearly opposite: both cloaks (especially the second) become emblems for the sphere of privacy that so often envelops individual existence in Bruegel—most hauntingly in his enigmatic drawing *The Bee-Keepers* (Fig. 145), but even in scenes like *The Harvest*, where there is such assurance in the common world. The same gesture, furthermore, that turns the cloaks into auras of separateness reveals idiosyncratic colors and textures beneath their outward sameness and clothes their wearers in this difference like a special grace. The glit-

152

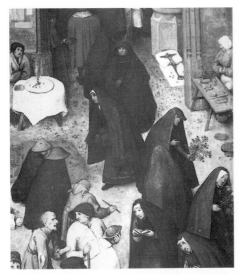

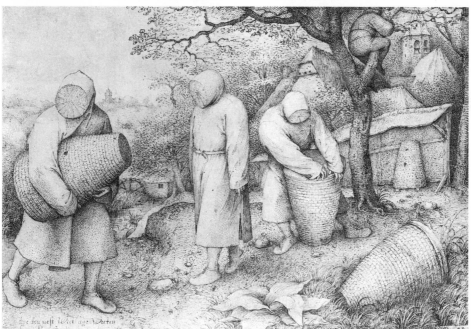

Fig. 143. Bruegel, *The Battle between Carnival and Lent* (detail)

Fig. 144. Bruegel, *Fides* (detail)

Fig. 145. Bruegel, *The Bee-Keepers*, c. 1568 (Kupferstichkabinett, Berlin)

tering, giltlike gold of the first processioner's cloak seems an especially pointed comment: the separate individual comes into focus in this game as something precious and unique—a view suppressed by the trappings of both everyday existence and communal piety.

The game, then, as Bruegel depicts it, offers an especially complex definition of play. The wedding procession is portrayed as a fairly straightforward instance of imitative activity; it suggests that play is a repetition of and a preparation for the forms of social life. But in the baptismal procession a principle of inversion is operating within and through the imitative impulse, undoing the effects of the forms it mimics. And the inversion here seems more primal than the festive mockery of *Carnival and Lent*—it has to do less with overturning convention than with returning to sources and beginnings. The piety of the processioners in *Children's Games* appears absolutely solemn and sincere, even though it is something they pretend. Playing at baptism seems, in fact, to put them in closer touch with the ritual impulse and the religious sense of life it expresses than instances of real religious behavior, which tend in Bruegel to convey a rote, unthinking absorption in the quotidian. Play here is a spirit (in some almost literal sense) that works unobtrusively through the players, providing from within what the blue cloth of the covering game bestows from without. If it repeats and supplements the forms of social life, it also re-creates the imaginative matrix that spawns them, and enacts their human emergence.

In the midst of this procession a plump, moon-faced little girl totters forward as if taking her first steps (Fig. 146). Her delight in being included in this ritual she no doubt barely understands is as evident as the affection with which Bruegel portrays it. Although the other participants have relegated her to a minor role toward the end of the procession, she is clearly the artist's focus. The improvised blue cowl that covers her head connects her with the ritual object being carried and transfers onto her something of the reverent attention given to it. The blue cowl also strengthens her connection with the figure behind her also cloaked in blue. Even if the latter is only an older child, the two enter into a subtle configuration of parental concern. The little girl seems almost to be splitting off from the figure behind her, while he or she appears in turn to launch her on her way. The image has to do with attachment and separation—with the move into the world, toward individuation. The older figure provides a context of solicitude for the little girl, and within it releases her into singularity.[10] The child proceeds forward on her own, her arms held out like the basket holder of the wedding procession and a similar gap opening behind her.

But she is ballasted by the gifts that fill her hands, and though she expe-
riences herself (delightedly) as separate, she appears to take with her—the
blue cowl is its visible sign—her trust in a backing presence ready to cush-
ion any fall.[11] The objects in her hands may be festive cakes, which were
traditionally thrown or distributed at baptisms, but they look more like
pieces of fruit being used to represent these cakes in the game. The child
recalls (strikingly for me) a medieval illumination of the Christ child
seated in "Abraham's bosom," distributing fruit to the elect (Fig. 147). And

Fig. 146

Fig. 147. *Paradise with
Christ in the Lap of Abra-
ham* (detail), leaf from a
Psalter, 1239 (?) (National
Gallery of Art, Washing-
ton, D.C.)

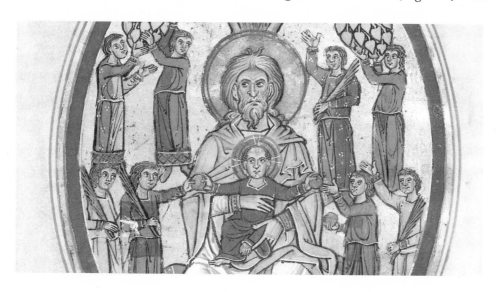

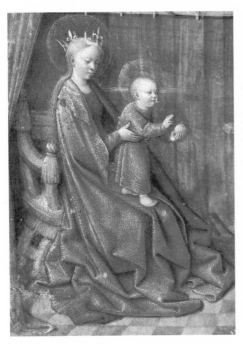

Fig. 148. Jean Fouquet,
*Virgin and Child En-
throned*, from *The Hours
of Simon de Varie*,
c. 1455 (J. Paul Getty
Museum, Malibu)

Fig. 149. Jean Fouquet,
Virgin and Child, from
*The Hours of Simon de
Varie*, c. 1455 (Kouink-
lijke Bibliotheek, The
Hague)

descending from this tradition are all those late medieval and early Ren-
aissance images of the Christ child in the Virgin's lap (sometimes with her
blue mantle as his cowl), extending to her or to the viewer the fruit he
clutches in his hand (Figs. 148 & 149). There may be in Bruegel's image
another instance of an object *substituted* in play that recovers (in spirit, at
least) the *origin* of the ritual.

The game, then, as Bruegel depicts it, has to do with christening in
more than one sense. It centers on an image that seems very hopeful about
the beginnings of the self, about starting out in the world and stepping into
the awaiting forms of life. Yet directly in front of the procession, only a
few steps away, two older figures vie ominously for bones, and one collects
her winnings in her aproned lap (Fig. 150)—an image at once of a malign
fate and the cruel mother. They are playing knucklebones, a game de-
scribed by Erasmus in one of his *Colloquies* as a children's game which
was once a form of dicing played by ancient Greeks and Romans.[12] As he
explains it, two competing players take turns throwing four bones, or *tali*,
adding to a stake which is won by the first to throw "Venus," the config-
uration in which each talus displays a different side of the four-sided bone.

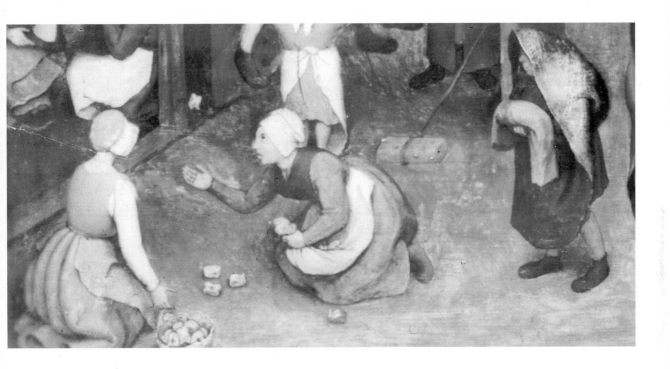

The drama of Bruegel's single suspended bone is thus intense. Caught in Fig. 150
its trajectory by the instant of representation, it evokes a very different
mood from the approaching baptismal "child" held securely aloft and
borne through space on its plush cushion. The three tali on the ground
display the three most difficult aspects to throw; everything hinges on the
fall of the bone suspended in mid-arc. In one respect the game thus seems
to present an image of imminent good fortune (Erasmus mentions that
among the Romans "throwing Venus" became proverbial for the attainment
of one's desires), but the player who may be about to win looks so malign
and fateful that the very prospect of her victory assumes an ominous cast.

The impression of the two figures as "Fates" may seem tenuous, but it
is reinforced by an engraving of *Infantia* published in 1570 by Hieronymus
Cock as the first of a series of the Ages of Man.[13] There the stages of child-
hood from birth to the earliest games explicitly revolve around the three
Fates, who dominate the foreground as they measure out and cut the thread
of human life. We might note also that an image which begins with a child
full of promise being watched over by a figure cloaked in blue, and pro-
ceeds toward an altar through two figures dicing on the ground with bones,

is almost bound at some level to evoke Christ's trajectory—especially given the way Renaissance depictions of the Christ child, even the most joyous ones, habitually allude to his sacrificial destiny.

Indeed, the christening procession can with the blink of an eye take on the lineaments of a funeral or a sacrifice. This may be only an accident of perception, but it accords with suggestions elsewhere in the painting about what it is to be absorbed into the social order. Hidden just inside the doorway that appears to be the procession's destination, two identical, adult-looking figures replicate themselves in faceless, identical-looking dolls—an emblem of society's perpetuation of itself that could scarcely be more at odds with non-mimetic investment in the baptismal procession's singular "child." And overseeing the work of the effigy makers, in much the same way that the distant cathedral oversees the channeling action of the receding street, is another sign of organized religion—this time a mock altar, strewn with objects that *look* more like dead relics or instruments of black magic than vessels of sacramental promise.

———

Everything in *Children's Games*, then—especially assurance—seems suspended. Indeed, the details of the painting seem knowingly to traverse the senses of that term. We began with an image of gravity annulled—a plump girl lifted by parental arms into a perspective one feels she will enjoy forever. Now we arrive at a single bone suspended in midair, blocking an open trajectory and placing a toddler's delighted steps under the sign of an imminent fate. And other instances abound. Consider again the two small windows at the upper story of the central building. Out of one a basket of heavy-looking objects hangs from the arm of a boy who seems poised to drop them on a victim; out of the other a long banner is carried by a breeze toward the pastoral calm far off on the left, and where it floats down a single iris curves up to meet it (Fig. 151). One could scarcely imagine two more antithetical images of the "rule" of gravity and of the time and spirit of things subject to it. Or recall the girl balancing the broom at the threshold of the same building: her gesture annuls practical function, conventional meaning, and social fate all at once, while posing the question of play as guileless and momentary or triumphant and consciously subversive.

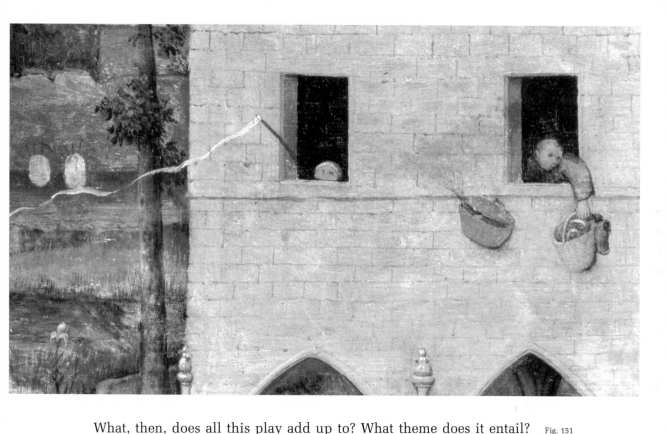

Fig. 151

What, then, does all this play add up to? What theme does it entail? And what finally does the painting say? Is there some single perspective from which to sum up all its detail and articulate it under the rubric of "the painting as a whole"? The impulse to generalize seems impossible to suppress. And yet in *Children's Games*, perhaps more than anywhere else in Bruegel, the proliferation of meaning defies any settled statement. The visual language of *Children's Games* is constantly presenting motifs to ponder—"suspension," for instance—but only in the process of fracturing them into their many aspects and scattering them into one another's field. Play, imaged as a pure instant, can hold the present, the almost-past, the not-yet, the about-to-be, the held-in-abeyance, the imagined-away, or the permanently translated. Things suspended run the gamut from the deferred to the undecided to the imminent to the gestating to the sublated or abolished or uplifted, become implicated in boundaries, thresholds, limits, gaps—indeed, crossings of all sorts—and enter into relation with motifs of groundedness that have their own rich problematic. Such endlessly pro-

liferating semiosis for all practical purposes *is* the painting: in an important sense there exists no "painting as a whole," if by that we mean something that frames, sums up, and holds in place its various details.

It may be that some works exist to defy generalization. "Depth without abstraction, achieved through detail pursued to the point of obsession," is how one contemporary writer has defined "the secret of art."[14] No painting exemplifies that claim more extravagantly than *Children's Games*. Its obsession with detail is obvious; what may be less immediately apparent is its depth. Bruegel's love of surfaces and his taxonomist's delight are real, but they can be misleading. For Bruegel is finally not just a collector and a cataloguer but a *thinker*, a Renaissance artist whose range and penetration rival Shakespeare's. Within his panoramic ambitions there is a veritable language of nuance, in which meaning, rather than being fixed, prior, and encoded, both enlists one's gaze and proliferates before it.

In this final section I've followed one of the more elusive themes of *Children's Games*—"assurance" is what I've called it—into Bruegel's disseminations, in order to show just how nuanced his images can be. To do so, admittedly, is to come to an end in the realm of particulars and, strictly speaking, without conclusion. It would be gratifying to offer a climactic statement of Bruegel's standpoint. But given the vision of *Children's Games*—one *sees* it there—it seems important to conclude with details, the issue of meaning left still open and undecided, but with any uneasy sensations linked to the prospect of interminability mitigated by a peripheral feel for the vast, complex statement that the painting holds out to us. For Bruegel's inclusiveness is the voluble, kaleidoscopic obverse of a gnomic density. Heraclitus gives us the enigma and nothing else: "Life is a child playing draughts; a child rules as king." Bruegel maps out and intermixes all the many statements such a saying might entail.

CHRONOLOGY

NOTES

BIBLIOGRAPHY

INDEX OF GAMES

GENERAL INDEX

Chronology

1525 Likely date of Peter Bruegel's birth, in Brögel, near Breda in the northern part of Brabant.

1551 Admitted to the status of "free master" in the Antwerp Guild of St. Luke.

1552 Travels to Italy by way of France; draws *Mountain Landscape with Italian-Style Cloister*, his earliest surviving dated work, and one of many such mountain landscape drawings he would execute between 1552 and 1556.

1554 Returns to Antwerp from Italy via the Alps and the Rhine Valley.

1555 Enters the employ of Jerome Cock, printmaker at the Sign of the Four Winds.

1556 Designs the first of many satirical, Boschlike drawings for engraving by Cock: *The Temptation of St. Anthony*, *Big Fish Eat Little Fish*, *The Ass at School*. Begins the series *The Seven Deadly Sins*.

1557 The earliest surviving dated oil painting generally accepted as Bruegel's: *Landscape with Parable of the Sower*.

1558 Many engravings published by Cock: *The Seven Deadly Sins*, a series of large Alpine landscapes, *Everyman*, *The Battle of the Moneybags and Strongboxes*, *The Alchemist*, *Landscape with St. Jerome*.

1559 Begins the series *The Seven Virtues*. Draws *The Kermis at Hoboken*. Paints *The Netherlandish Proverbs* and *The Battle between Carnival and Lent*.

1560 Changes his signature from BRUEGHEL to BRUEGEL. (His sons will adopt the earlier spelling.) Paints *Children's Games*, the first work to bear this new signature.

1562 Leaves Antwerp, visits Amsterdam. Cock begins publishing a series of warship prints after drawings by Bruegel. (None of these drawings survives.) Bruegel paints: *Dulle Griet*, *The Triumph of Death*, *The Fall of the Rebel Angels*, *The Suicide of Saul*, *Two Monkeys*. From this year on, he devotes himself almost entirely to painting.

1563 Marries Maryken Coeck, then about twenty years old. Her mother is Maria Verhulst, a well-known miniaturist; her father is the painter Peter Coeck van Aelst, Bruegel's first teacher. They settle in Brussels. Bruegel paints the Vienna *Tower of Babel*.

1564 Bruegel's first son is born—Peter II, who will become famous as "Peter Brueghel the Younger" or "Hell Brueghel" when he takes up painting after his father's death, copying many of his father's works. Bruegel paints *The Procession to Calvary* and *The Adoration of the Magi*.

1565 Bruegel paints, perhaps for Nicolas Jongelink, a series of seasonal landscapes: *Hay-Making*, *The Harvest*, *Hunters in the Snow*, *The Dark Day*. Also: *Winter Landscape with Birdsnare*, *John the Baptist Preaching*, *Jesus and the Woman Taken in Adultery*.

1566 Paints *The Massacre of the Innocents* and *The Census in Bethlehem*. Designs and etches *Landscape with Rabbit Hunters*.

1567 Paints *The Conversion of St. Paul* and *The Land of Plenty*. Probable date of *The Adoration of the Kings in the Snow* and the Rotterdam *Tower of Babel*.

1568 Bruegel's second son is born—John I, or Jan, who will become a painter of renown (often known as the Velvet Brueghel) and a collaborator with Rubens. Bruegel paints *The Bird's-Nester*, *The Parable of the Blind*, *The Misanthrope*, *Magpie on the Gallows*, and *The Cripples*. Probable date (1568–69) of *Peasant Dance* and *The Wedding Feast*, as well as of the drawings *The Bee-Keepers* and *Summer*. Possible date of *Landscape with Fall of Icarus*.

1569 Bruegel dies on September 5. He is buried in the church of Notre Dame de la Chapelle in Brussels. His son Jan later commissions a painting by Rubens to decorate the tomb.

Notes

INTRODUCTION

1. The question of purpose drives almost all theories of play into contradiction. Consider the passage from Huizinga from which I have purloined the epigraph for this book: "[Play] is a *significant* function—that is to say, there is some sense to it. In play there is something 'at play' which transcends the immediate needs of life and imparts meaning to the action. All play means something" (*Homo Ludens: A Study in the Play Element in Culture* [1938; Boston: Beacon Press, 1950], 1). Even here the attempt to invest play with a higher rationale tends to make it serve the very realms—culture, biology—it supposedly transcends. Bruegel's *Children's Games* may be unique in the degree to which it allows us to contemplate, uncoerced, the *play* of play.

2. "To Generalise is to be an Idiot . . . Strictly Speaking All Knowledge is Particular" (William Blake, marginalia to Reynolds, in *The Complete Writings of William Blake*, ed. Geoffrey Keynes [Oxford University Press, 1966], 451 and 459).

3. Friedrich Nietzsche, *Daybreak: Thoughts on the Prejudices of Morality*, trans. R. J. Hollingdale (Cambridge University Press, 1982), 5.

PART ONE

THINKING IN IMAGES

1. Timothy Foote, *The World of Bruegel* (New York: Time-Life Books, 1968), 114.

2. This interpretation was first suggested by Charles de Tolnay, *Pierre Bruegel l'Ancien*, 2 vols. (Brussels: Nouvelle Société d'Éditions, 1935), 2:18. Otto Benesch, *The Art of the Renaissance in Northern Europe*, rev. ed. (1947; London: Phaidon, 1965), 112, describes the children as images of the queerness of adults and refers to the presence of a "moral meaning" in which the conceited walk on stilts while others look at the world upside down. Carl Gustav Stridbeck, *Bruegelstudien: Untersuchungen zu den ikonologischen Problemen bei Pieter Bruegel d. A.* (*Acta Universitatis Stockholmiensis. Stockholm Studies in the History of Art*, II) (Stockholm: Almquist & Wiksell, 1956), 185–91, expands these critical asides into a full-scale reading of the painting. For a recent statement of this view, see Walter Gibson, *Bruegel* (New York and Toronto: Oxford University Press, 1975), who suggests that the games "symbolize folly" (p. 85) and claims, "No picture could better convey the futility of mankind's professions as they were viewed by Erasmus and other satirists" (p. 88). For the "moral" interpretation of Bruegel in general, see Stridbeck; K. C. Lindsay and B. Huppé, "Meaning and Method in Brueghel's Painting," *Journal of Aesthetics and Art Criticism* 14 (1956): 376–86; and F. Grossmann, *Pieter Bruegel: Complete Edition of the Paintings*, 3rd rev. ed. (1955; London and New York: Phaidon, 1973).

The iconographic readings of *Children's Games* have not been exclusively moralistic.

E. Tietze-Conrat, "Pieter Bruegels Kinderspiele," *Oudheidkundig Jaarboek*, II, series 4 (1934):127–31, claims that the painting represents "Infantia," the first of the Ages of Man. According to Jan van Lennep, "L'Alchimie et Pierre Bruegel l'Ancien," *Bulletin des Musées Royaux des Beaux-Arts des Belgiques* 14 (1965):125, it represents the stage of "coagulation" in the alchemical process and, perhaps, the Golden Age of the philosopher's stone. Tolnay, *Pierre Bruegel l'Ancien*, 1:23–25, takes the painting as an emblem of summer and claims it is part of a lost cycle of works representing seasonal amusements. More recently, C. Gaignebet, "Le Combat de Carnival et de Carême de P. Bruegel (1559)," *Annales: Economies, Sociétés, Civilisations* 28 (1972):331, has suggested that the painting is laid out like a calendar, with the games that can be associated with specific folk customs indicating the time of the year. These interpretations have remained marginal to Bruegel criticism, however, while the moralistic interpretation has become canonical. For an attempt to synthesize all the iconographic readings of the painting into an interpretation that views it as a presentation of the folly of adolescence and manhood, and specifically of marriage, see Sandra Hindman, "Pieter Bruegel's *Children's Games*, Folly, and Chance," *Art Bulletin* 63 (1981):447–75.

3. Robert L. Delevoy, *Bruegel*, tr. Stuart Gilbert (Geneva: Skira, 1959), 58. The literal view of the painting usually holds that it is meant simply as a visual encyclopedia of children's games. Of the several attempts to identify the games represented in the painting, the most important are Gustave Gluck, *Bruegels Gemälde* (Vienna: A. Schroll & Co., 1932), 54–56 (identifications by J. Borms); Jeanette Hills, *Das Kinderspielbild von Pieter Bruegel d. A.: Eine volkskundliche Untersuchung* (*Veröffentlichungen des Österreichischen Museums für Volkskunde* 10) (Vienna, 1957); and Grietje Hartman and Ellen Lens, *Hééé joh! kom je buiten spelen: De spelregels bij "De kinderspelen" van Pieter Bruegel de Oude* (Amsterdam: Bert Bakker, 1976). Hills's identifications are especially valuable for their references to the relevant literature on children's games and sixteenth-century customs and folklore.

4. The faces are even rendered to make them seem twinned. Note the shared hues and the similarly depicted "eyeholes," as well as the line of ruddiness that bridges the nose and curves under the eyes of both.

5. Versions of this counterpoint appear frequently in Bruegel. An especially pointed instance occurs in the far background of the Vienna *Peasant Dance*, where an innocent-looking fool and a sour misanthrope stand side by side, their opposite outlooks subsumed in a common spectatorial detachment. For an extended discussion of this painting, see pp. 43–57. For the detail in question, see p. 54.

6. William Blake, *The Marriage of Heaven and Hell*, plate 4; *The Complete Writings of William Blake*, ed. Geoffrey Keynes (London: Oxford University Press, 1966), 149.

7. Hindman, 450–51.

8. The phrase is borrowed from Nelson Goodman: see his *Ways of Worldmaking* (Indianapolis: Hackett Publishing Co., 1978).

9. But even as they suggest "vanitas," the two hoop rollers generate oppositions that exceed any moral reading: one is clearly a boy, the other is oddly gendered; one actively strikes the hoop to keep it going, the other watches passively as it rolls; one remains outside and behind the hoop's momentum, the other is half-included in its frame.

MORAL FIXITIES AND CONNOTATIVE PLAY

1. The iconography of the proverb has been exhaustively studied by Louis Lebeer, "De blauwe Huyck," *Gentsche Bijdragen tot de Kunstgescheidenis* 6 (1939–40), 161–229; see also

J. Grauls, *Volkstaal en volksleven in het werk van Pieter Bruegel* (Antwerp: Standaard Boekhandel, 1957), 89–90.

2. Stridbeck, 188–89.

3. H. David Brumble, III, "Pieter Brueghel the Elder: The Allegory of Landscape," *Art Quarterly*, n.s. 2 (1979), 132–34.

4. A recent essay on Bruegel's *Two Monkeys* (Fig. 78), for instance, interprets it, too, as an emblem of folly and cites as evidence the fact that in *Children's Games* "the children are symbols of irrational and foolish adults": see Margaret A. Sullivan, "Pieter Bruegel the Elder's *Two Monkeys*: A New Interpretation," *Art Bulletin* 63 (1981), 118.

5. Hindman, 448.

6. For a facsimile of Visscher, see *Sinnepoppen van Roemer Visscher*, ed. L. Brummel (The Hague: M. Nijhoff, 1949). For a listing and description of early editions, see John Landwehr, *Emblem Books in the Low Countries 1554–1949: A Bibliography* (*Bibliotheca Emblematica* 3) (Utrecht: Haentjens Dekker & Gumbert, 1970), nos. 720–25. For editions of Cats, see Landwehr, nos. 80–101. For seventeenth-century emblem books of children's games, see Hindman, 462 and references.

7. The only emblem book published in Belgium before 1560 was a 1554 translation of La Perrière's *Le Théâtre des bons engins*. Of the emblem books that proliferated in Antwerp in the decade after 1560, none depict children playing, except for an occasional image of children blowing bubbles: see Hindman, 462–64.

8. Erwin Panofsky, *Early Netherlandish Painting*, Vol. I (1953; Cambridge: Harvard University Press, 1971), 131–48; the quoted phrases are on p. 142.

9. *Sinnepoppen*, 143; quoted in Stridbeck, 189.

10. For the medieval and early Renaissance association of children and the lower classes, see Leah Sinanoglou Marcus, *Childhood and Cultural Despair: A Theme and Variations in Seventeenth-Century Literature* (University of Pittsburgh Press, 1978), 9–30.

11. Simon Schama, *The Embarrassment of Riches: An Interpretation of Dutch Culture in the Golden Age* (New York: Knopf, 1987), 509.

12. The indeterminacy of Bruegel's setting becomes even more pronounced in relation to the two paintings of his that immediately precede *Children's Games*. As a "town square" it is more abstract and schematic than the realistically detailed village setting of *The Battle between Carnival and Lent*; as a "composite" it is more unified and rooted in place than the surrealistic pastiche of *Netherlandish Proverbs*.

13. For a more detailed interpretation of the "pessimism" of the upper-right-hand area, see Part Two, "Nature and Culture."

CHILDHOOD AND FOLLY

1. Margaret A. Sullivan, "Madness and Folly: Pieter Bruegel the Elder's *Dulle Griet*," *Art Bulletin* 59 (1977): 63 n. 54; Stridbeck, 191.

2. Hindman, 449.

3. There *are* moments in Shakespeare when childhood is treated emblematically, but in such instances meaning tends to be especially elusive. Consider the following description of child's play in *Coriolanus*:

O' my word, the father's son; I'll swear 'tis a very pretty boy. O' my troth, I look'd upon him o' Wednesday half an hour together: he has such a confirmed countenance. I saw him run after a gilded

butterfly; and when he caught it, he let it go again; and after it again; and over and over he comes, and up again; catched it again: or whether his fall enraged him, or how 'twas, he did so set his teeth and tear it; O! I warrant, how he mammocked it! (I. iii)

Child's play here—admittedly a vain pursuit—epitomizes *something* in the adult world—but what? Does it propound a mechanism of desire? comment on desire's relation to its object? implicate desire in a compulsion to repeat? enact the "fall" of desire into anger and frustration? And does the vignette relate to the play as a whole? How globally does it apply? Does it comment on the oddness of the play's protagonist? on the specifically Roman ethos that spawns him? on maleness or orality or human nature in general? Whatever one's approach, to label the episode "vanity" and have it comment moralistically on mankind would be a travesty of interpretation. Why should a mode of critical response so clearly inadequate to the workings of Shakespeare's language seem so unremarkable when applied to Bruegel's images?

4. See Enid Welsford, *The Fool: His Social and Literary History* (London: Faber, 1968); Barbara Swain, *Fools and Folly during the Middle Ages and Renaissance* (New York: Columbia University Press, 1932). The theme persisted into the early Renaissance as both a humanist and a Reformation motif. Compare Luther's preface to the 1516 edition of *German Theology*: "Now, as always, as the Apostle Paul says in 1 Cor. 1 [:23], what is true and solid teaching in the Holy Scripture must either make fools of men or become itself foolish. We preach Christ who is foolishness to the heathen, but the wisdom of God to the saints" (quoted in Steven E. Ozment, *Mysticism and Dissent: Religious Ideology and Social Protest in the Sixteenth Century* [New Haven: Yale University Press, 1973], 19).

5. Marcus, 14, citing Welsford, 200–3, and Swain, 4–5, 55–61.

6. See Walter Kaiser, *Praisers of Folly: Erasmus, Rabelais, Shakespeare* (Cambridge: Harvard University Press, 1963); Rosalie Colie, *Paradoxia Epidemica: The Renaissance Tradition of Paradox* (Princeton University Press, 1966); Barbara Bowen, *The Age of Bluff: Paradox and Ambiguity in Rabelais and Montaigne* (Urbana: University of Illinois Press, 1972). For an account of the nuances that can attend even ordinary-language usages of the vocabulary of folly, see William Empson, *The Structure of Complex Words* (London: Chatto & Windus, 1951), 105–24.

7. For three very different contextual accounts of these prints and Bruegel's other depictions of peasant festivities, see Svetlana Alpers, "Bruegel's Festive Peasants," *Simiolus* 6 (1972/73): 163–76; Keith Moxey, "Sebald Beham's Church Anniversary Holidays: Festive Peasants as Instruments of Repressive Humor," *Simiolus* 12 (1981/82): 109–30; and Margaret Carroll, "Peasant Festivity and Political Identity," *Art History* 10 (1987): 289–314.

8. The drawing of the *Kermis at Hoboken* is signed by Bruegel and dated 1559. The engraving after it by Frans Hogenberg is undated. The engraving of the *St. George's Day Kermis*, published by Hieronymus Cock after Bruegel's design, is undated, and no preliminary drawing by Bruegel survives. The *St. George's Day* print is usually regarded as the later work (proposed dates range from 1560 to 1562), but the *Hoboken* scene is stylistically and intellectually the more sophisticated—one would like to say the more "Bruegelian"—of the two. The absence of a drawing for the *St. George* scene makes comparison difficult; nevertheless, the relatively straightforward anecdotal quality of the *St. George's Day* overview feels "prior" to the watershed moment of Bruegel's *Battle between Carnival and Lent*, whereas the sophisticated mapping of social flow in the construction of the *Hoboken* scene seems "later." For the development in Bruegel from *Carnival and Lent* to *Children's Games*, see pp. 69–73.

9. Bob Claessens and Jeanne Rousseau, *Our Bruegel* (Antwerp: Mercatorfonds, 1969), overleaf between 140 and 141.

10. This "precocious" aspect of the gesture is given added emphasis in Hogenberg's engraving of Bruegel's drawing, where the child becomes almost an initiatory figure of wisdom.

11. Most of Bruegel's fools—those in *Carnival and Lent* and the Vienna *Peasant Dance*, for instance—seem stock figures, but in *The Kermis at Hoboken* he seems primarily concerned with depicting the man beneath the costume—the village idiot, or perhaps one of its doddering elders dressed up to play the part, but certainly a familiar and accepted presence in the life of the community, not an abstract sign of its folly. (This individualization of the figure is lost entirely in Hogenberg's print.) The spirit in which this figure has been conceived evokes, in fact, the benign fool of *The Praise of Folly*, who is an index of the good community, not an instance of individual sinfulness or bad temptation:

> Remember also that they are continually merry, they play, sing, and laugh; and what is more, they bring to others, wherever they may come, pleasure, jesting, sport, and laughter, as if they were created, by a merciful dispensation of the gods, for this one purpose—to drive away the sadness of human life. Thus it comes about that, in a world where men are differently affected toward each other, all are at one in their attitude toward these innocents; all seek them out, give them food, keep them warm, embrace them, and give them aid, if occasion rises; all grant them leave to say and do what they wish, with impunity. So true it is that no one wishes to hurt them that even wild beasts, by a certain natural sense of their innocence, will refrain from doing them harm. (Desiderius Erasmus, *The Praise of Folly*, tr. Hoyt Hopewell Hudson [1941; Princeton University Press, 1970], 47–49.)

12. The difference between these two children finds a parallel in the two basket carriers at the head of the bridal procession in *Children's Games* (Fig. 141). For a discussion of the latter pair, see Part Two, "Assurance."

13. For a related discussion, see Part Two, "Opposition."

14. Richard Baxter, *Treatise of Conversion*, chapter 1, in *The Practical Works* (London, 1838), 2:424; quoted in Marcus, 71. Such resistances to Protestant doctrine persisted throughout the sixteenth century, even in the countries where it officially prevailed. For documentation, see Gerald Strauss, *Luther's House of Learning: Indoctrination of the Young in the German Reformation* (Baltimore: Johns Hopkins University Press, 1978), esp. 268–99.

15. *Childhood and Cultural Despair*, chapters 1 and 2. My summary follows closely Marcus's rich and cogent survey of the historical and cultural thematics of childhood.

16. The 1560 Geneva Bible gives the incident as follows:

> And as the ark of the Lord came into the city of David, Michal Saul's daughter looked through a window, and saw King David leap and dance before the Lord; and she despised him in her heart . . . Then David

returned to bless his house, and Michal the daughter of Saul came out to meet David, and said, O, how glorious was the king of Israel this day, which was uncovered today in the eyes of the maidens of his servants, as a fool uncovereth himself! Then David said unto Michal, it was before the Lord, which chose me rather than thy father, and all his house, and commanded me to be ruler over all the people of the Lord, even over Israel: therefore will I play before the Lord, and will yet be more vile than thus, and will be low in mine own sight, and of the very same maidservants which thou hast spoken of, shall I be had in honour. Therefore Michal the daughter of Saul had no child unto the day of her death.

Given the paradigmatic status of this passage for so much of the sixteenth-century controversy about ritual "play," might Bruegel intend it to color our perception of the misanthropic-looking mask that stares out the window in *Children's Games* at the games going on below? One might compare again Bruegel's coupling of misanthropy and folly in the background of his Vienna *Peasant Dance.*

17. St. Bernard, *Life and Works*, tr. and ed. John Mabillon and Samuel J. Eales (London, 1896), 1:314:

> I should, then, be able to take to myself the word of the Prophet: *After having been exalted I have been cast down and filled with confusion* (Ps. 1xxxviii.15, VULG.), and this, *I will play and will be yet more vile* (2 Sam vi.21, 22). Yes I will play this foolish game that I may be ridiculed. It is a good folly, at which Michal is angry and God is pleased. A good folly which affords a ridiculous spectacle, indeed, to men, but to angels an admirable one . . . Upon the eyes of all we produce the effect of jugglers and tumblers, who stand or walk on their hands, contrary to human nature, with their heads downward and feet in the air. (Quoted in Marcus, 76–77.)

18. *Dives and Pauper* (London, 1534 or 1536), fols. 120–32; quoted in Marcus, 77.

19. Again, it should be stressed that all these positions are duplicated within the "matrix" of folly.

20. Erasmus glossed the praise of childhood in Matthew 18 to mean that children are "farre from all affeccions of ambition and envy, symple, pure, and lyving after the onely course of nature," but he added that "we ought not to tarie long with them, but to make spede to things of more perfection" (*Paraphrases upon the New Testament*, ed. Nicholas Udall [London, 1551–52], 1:lxxii and lxxvi). Quoted in Marcus, 25. When he held up the Christ child as an example to emulate in his colloquy "The Whole Duty of Youth," it was not the Infant Jesus but "he who as a boy of twelve, sitting in the temple, taught the doctors themselves" (*The Colloquies*, tr. Craig Thompson [University of Chicago Press, 1965], 32). For the early humanist enthusiasm for educational regiments, see Marcus, 23–30 and references.

21. The crucial study is that of Norbert Elias, *The History of Manners*, Vol. I of *The Civilizing Process*, originally published as *Uber den Prozess der Zivilization* (1939; New York: Pantheon, 1978).

22. Bruegel depicts children learning studiously in two prints, *The Ass at School* (1556) and *Temperantia* (1559), and in neither image is his attitude transparent. The former appears openly satiric, but neither the object of the satire (children? teachers? proverbs?) nor its message is determinable. The latter belongs to Bruegel's series of *Virtues*, but its bizarre allegorical depictions of humanist intellectual ideals (tall pillars and heavenly bodies being measured with the same scurrying, instrumental zeal, Temperantia herself with a bit between her teeth, and holding the reins in her own right hand) makes it especially vulnerable to ironical interpretation.

23. See Strauss, esp. 135–50. Favorite examples in Protestant educational books were Tobias, Isaac, and the Jesus Christ who willingly suffered crucifixion in obedience to his father. It would be an oversimplification, however, to see this distinction between humanist and Protestant educators as hard and fixed. The difference between the most liberal of the former and the most conservative of the latter was indeed vivid, but in the area between, distinctions tend to blur. For an account of Protestant "discipline" more sympathetic than Strauss's, see Steven Ozment, *When Fathers Ruled: Family Life in Reformation Europe* (Cambridge, Mass.: Harvard University Press, 1983), 132–77.

24. Otto Brunfels, *Von der Zucht und Underweisung der Kinder . . .* (Strasbourg, 1525); quoted by Ozment, *When Fathers Ruled*, 136.

25. For Renaissance skepticism about humanist ambitions, see Hiram Haydn, *The Counter-Renaissance* (New York: Scribner, 1950); for Agrippa in particular, see Charles G. Nauert, *Agrippa and the Crisis of Renaissance Thought* (Urbana: University of Illinois Press, 1965). But rarely can the major intellectual figures of the early Renaissance be confidently divided into humanists and antihumanists, or skeptics and knowledge seekers: such oppositions were internal to the period, symptoms of a general cultural ambivalence and of heteroglossic ways of thinking to which few of the major figures of the period were immune. The Erasmus of the *Colloquies* also authored the *Praise of Folly*; the Agrippa of *De vanitae* also compiled the encyclopedic *De occulta philosophia*. For a provocative account of the pre-Cartesian *mentalité* that mobilized such contradictions, see Timothy Reiss, *The Discourse of Modernism* (Ithaca: Cornell University Press, 1982).

26. Rabelais, *The Histories of Gargantua and Pantagruel*, tr. J. M. Cohen (Middlesex and New York: Penguin Books, 1955), 2, 4:180–81.

27. Philippe Ariès, *Centuries of Childhood: A Social History of Family Life*, tr. Robert Baldick (New York: Knopf, 1962), 100–27.

28. For a lucid presentation of both the "Ariès thesis" and the many critiques of it, see Linda A. Pollock, *Forgotten Children: Parent-Child Relations from 1500 to 1900* (Cambridge: Cambridge University Press, 1983).

29. Though even here, to speak of "overlap" may be to rationalize in terms of temporality and opposition what from another perspective could be described as a simultaneous, heteroglossic field. For an obliquely relevant discussion of this issue, see Reiss, 55–197.

30. Luther's disapproval in his "Exhortation to the Clergy at Augsburg" is exceptional only for its relative good humor:

> If these things had been kept as play for the youth and for young pupils, so that they would have had a childish game of Christian doctrine and life, in the same way that we must give children dolls and hobbyhorses and other toys; and if the custom had been allowed to stay at that, as we teach the children to fast for the sake of the Christ-Child and of St. Nicholas, so that they may give them presents on their nights (for it was thus, as we can see, that our ancestors meant it to be); if it were to be left at that, the palm-ass, the ascension and many things of that kind could be tolerated, for then they would not lead anyone's conscience astray. But for us old fools to go about in mitres and clerical finery, and take it seriously,—so seriously, indeed that it becomes an article of faith,—so that whoever does not adore this child's play must have committed a sin and have his conscience tortured by it,—that is the very devil! (*The Works*, ed. by Henry Eyster Jacobs et al. [Philadelphia, 1915–32], 4:380–81; quoted in Marcus, 79–80.)

31. The metaphor had already become a commonplace by the time of Heinrich Bullinger's compendious attack of 1529: "Indeed, in our places of worship, what are representations of the

Virgin mother and the other gods and goddesses but huge dolls [*puppae*]? Are they set up by barbarians? Are we children not only twice but always?" (*De origine erroris libri duo* [1529; Zurich, 1539]; quoted and tr. by Keith Moxey, *Pieter Aersten, Joachim Beuckelaer, and the Rise of Secular Painting in the Context of the Reformation* [New York: Garland Pub., 1977], 136–37).

32. Keith Thomas, *Religion and the Decline of Magic* (New York: Scribner, 1971), 75.

33. Marcus, 60–75. For a concise summary of this emblem literature, along with a discussion of how it was subsequently adapted by Protestant writers, see Barbara Kiefer Lewalski, *Protestant Poetics and the Seventeenth-Century Religious Lyric* (Princeton University Press, 1979), 179–212.

34. Calvin's "official" view was repeated *ad infinitum*:

> Even infants themselves, while they carry their condemnation along with them from their mother's womb, are guilty not of another's fault but of their own. For, even though the fruits of their iniquity have not yet come forth, they have the seed enclosed within them. Indeed, their whole nature is a seed of sin; hence it can only be hateful and abhorrent to God. (*The Institutes of the Christian Religion*, Book II, Chapter I, tr. Ford Lewis Battles, ed. by John T. McNeill, *Library of Christian Classics*, Vol. 20 [London: S.C.M. Press, 1960], 251.)

35. For the debate about childhood innocence that grew up within the Protestant movement, specifically over the issue of infant perdition, see John S. Oyer, *Lutheran Reformers Against Anabaptists* (The Hague: M. Nijhoff, 1964), esp. 6–40.

36. Strauss, 33–34, 100–1.

37. Pieter Riedemann, *Account of Our Religion, Doctrine, and Faith* (1540–41), 2nd English ed. (Rifton, N.Y.: Plough Pub., 1974), 68; see also "Two Kinds of Obedience: An Anabaptist Tract on Christian Freedom," tr. and ed. by J. C. Wenger, *Mennonite Quarterly Review* 21 (1947): 18–22. On the other hand, Anabaptists typically argued that baptism should be limited to adults, because the Christian life is not "child's play": see George Hunston Williams, *The Radical Reformation* (Philadelphia: Westminster Press, 1962), 173.

38. Ephraim Pagitt, *Heresiography* (London, 1645), 35; quoted in Marcus, 59. The *pueres similes* were a Continental Anabaptist sect; the source of Pagitt's information is Bullinger's attack on the Anabaptists published in 1531.

39. For quotations and references, see Ozment, *When Fathers Ruled*, 133–34.

PEASANT DANCERS

1. The motif is discussed in Laurinda S. Dixon, *Alchemical Imagery in Bosch's "Garden of Delights," Studies in the Fine Arts: Iconography* 2 (Ann Arbor: UMI Research Press, 1981), 25–26.

2. I am indebted here to Michael O'Loughlin, *The Garlands of Repose* (University of Chicago Press, 1978), 244–52.

3. For a discussion, see Richard M. Berrong, "Rabelais's *Quart Livre*: The Nature and Decline of Social Structure," *Kentucky Romance Quarterly* 28 (1981):39–54.

4. For the "conservative" view, see Moxey, "Sebald Beham's Church Anniversary Holidays"; for the "radical" view, see Carroll, "Peasant Festivity and Political Identity." Alpers attempts a more sophisticated anthropological approach in "Bruegel's Festive Peasants," although her focus is the Detroit *Wedding Dance* (for complete references, see note 7, p. 168). Alpers's article elicited from Hessel Miedema a fierce response which demonstrates, among other things, how *entrenched*

traditional Northern Renaissance art historians tend to be in their long-held iconographic positions: see "Realism and the Comic Mode: The Peasant," *Simiolus* 9 (1977): 205–19; and Alpers's response, "Taking Pictures Seriously: A Reply to Hessel Miedema," *Simiolus* 10 (1978–79): 46–50.

5. Alpers, "Bruegel's Festive Peasants," 174–75.

6. Cf. Wolfgang Stechow, *Pieter Bruegel the Elder* (New York: Abrams, 1955), p. 130:

> The *Wedding Dance* in Detroit of 1566 had already defined Bruegel's attitude toward an excess of dancing on a solemn occasion: it is sinful and, like all sin, foolish. His opinion did not change as he contemplated man's folly on what must be a saint's day, probably even one connected with the veneration of the Mother of God. A tiny image of Mary (perhaps a cheap woodcut?) is affixed to the tree at the right, above a pot with a few flowers which, neglected, is about to fall down; the only really prominent building is the tavern, that "devil's schoolhouse," on the left side; its huge flag dwarfs the Madonna picture manifold; a woman is about to pull a man into its door.

7. The buildings in *Peasant Dance* are characterized without distinction as "farmhouses" in Marijnissen and Seidel, *Bruegel* (New York: Harrison House, 1984), p. 50. The banner is taken by most commentators to be the sign of the saint's day, not that of the "tavern." Its barely legible crossed arrows have led some to connect it with the wind-filled banners of Bruegel's earlier *St. George's Day Kermis* and his *Kermis at Hoboken* (Figs. 29 & 30): see A. Monballieu, "*De Kermis van Hoboken* van P. Bruegel . . . ," in *Jaarboek van het Koninklijk Museum voor schone Kunsten Antwerpen* (Antwerp, 1974), 147; also Klaus Demus, *Flämische Malerei von Jan Van Eyck bis Pieter Bruegel d. A.: Katalog der Gemäldegalerie* (Vienna: Kunsthistorisches Museum, 1981), 117. I know of no attempt to identify and/or interpret the two standing figures represented on the banner.

8. This border between the grass and the ocher ground is also utilized in *Children's Games*, in at least two places: see Part Two, pp. 111–12, 146, for discussions.

9. The "moral" critics tend to view this detail, too, as a negative comment by Bruegel: see Stechow, 131 (quoted in n. 6 above), and Grossmann, 201:

> We find here a further development of the tendencies observed in the Detroit *Wedding Dance*. But now it is not only the sin of lust which Bruegel portrays: anger and gluttony appear combined with it (at the table on the left). The man seated next to the bagpipe player wears on his hat the peacock feather of vain pride. The occasion for all this sinful behavior is a kermesse, to celebrate some saint's day! The church appears in the background, but all figures are shown with their backs to it. Moreover, they do not pay the slightest attention to the picture of the Madonna which looks down on the sinners from the tree on the right.

And yet it is the critic here, in his rush to moral judgment, who pays insufficient attention. Though Stechow describes the pot just below the image as "neglected" and "about to fall," it hangs securely from a huge nail, and it contains what appears to be a fresh, newly gathered sprig of leaves and flowers. And if the Madonna (whose loving attention is concentrated on her child) "looks down" on the "sinners," it is as the Virgin of Mercy, not the judging Christ or the wrathful God. In fact, the plaque and pot of flowers seem placed higher on the tree than any hand within the scene could reach: they are more like a grace note that Bruegel himself has provided, and they seem meant to address *our* attention more than that of the dancing peasants who in Grossmann's view ignore them.

1. Van Lennep, "L'Alchimie et Pierre Bruegel."

2. Stridbeck, 161. This view is repeated often in Bruegel criticism, usually with the same matter-of-fact, authoritarian blandness. See, for instance, Gibson, *Breugel*, 62: "Thus *Justice* is accompanied by scenes of torture and punishment; if these incidents seem unduly harsh to us, they were accepted by Bruegel's contemporaries as necessary to maintain public law and order. This attitude is expressed in several Flemish legal treatises of the period," etc.

3. Such spectacles would have been especially vivid realities for someone living in Antwerp during the 1550s, when both the spread of radical Protestant sects and the attempts of the Inquisition to suppress them escalated rapidly. See John J. Murray, *Antwerp in the Age of Plantin and Brueghel* (Norman: University of Oklahoma Press, 1970), 29–42; and A.L.E. Verheyden, *Anabaptism in Flanders, 1530–1650* (*Studies in Anabaptist and Mennonite History* 9) (Scottdale, Pa.: Herald Press, 1961), 30–75. For a richly textured survey of the whole climate of dissent and social protest during the period, see Ozment, *Mysticism and Dissent*.

4. For the quotation from More, see *The Yale Edition of the Complete Works of St. Thomas More*, Vol. 4, *Utopia*, eds. Edward Surtz, S.J., and J. H. Hexter (New Haven: Yale University Press, 1965), 71; for the one from Montaigne, see *The Complete Essays of Montaigne*, tr. Donald Frame (Stanford University Press, 1958), 314. See also the latter's "Of Cannibals," 155:

> I am not sorry that we notice the barbarous horror of such acts, but I am heartily sorry that, judging their faults rightly, we should be so blind to our own. I think there is more barbarity in eating a man alive than in eating him dead; and in tearing by tortures and the rack a body still full of feeling, in roasting a man bit by bit, in having him bitten and mangled by dogs and swine (as we have not only read but seen within fresh memory, not among ancient enemies, but among neighbors and fellow citizens, and what is worse, on the pretext of piety and religion), than in roasting and eating him after he is dead.

Montaigne's fiercest and most sustained attack on contemporary systems of justice occurs in his final essay, "Of Experience," 819ff.; e.g., "Consider the form of this justice that governs us: it is a true testimony of human imbecility, so full it is of contradiction and error."

5. Other interpreters have perceived ironies in the prints and interpreted them from an Erasmian, Christian-humanist perspective: see Irving L. Zupnick, "Appearance and Reality in Bruegel's Virtues," *Actes du XXIIᵉ Congrès International d'Histoire de l'Art, Budapest, 1969* (Budapest: Akademiai Kiado, 1972), I: 745–53.

6. This is Charles de Tolnay's interpretation: see his *The Drawings of Pieter Bruegel the Elder*, 2nd rev. ed. (1925; New York: Twin Editions, 1952), 27.

7. See, for instance, Adriaan J. Barnouw, *The Fantasy of Pieter Brueghel* (New York: Lear Publishers, 1947), 32: "Brueghel has expressed in the faces of the magistrates, law officers, and spectators that they are not prompted by cruelty or lust for vengeance. No one takes pleasure in the scene. They all look serious and aware of the solemnity of the proceedings. One realizes that the essence of the grim spectacle is not the death of a criminal but the law triumphant in his punishment."

8. Barnouw, 32.

BRUEGEL'S BODIES

1. There are, to be sure, instances in early Northern Renaissance art where blue does signify deception and/or folly. In Bosch's paintings, especially, ironic uses of the color abound. But even

in Bosch such uses require "prior" reference points to be understood as such. One's perception, for instance, of the blue hat and face of the figure in the central panel of Bosch's *The Temptation of Saint Anthony* as "negative" hinges on a recognition of the threesome to which he belongs as a demonic parody of the Holy Family.

2. For a related discussion of early Renaissance sensitivity to the "value" of blue pigment, see Michael Baxandall, *Painting and Experience in Fifteenth Century Italy: A Primer in the Social History of Pictorial Style* (1972; London: Oxford University Press, 1974), 10–11.

3. J. Huizinga, *The Waning of the Middle Ages: A Study of the Forms of Life, Thought, and Art in France and the Netherlands in the XIVth and XVth Centuries* (1919; New York: St. Martin's Press, 1924), 249–50.

4. Rabelais, *Gargantua and Pantagruel*, Book I, Chapter 9.

5. For an interpretation of the shepherd's mantle as an emblem of hope, see R. C. Fox, "Milton's *Lycidas* 192–93," *Explicator* 9 (1951), no. 54.

6. Stridbeck's own sources tend to confirm such a suspicion. He cites Huizinga for the information that blue is the color of folly, but when one consults the relevant passage, one is surprised to find a discussion of blue as the color of "faithful love" in late-medieval love poetry (see note 3, above; cited in Stridbeck, 189). After giving one straightforward example, Huizinga quotes a poem by Christine de Pisan in which a lady chides her lover's blue vestments, countering that love consists in serving with a loyal heart, not in wearing blue, which may be merely a cover for the offense of falsehood (*The Waning of the Middle Ages*, 250). Huizinga speculates that the logic of this passage probably explains how by a "curious reversal" blue also came to mean infidelity, too, and to signify the cuckold and the fool as well as the faithful lover. Stridbeck selects only from this last remark.

The *Twelve Flemish Proverbs* in Antwerp, accepted by most critics as Bruegel's work, includes a man holding a blue cloak similar to the one in the Berlin *Netherlandish Proverbs* over his head, accompanied by the inscription: "I hide myself under a blue cloak, but the more I do so, the more easily people recognize me" (*ick stoppe my onder een blav hvycke / meer worde ick bekent hoe ick meer dvycke*). Here, as in Huizinga's example, the blue cloak does not in itself seem to symbolize deception or hypocrisy or cuckoldry (otherwise the man's strategy of concealing himself under it would make no sense); it is in spite of its "innocent" meaning that the deceit underneath it is transparent and causes it to signify its opposite. The speaker in this proverb-illustration seems undone by the mechanism of disavowal. Blue coverings, then, even in their emblematic role, are overdetermined objects that can signify either truthfulness or its false appearance: their meaning depends on one's reading of the context in which they appear.

7. Just as, conversely, one *could* argue that in Bruegel's *Adoration* the Virgin's traditional mantle has become the "blue cloak" of deception, and that the diabolical appearance of the infant who ushers in the age of Christendom is not just an accident or "failure" of representation.

8. Baxandall, *The Limewood Sculptors of Renaissance Germany* (New Haven: Yale University Press, 1980), 164–72 and references. Instances of the motif are reproduced in Plates 58 and 68, and Figs. 72 and 100–5. The passage I have quoted is on p. 164.

9. *Hymelwagen* (Augsburg, 1518), 5. Quoted in Baxandall, 166.

10. Compare the way in which proverbs are "liberated" into a kind of carnivalesque play of language in Rabelais's account of Gargantua's childhood:

> He would draw two loads from one sack, play the donkey to get the bran, use his fist for a mallet, take cranes at the first leap, think a coat of mail was made link by link, always look a gift horse in the mouth,

ramble from cock to bull, put one ripe fruit between two green, make the best of a bad job, protect the moon from the wolves, hope to catch larks if the heavens fell, take a slice of whatever bread he was offered, care as little for the bald as the shaven, and flay the fox every morning. (*Gargantua and Pantagruel*, I: 11, 63)

11. We might say that in *Children's Games* the human body elicits from Bruegel the same kinetic empathy which from the beginning (i.e., the drawings of 1552 onward) animates his response to the "body" of nature. For an intensely descriptive if idiosyncratic account of this response to nature, see Tolnay, *The Drawings of Pieter Bruegel the Elder*, where Bruegel's response to the human figure is described by contrast as that of a "puppeteer."

12. F. Grossmann, "Pieter Bruegel the Elder," in *Encyclopedia of World Art* 2 (1960), 641.

13. Gibson, 182–84.

RETROSPECT

1. Elizabeth Wright, *Psychoanalytic Criticism: Theory in Practice* (London and New York: Methuen, 1984), 98. Wright is discussing Julia Kristeva's theory of the "pre-symbolic child."

2. For a more elaborate discussion of Bruegel's conversion of linear into circular energy, see Part Two, "Opposition," pp. 97–104.

3. For an uncomplicated interpretation of Bruegel's vision as one in which man is seen as part of "the mechanism of the universe," see Benesch, 87–106.

PART TWO

NATURE AND CULTURE

1. Panofsky discusses this convention in his *Early Netherlandish Painting*, I: 131–48. He shows how contrasting background areas, especially when they frame Annunciations and depictions of the Virgin and Child, can bring into play oppositions between nature and grace, paganism and Christianity, the "cities" of man and god, and/or the old and new dispensations. In the form of the convention on which Panofsky concentrates, the right-hand area is always valorized over the left or "sinister" one. But different contexts can reverse these valences. Last Judgment paintings and frescoes, for instance, sometimes also employ contrasting background areas, but organize them with respect to the hands of a frontal, judging, and/or crucified Christ, so that the left locates the realm of the just and the saved and the right (i.e., Christ's left) that of the derelict and the damned. For a useful account of this convention, see Samuel Y. Edgerton, Jr., *Pictures and Punishment: Art and Criminal Prosecution During the Florentine Renaissance* (Ithaca: Cornell University Press, 1985), 21–45. And of course there are countless triptychs that bracket central panels with left-hand scenes of Eden and right-hand scenes of Hell. Bruegel's posing of a placid pastoral scene against an alienated cityscape is thus iconographically overdetermined: it may be inverting one set of conventions, referring straightforwardly to another, or deliberately mixing signals.

2. The term is Panofsky's: see *Early Netherlandish Painting*, 133.

3. The same features—patches of grass at the base of a building, a ruined wall overgrown by nature—are juxtaposed in the Friedsam *Annunciation*, where there is an elaborate *mise-en-scène* of grace and nature. See Panofsky, 142–44.

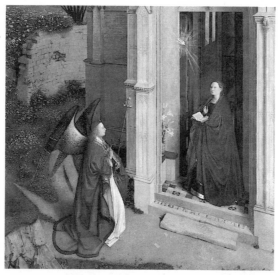

Peter Christus (?), *The Annunciation* (detail), 15th century (Metropolitan Museum of Art, New York)

4. For examples, see A.J.J. Delen, *Iconographie van Antwerpen* (Brussels: L. J. Kryn, 1930).

5. The opposite sometimes occurs in early Netherlandish triptychs: in Patinir's *Saint Jerome* triptych (Metropolitan Museum of Art, New York) three discontinuous, partitioned scenes are united by a single uninterrupted horizon line.

6. Panofsky has argued powerfully, if controversially, that in the early Renaissance techniques of perspective also "represented" worldviews and/or ingrained habits of mind. He considers only linear perspective, however, and leaves undiscussed any relation between it and "natural" perspective. See Erwin Panofsky, *Perspective as Symbolic Form*, tr. Christopher S. Wood (1927; New York: Zone Books, 1991).

7. Tolnay, *The Drawings of Pieter Bruegel the Elder*, 26–27.

8. Other analogies with *Justicia* are discussed on pp. 115–17.

THE MIDDLE REALM

1. This structure is evidently a familiar sixteenth-century presence; identical constructions appear frequently in popular imagery of the period, often with figures leaning on them. But this is the only one I know of in Bruegel. The closest structure to it in his paintings, in fact, is the gallows in *Magpie on the Gallows* (p. 183), where there is another complex meditation on the insertion of the human order into the natural scheme of things.

Map of Antwerp (detail), 1515 (City Archives, Antwerp)

"October" (detail), from *The Grimani Breviary*

2. Benesch, 112.

3. Gibson, 38; Hindman, 454.

4. A broom, for instance, was one of the sickly St. Petronilla's attributes, "because she busied herself about the house, whenever her health permitted" (P. Guerin, *Les Petites Bollandistes. Vie des Saintes*, 7th ed. [Paris, 1888], 6: 322; quoted in Leo Steinberg, "Guercino's *Saint Petronilla*," *Studies in Italian Art History* 1 [1980]: 229). The broom or brush became an hortatory emblem of female domestic virtue in Northern Renaissance art: see Jan Baptiste Bedaux, "The Reality of Symbols: The Question of Disguised Symbolism in Jan van Eyck's *Arnolfini Portrait*," *Simiolus* 16 (1986): 19–21. For a more general discussion of the Netherlandish regime of cleanliness and of woman as "upholder" of that regime, see Schama, 375–480. Schama reproduces many emblematic brooms and quotes from an instructional poem that has a magistrate's daughter declare, "My brush is my sword; my broom my weapon / Sleep I know not, nor any repose . . . / No labor is too heavy; no care too great . . ." (379–80).

A broom similar to the one in *Children's Games* juts out from an upper window in Bruegel's *Netherlandish Proverbs*, while under it a man and woman embrace. It may conflate two separate proverbs: "To stick out the broom" (to celebrate while the head of the household is away) and

Bruegel, *Netherlandish Proverbs* (detail)

"Courting under a roof" (common-law marriage or a "domestic" liaison). Between them they suggest an undoing of the economy of the domestic sphere. Schama (448–49) reproduces a print from the later seventeenth century in which a broom extending from an upper window displays the flag of insurrection and signals a wife's usurpation of her husband's authority. It seems possible that this constellation of ideas having to do with woman's domestic fate carries over to the broom balancer in *Children's Games*, but in ways that are impossible to pin down. Perhaps more important than any specific correspondence is the way the reappearance in *Children's Games* of an element from *Netherlandish Proverbs* again involves a suspension or unmooring of fixed meanings: there is a crossing from proverb to provisionality, from emblem to connotation, from the enclosed to the open side of liminal space.

OPPOSITION

1. Games on either side of the tug-of-war also focus this grasp on the "space between": compare the small couple playing "odds and evens," the pair of girls holding the flower basket, and the two boys clinging to the barrel's bunghole.

2. Alan Dundes and Claudia A. Stibbe make this observation in *The Art of Mixing Metaphors:*

A Folkloristic Interpretation of the "Netherlandish Proverbs" by Pieter Bruegel the Elder, FF Communications 97, no. 230 (Helsinki: Academia Scientiarium Fennica, 1981), 58–59.

3. No direct uses of children's games to illustrate social conflict predate Bruegel's images (though in 1627 Visscher could allegorize "How many horns does the goat have?" [Fig. 6] as "Tyranny"), but class structure as sustained on the backs of the peasantry was a common verbal and visual theme. And political implications were evidently never far from hand. At the bottom of the "January" page of the *Grimani Breviary*, two "knights" on barrels are being pulled toward each other by teams carrying the banners of the Holy Roman Empire and of Flanders—an image

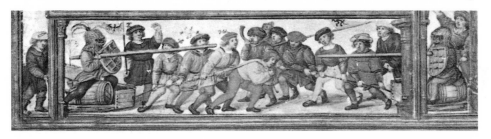

that seems to mediate *The Battle between Carnival and Lent* as well as *Children's Games*. And the "Q" of a grotesque alphabet by Master E.S. shows two armored knights fighting each other while two hapless peasants hold up and are trampled by their mounts. This latter image seems especially close in spirit to Bruegel's tug-of-war.

"January" (detail), from *The Grimani Breviary*

Master E.S., "The Letter Q," 1467 (Staatliche Graphische Sammlung, Munich)

COAGULATION

1. Stechow, 64. Note the critic's schoolmasterly assumptions about what constitutes "normal" childhood behavior.

2. This motif never fully materializes in the painting, but aspects of it are dispersed throughout the games in the lower and middle right, and occasionally appear elsewhere. Compare, for

instance, the blindfolded figure near the shed at the lower left with the many blindfolded Christs in late-medieval and early Renaissance Passion imagery.

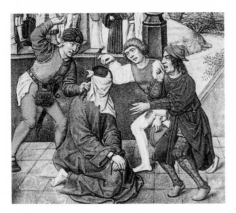

3. The Renaissance devised emblems of this relation. Puttenham, in his *Art of Englishe Poesie*, refers to a portrait of Hercules "where they had figured a lustie old man with a long chayne tied by one end at his tong, by the other end at the peoples eares, who stood a farre of and seemed to be drawn to him by the force of the chayne fastened to his tong, as who would say, by force of his perswasions." He is describing a "Gallic Hercules," often depicted in the Renaissance as a "hieroglyph" of eloquence. For an account of the iconographic tradition, see John M. Steadman, *The Hill and the Labyrinth: Discourse and Certitude in Milton and His Near-Contemporaries* (Berkeley: University of California Press, 1985), 136–53.

4. Erving Goffman, *Gender Advertisements* (New York: Harper & Row, 1979), 76, nos. 445–58.

5. This boundary is crossed or bridged in two other places in *Children's Games*, each time conspicuously so. (Recall also its function as a threshold in the Vienna *Peasant Dance*.) In a game just above the scattered bricks, hats are being tossed between a boy's legs from the trampled region of the ocher ground onto a grassy area just beyond. Whatever the actual rules of the game, the hats that have already landed on the grass imprint there, as Tolnay points out (*Bruegel l'Ancien*, I: 26), the rudiments of a human face, viewable as such only from the place of the observer—and

thus unlikely to be the intention of the players. Tolnay sees it as the face of a clown, and takes it as another indication of the theme of folly. But all one can confidently claim to perceive in the way of "face" is a rudimentary anthropomorphic gestalt (though one *does* have to wonder if the look of stunned dismay is only an accident of perception), as if what were at issue were the mark

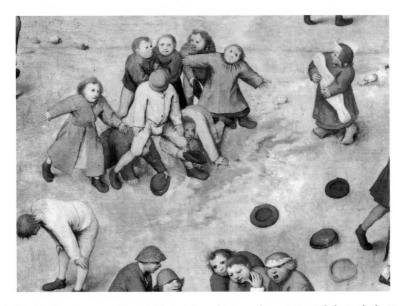

human beings make on nature. Three girls twirling skirts on the painting's left similarly "imprint" an area of grass. Not far away from them a gesture of covering crosses the boundary between the grass and the ocher ground in the reverse direction from that of the tossed hats. For a discussion of the latter game, see "Assurance," pp. 143–44.

6. See especially the beautiful *River Valley with Mountain in the Background*, where a man-made dike materializes this curve, which in turn informs the whole natural scene. In Bruegel's

Bruegel, *River Valley with Mountain in the Background*, 1552 (Louvre, Paris)

River Landscape with the Rape of Psyche by Cupid a long raft of logs rounding the bend of a river similarly isolates this curve that shapes things everywhere in nature—here a mobile figure that serves simultaneously as conveyance, material, and support.

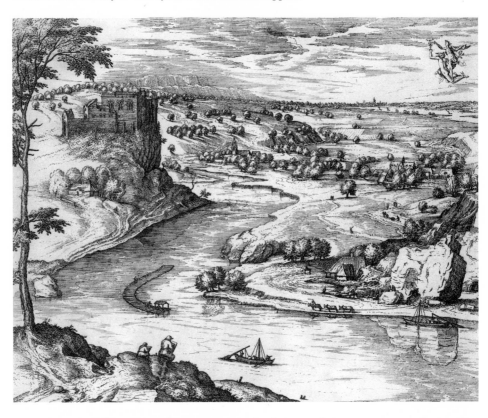

7. Maps and illustrations of Renaissance Naples depict a rectilinear pier: Bruegel's curvilinear structure is evidently his own visionary transformation. The spiral ramps of Bruegel's Vienna *Tower of Babel* similarly transform the sharp angles of its iconographic predecessors. It is as if the impulse to bend the rectilinear into the curvilinear were a primal urge in Bruegel's oeuvre.

Perhaps Bruegel's most poignant working out of the idea occurs in his *Magpie on the Gallows*, where the rectilinear gallows twists just enough to become a portal onto an eternal river landscape, while behind it two trees spiral into marriage as they rise. Only the wooden cross seems immune to the "bending" impulse.

1. Conventions from popular imagery of the period reinforce this perception. Dividing columns and arches were commonly used to frame either antithetic scenes (Pencz, below) or narrative sequences (*The Origin of Sin*). Bruegel does something similar in the right background of *Justicia*, where two arches and a central pillar frame separate scenes of punishment that tend to *read* as successive stages of a single event.

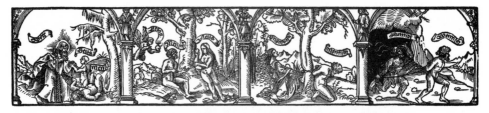

G. Pencz, *The Content of Two Sermons*, c. 1529 (Warburg Institute, London)

Monogrammist NG, *The Origin of Sin and Man's Justification* (detail) (Universitätsbibliothek, Göttingen)

Bruegel, *Justicia* (detail)

2. The top spinners in *Carnival and Lent* either whip their tops or, empty-handed, watch them spin. This split between agonistic and aleatory modes persists in the group of top spinners of *Children's Games* (note the analogous distinction between the two hoop rollers), but the central column subordinates it to more complex and deep-seated differences between active and passive, kinetic and spectatorial poles of experience.

3. The sixteenth century had its own ways of formulating this issue. Strauss cites a story related by Jorge Wickram in which a group of children get so carried away while playing "butcher, cook, and pig" that they slit the throat of one of their playmates and make a blood pudding. The judges in the case, feeling the inapplicability of the adult legal apparatus, offer the "butcher" a choice between a gold florin and an apple; when he happily chooses the apple, they declare him blameless. See *Luther's House of Learning*, 99.

4. Subliminal perception of the Flagellation is reinforced by the proximity of lash and column, two of the central attributes of Christ's Passion (both are prominently displayed together in the left foreground of Bruegel's *Fides*). Compare the depiction of the Flagellation in the *Très Riches Heures*, where, interestingly enough, a vulnerably naked Eve is suspended directly above the scene of torture, and the column divides the flagellators into a single figure and a dense group (Fig. 55).

5. See Julia Kristeva, *Powers of Horror: An Essay on Abjection*, tr. Leon S. Roudiez (New York: Columbia University Press, 1982).

6. Cf. Freud, *Civilization and Its Discontents*: "The effect of instinctual renunciation on the conscience then is that every piece of aggression whose satisfaction the subject gives up is taken over by the super-ego and increases the latter's aggressiveness (against the ego)" (*The Standard Edition of the Complete Psychological Works of Sigmund Freud*, tr. and ed. James Strachey [London: Hogarth Press, 1955], 21:120).

7. One *could* reverse this interpretation and, reading from left to right, find the figure of the single boy both prior and internal to the group of "innocent" spinners. Implicit in such a reading would be a more pessimistic view of the energies Bruegel depicts here and throughout the central region. But the right-to-left reading is powerfully supported by the feeling of visceral exuberance which Bruegel keeps insisting on in these areas and which registers so intensely as *loss* in key areas like the receding street. Even so, Bruegel, whose drawings were often instructions for prints, would have doubtless been alive to possibilities of reversal, and *Children's Games* exhibits everywhere—in the complex relation between the central region and the receding street, for instance—complex checks against *both* optimism and pessimism.

8. This fiction is intended to have heuristic value only and is equally subject to reversal: one could just as easily imagine Bruegel approaching children's games ironically, and discovering in them (and in the images and energies they elicit from him) something innocent and/or redemptive in the imagination.

GENDER DIFFERENCE

1. An alternative would be to see the two boys as playing some game of "slippage" on the sandy incline; the contrast would then be with the single girl's stability and the smooth round place she has made for herself near its base.

2. For different perspectives on Renaissance ideas about gender difference and the nature of woman, see Ian Maclean, *The Renaissance Notion of Woman* (Cambridge University Press, 1980); Carolyn Merchant, *The Death of Nature: Women, Ecology, and the Scientific Revolution* (San Francisco: Harper & Row, 1980); and Thomas Laquer, "Orgasm, Generation, and the Politics of

Reproductive Biology," *Representations* 14 (1986): 1–41. For the "Querelle des Femmes," see Constance Jordan, *Renaissance Feminism: Literary Texts and Political Models* (Ithaca: Cornell University Press, 1990); Joan Kelly, *Women, History, and Theory* (University of Chicago Press, 1986), 65–109 and references; Linda Woodbridge, *Women in the English Renaissance: Literature and the Nature of Womankind, 1540–1642* (Urbana: University of Illinois Press, 1984), 1–71; and M. A. Screech, *The Rabelaisian Marriage* (London: Arnold, 1958). For a discussion of Renaissance misogynism and Bruegel's relation to it, see Walter S. Gibson, "Bruegel, Dulle Griet, and Sexist Politics in the Sixteenth Century," in *Pieter Bruegel und Seine Welt*, eds. Otto von Simson and Matthias Winner (Berlin: Gebr. Mann Verlag, 1979), 9–15.

3. Erik Erikson, "Womanhood and the Inner Space," in *Identity, Youth, and Crisis* (New York: W. W. Norton, 1968), pp. 261–94. The quoted passages are on pages 271 and 273, respectively.

4. Ibid., 270.

5. Ibid., 271.

6. The gender ambiguity also poses a question about the nature of play. If the child is a girl, then in playing at "growing pregnant" she is anticipating her social and biological fate: play prepares for adulthood and fills out (however imaginatively) the gendered self. But if the child is a boy, then he is playing at/with the *other's* experience: play would here involve the crossing of biological and gendered lines, the supplementing of limits, the imagining of precisely what can *never* be experienced "in reality."

7. Several critics have found the boy's presence unsettling; Hans Sedlmayr, for instance, describes him as "recalling an executioner": see his "Die 'Macchia' Bruegels," in *Jahrbuch der kunsthistorischen Sammlungen in Wien*, n.f., 8 (1934): 237.

THE SEXUAL RELATION

"October" (detail), *The Grimani Breviary*

1. The training potty of *Children's Games* occupies, in fact, almost exactly the same place as the sacks of grain being sown in the scenes depicted on the "October" pages of both the *Très Riches Heures* and *The Grimani Breviary*. Note also in the two latter images the conspicuous juxtaposition of flat grid and volumetric circle, almost as if the motifs were waiting to be swept into Bruegel's intricate play.

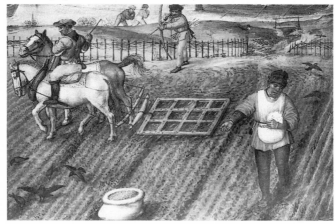

2. The two carrying figures appear to be actual adults, not adultlike children. There is obviously no objective basis for identifying them as the parents of the child they hold, but the nuances of the image—and this holds true even if the larger figures are construed as older children—emphatically suggest a "nuclear" family.

3. Dorothy Dinnerstein, *The Mermaid and the Minotaur* (New York: Harper & Row, 1981), 87.

ASSURANCE

1. The game is usually identified as "carrying an angel" or "Baby Jesus in the little chapel": even at the "named" level the arms house something special.

2. Explanations of the game vary, but in every version the function of the cloth is to select one player from among many. Jeanette Hills is the only commentator who dwells on the idiosyncrasies of Bruegel's image. She identifies the game as one of a group in which two figures stand on either side of a row of seated children and pass a cloth over it, "choosing" one player at a certain moment. She suggests that one end of the cloth is having to be held up by a player within the seated row (Bruegel seems to want to camouflage this fact), because the two gangling boys on the right are deliberately getting in the way. They are not, that is, playing the game but attempting to disrupt it, and thus engaging in yet another game, "teasing girls" (*Das Kinderspielbild von Pieter Bruegel*, 39–41). This interpretation usefully calls attention to the incongruous-looking presence of the two boys, but it seems to me to mistake Bruegel's adjustments for the children's own. The ideas embedded in the image, as we shall see, require the interaction of a single figure and a clustering group, and hinge on the gesture that bridges the gap between them. It may be that the thematic emphasis on these aspects of the image has distorted the original game (if there is one) beyond recognition.

3. The contrast between these two groups is vaguely reminiscent of depictions of *The Pious and the Impious* or *The Christian and the Heathen*, a popular motif in religious imagery of the fifteenth and early sixteenth centuries; Bruegel may have intended the iconographic tradition to

Master of the Nuremberg Passion, *The Christian and the Heathen*, 1540 (Öffentliche Kunstsammlung, Basel)

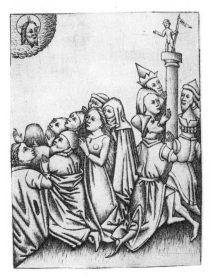

provide a remote connotative link. Or there may be a common underlying iconography of confusion and accord. In the *Grimani Breviary*, on facing pages, "Pentecost" (showing the disciples seated "all with one accord in one place" as the Spirit descends on them with the gift of tongues), is juxtaposed with the building of the Tower of Babel. One wonders if the contrast was a common one. There are, in addition, purely formal correspondences between the two groups in *Children's Games.* The stance and gesture of the cloth holder pointedly resemble those of the "hair puller" on the near left of the group of boys. And the areas in which the two games take place are populated by thematically similar material: the hats being tossed between the boy's legs cross the boundary between the grass and the ocher ground just as the cloth holder's reaching gesture does, and they stamp the grassy area with a "face" in much the same way that the three spinning girls imprint the grassy area near the stream. And both areas contain a small boy "grafted" to a tree trunk.

4. Sixteenth-century boys left gowns for doublet and hose at about seven or eight years of age (although some authorities think that the changeover point was achieved continence—which would add resonance to Bruegel's bare-legged hobbyhorse rider galloping away from the training potty just behind him). This transition marked one of the crossover points in the Ages of Life tradition, which in its most common form distinguished three stages of childhood: *infantia, pueritia*, and *adolescentia.* The first extended through the age of seven or eight, the second terminated at the fourteenth year, and the third was said to last until anywhere from twenty-one through thirty-five, depending on the authority. The two boys in Bruegel's image appear to have just crossed from the first to the second of these stages and to be putting off (or momentarily escaping) that knowledge. For children's costume in the early Renaissance, see Ariès, 15–33; for the Ages of Life tradition, see Elizabeth Sears, *The Ages of Man: Medieval Interpretations of the Life Cycle* (Princeton University Press, 1986).

5. D. W. Winnicott, *Playing and Reality* (London & New York: Tavistock, 1971), passim. The phrase is his term for the objects children use to negotiate the space between the "me" and the "not-me," subjective fantasy and objective reality, enveloping maternal assurance and separate, exposed identity. (Linus's blanket is a popular example.) What "defines" these objects and the power invested in them, according to Winnicott, is the way the questions "Is it real or fantasized?" and "Is it invented or given by the environment?" are pointedly *not* asked of them. His discussion of the way such objects complete and at the same time extend the process of weaning, providing children with a way of taking with them what they leave behind, is richly evocative of the gesture that organizes Bruegel's image.

6. The association of the Virgin's blue mantle with grace and mercy is well established; for the iconography, see Part One, pp. 65–67 and references. But no one, as far as I am aware, has called attention to the green lining or explored its iconographic significance—although Leo Steinberg, in his Mellon lectures on Michelangelo, has speculated brilliantly on the blue and green garments of the *Doni Tondo*'s Madonna. But it is an insistent motif in both the North and the South, from the late fourteenth century on. I have counted twenty green linings beneath a Virgin's blue mantle in the Washington National Gallery alone, and in many cases the artist has devised ingenious means to make just a glimpse of the underlying green visible. One suspects the iconographic presence of early Renaissance ideas about the Virgin as a mediatrix between nature and grace, or between the human and the divine, similar to those which resulted in so many Madonnas placed in landscapes and on grassy banks.

7. Grossmann, *Bruegel*, 191.

8. For the iconography of this gesture, see Moshe Barasch, *Gestures of Despair in Medieval and Early Renaissance Art* (New York University Press, 1976). Many depictions of the Lamentation—Masaccio's, for instance—approximate the girl's gesture even more closely. But the Piero uncannily makes visible the Crucifixion image sublimated in Bruegel's pair and seems to unfold all the *differential* gestures subsumed in the girl's widespread arms. It is also interesting that in its original setting the Piero Crucifixion sat atop a representation of the Virgin of Mercy, whose dimensions all but dwarf it.

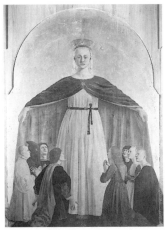

Piero della Francesca, *The Virgin of Mercy* (central panel of the Polyptych of the Misericordia, Palazzo Comunale, Borgo San Sepolcro)

9. Small girls make this gesture in two other paintings by Bruegel, and in both cases it is similarly indeterminate. In the left middle background of *The Battle between Carnival and Lent*, three children in a circle gesture extravagantly toward a boy who stands on a barrel above them and drinks from a tankard. Bruegel gives us at least three interpretations to choose from: the children on the ground may be celebrating the boy as their own post-Epiphany king, or clamoring for some of the drink he gluttonously hoards, or anticipating—with either glee or warning shouts—the dousing he is about to take from a bucket being emptied on him (accidentally or on purpose?) from above.

Bruegel, *The Battle between Carnival and Lent* (detail)

The gesture reappears several years later in *The Numbering at Bethlehem*, where a small solitary girl in the far-right distance stands at the edge of a frozen pond and flings her arms open in another wide embrace. The ambiguity here is even closer to that of the gesture in *Children's Games*. She may be flapping her arms at the birds which walk unfazed on the pond (is she trying to scatter them or evoke in herself their power of flight?), but her gesture, like the girl's in *Children's Games*, exceeds its mundane context and reaches out toward all reality. If one follows the shoreline down into the right foreground, one discovers there the girl's "negative" counterpart, in the person of a small boy who stands at the lake's edge with his arms dangling at his sides, the very epitome of abject excludedness.

 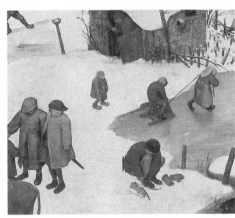

10. At least one contemporary "Ages of Man" cycle depicts under "Infantia" a mother standing just behind a small child, holding its hands from above as she helps it walk; after this comes the next stage in the learning (or weaning) process, with the child now alone, walking with the aid of a wooden helper. Even closer to Bruegel's image is a Catalan painting which depicts an angel teaching the Child Jesus to walk; a drawing of the latter is reproduced in Georgiana Goddard King, "The Virgin of Humility," *Art Bulletin* 17 (1935): 475.

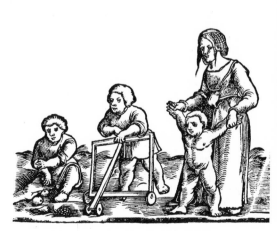 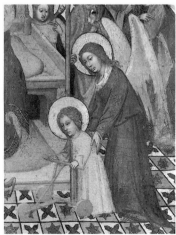

11. Hindman, subscribing to the view that all blue coverings are signs of deception and folly, reads the image differently: "The last male in the baptismal procession likewise wears a blue cloak, not only symbolizing deceit, but also suggesting that he may be an unsuspecting cuckolded husband, who parades as the natural father of the baptismal infant" ("*Children's Games*, Folly, and Chance," 452). This interpretation seems to me to lack intuitive feel for either the nuances of the image or its relevant iconographic background.

12. Erasmus, "Knucklebones, or the Game of Tali," *The Colloquies*, 432–40.

13. For a reproduction, see Hindman, 462, fig. 20.

14. Roberto Mangabeira Unger, *Passion: An Essay on Personality* (New York: Free Press, 1984), 270.

Bibliography

Alpers, Svetlana. "Bruegel's Festive Peasants." *Simiolus* 6 (1972–73), 163–76.

———. "Taking Pictures Seriously: A Reply to Hessel Miedema." *Simiolus* 10 (1978–79), 46–50.

Ariès, Philippe. *Centuries of Childhood: A Social History of Family Life*, tr. Robert Baldick (New York: Knopf, 1962).

Barasch, Moshe. *Gestures of Despair in Medieval and Early Renaissance Art* (New York University Press, 1976).

Barnouw, Adriaan J. *The Fantasy of Pieter Brueghel* (New York: Lear, 1947).

Baxandall, Michael. *The Limewood Sculptors of Renaissance Germany* (New Haven: Yale University Press, 1980).

———. *Painting and Experience in Fifteenth-Century Italy: A Primer in the Social History of Pictorial Style* (1972; Oxford: Oxford University Press, 1974).

Bedaux, Jan Baptiste. "The Reality of Symbols: The Question of Disguised Symbolism in Jan van Eyck's *Arnolfini Portrait*." *Simiolus* 16 (1986), 5–28.

Benesch, Otto. *The Art of the Renaissance in Northern Europe*, rev. ed. (1947; London: Phaidon, 1965).

Berrong, Richard M. "Rabelais's *Quart Livre*: The Nature and Decline of Social Structure." *Kentucky Romance Quarterly* 28 (1981), 139–54.

Blake, William. *The Complete Writings of William Blake*, ed. Geoffrey Keynes (London: Oxford University Press, 1966).

Bowen, Barbara. *The Age of Bluff: Paradox and Ambiguity in Rabelais and Montaigne* (Urbana: University of Illinois Press, 1972).

Brumble, H. David, III. "Pieter Bruegel the Elder: The Allegory of Landscape." *Art Quarterly*, n.s. 2 (1979), 125–39.

Brummel, L., ed. *Sinnepoppen van Roemer Visscher* (The Hague: M. Nijhoff, 1949).

Calvin, John. *The Institutes of the Christian Religion*, Vols. 20–21 (ed. John T. McNeill, tr. Ford Lewis Battles), in *The Library of Christian Classics*, 26 vols. (1953; London: S.C.M. Press, 1960).

Carroll, Margaret. "Peasant Festivity and Political Identity." *Art History* X (1987), 289–314.

Claessens, Bob, and Jeanne Rousseau. *Our Bruegel* (Antwerp: Mercatorfonds, 1969).

Colie, Rosalie. *Paradoxia Epidemica: The Renaissance Tradition of Paradox* (1966; Princeton University Press, 1996).

Delen, A.J.J. *Iconographie van Antwerpen* (Brussels: L. J. Kryn, 1930).

Delevoy, Robert L. *Bruegel: Historical and Critical Study*, tr. Stuart Gilbert (Geneva: Skira, 1969).

Demus, Klaus. *Flämische Malerei von Jan van Eyck bis Pieter Bruegel d. A.: Katalog der Gemäldegalerie* (Vienna: Kunsthistorisches Museum, 1981).

Dinnerstein, Dorothy. *The Mermaid and the Minotaur* (New York: Harper & Row, 1981).

Dixon, Laurinda S. *Alchemical Imagery in Bosch's "Garden of Delights." Studies in the Fine Arts: Iconography* No. 2 (Ann Arbor: UMI Research Press, 1981).

Dundes, Alan, and Claudia A. Stibbe. *The Art of Mixing Metaphors: A Folkloristic Interpretation of the "Netherlandish Proverbs" by Pieter Bruegel the Elder. FF Communications* XCVII, no. 230 (Helsinki: Academia Scientiarium Fennica, 1981).

Edgerton, Samuel Y., Jr. *Pictures and Punishment: Art and Criminal Prosecution During the Florentine Renaissance* (Ithaca: Cornell University Press, 1985).

Elias, Norbert. *The History of Manners*, Vol. I of *The Civilizing Process*, originally published as *Uber den Prozess der Zivilization* (1939; New York: Pantheon, 1978).

Empson, William. *The Structure of Complex Words* (London: Chatto & Windus, 1951).

Erasmus, Desiderius. *The Colloquies*, tr. Craig Thompson (University of Chicago Press, 1965).

———. *The Praise of Folly*, tr. Hoyt Hopewell Hudson (1941; Princeton University Press, 1970).

Erikson, Erik. *Identity, Youth, and Crisis* (New York: W. W. Norton, 1968).

Foote, Timothy. *The World of Bruegel: Thinking in Images* (New York: Time-Life Books, 1968).

Fox, R. C. "Milton's *Lycidas* 192–193." *Explicator* 9 (1951), item 54.

Freud, Sigmund. *Civilization and Its Discontents*, Vol. 21 in *The Standard Edition of the Complete Psychological Works of Sigmund Freud*, 24 vols., tr. James Strachey et al. (London: Hogarth Press, 1974).

Gaignebet, C. "Le Combat de Carnival et de Carême de P. Bruegel (1559)." *Annales: Economies, Sociétés, Civilisations* 27 (1972), 313–45.

Gibson, Walter S. *Bruegel* (New York and Toronto: Oxford University Press, 1975).

———. "Bruegel, Dulle Griet, and Sexist Politics in the Sixteenth Century," in *Pieter Bruegel und Seine Welt*, eds. Otto von Simson and Matthias Winner (Berlin: Gebr. Mann Verlag, 1979), 9–15.

Gluck, Gustave. *Bruegels Gemälde* (Vienna: A. Schroll & Co., 1932).

Goffman, Erving. *Gender Advertisements* (New York: Harper & Row, 1979).

Goodman, Nelson. *Ways of Worldmaking* (Indianapolis: Hackett Publishing Co., 1978).

Grauls, J. *Volkstaal en volksleven in het werk van Pieter Bruegel* (Antwerp: Standaard Boekhandel, 1957).

Grossmann, F. *Pieter Bruegel: Complete Edition of the Paintings*, 3rd rev. ed. (1955; London and New York: Phaidon, 1973).

———. "Pieter Bruegel the Elder." *Encyclopedia of World Art*, 15 vols., ed. Bernard Samuel Myers (New York: McGraw-Hill, 1959–c. 1983).

Hartman, Grietje, and Ellen Lens. *Hééé joh! kom je buiten spelen: De spelregels bij "De kinderspelen" van Pieter Bruegel de Oude* (Amsterdam: Bert Bakker, 1976).

Haydn, Hiram. *The Counter-Renaissance* (New York: Scribner, 1950).

Hills, Jeanette. *Das Kinderspielbild von Pieter Bruegel d. A.: Eine volkskundliche Untersuchung* (*Veröffentlichungen des Österreichischen Museums für Volkskunde* X) (Vienna: Österreichischen Museums für Volkskunde, 1957).

Hindman, Sandra. "Pieter Bruegel's *Children's Games*, Folly, and Chance." *Art Bulletin* 63 (1981), 447–75.

Huizinga, J. *Homo Ludens: A Study of the Play Element in Culture* (1938; Boston: Beacon Press, 1950).

———. *The Waning of the Middle Ages: A Study of the Forms of Life, Thought, and Art in France and the Netherlands in the XIVth and XVth Centuries* (1919; New York: St. Martin's Press, 1924).

Jordan, Constance. *Renaissance Feminism: Literary Texts and Political Models* (Ithaca: Cornell University Press, 1990).

Kaiser, Walter. *Praisers of Folly: Erasmus, Rabelais, Shakespeare* (Cambridge, Mass.: Harvard University Press, 1963).

Kelly, Joan. *Women, History, and Theory: The Essays of Joan Kelly* (University of Chicago Press, 1984).

King, Georgiana Goddard. "The Virgin of Humility." *Art Bulletin* 17 (1935), 474–91.

Kristeva, Julia. *Powers of Horror: An Essay on Abjection*, tr. Leon S. Roudiez (New York: Columbia University Press, 1982).

Landwehr, John. *Emblem Books in the Low Countries 1554–1949: A Bibliography* (*Bibliotheca Emblematica*, III) (Utrecht: Haentjens Dekker & Gumbert, 1970).

Laquer, Thomas. "Orgasm, Generation, and the Politics of Reproductive Biology." *Representations* 14 (1986), 1–16.

Lebeer, Louis. "De blauwe Huyck." *Gentsche Bijdragen tot de Kunstgescheidenis* 6 (1939–40), 161–229.

Lennep, Jan van. "L'Alchimie et Pierre Bruegel l'Ancien." *Bulletin des Musées Royaux des Beaux-Arts des Belgiques* 14 (1965), 105–26.

Lewalski, Barbara Kiefer. *Protestant Poetics and the Seventeenth-Century Religious Lyric* (Princeton University Press, 1979).

Lindsay, K. C., and B. Huppé. "Meaning and Method in Brueghel's Painting." *Journal of Aesthetics and Art Criticism* 14 (1956), 376–86.

Maclean, Ian. *The Renaissance Notion of Woman: A Study in the Fortunes of Scholasticism and Medical Science in European Intellectual Life* (Cambridge University Press, 1980).

Marcus, Leah Sinanoglou. *Childhood and Cultural Despair: A Theme and Variations in Seventeenth-Century Literature* (University of Pittsburgh Press, 1978).

Marijnissen, Roger H., and Max Seidel. *Bruegel* (New York: Harrison House, 1984).

Merchant, Carolyn. *The Death of Nature: Women, Ecology, and the Scientific Revolution* (San Francisco: Harper & Row, 1980).

Meyere, Victor de. *De Kinderspelen van Pieter Bruegel den Oude verklaard* (Antwerp, 1941).

Miedema, Hessel. "Realism and the Comic Mode: The Peasant." *Simiolus* 9 (1977), 205–19.

Monballieu, A. "*De Kermis van Hoboken* bij P. Bruegel, J. Grimmer en G. Mostaert." *Jaarboek Koninklijk Museum voor schone Kunsten Antwerpen* (Antwerp: het Koninklijk Museum, 1974), 139–69.

Montaigne, Michel de. *The Complete Essays of Montaigne*, tr. Donald Frame (Stanford University Press, 1958).

More, St. Thomas. *Utopia*, eds. Surtz, E., S.J., and J. H. Hexter, Vol. 4 in *The Yale Edition of the Complete Works of St. Thomas More*, 16 vols. (New Haven: Yale University Press, 1965).

Moxey, Keith. *Pieter Aertsen, Joachim Beuckelaer, and the Rise of Secular Painting in the Context of the Reformation* (New York: Garland, 1977).

———. "Sebald Beham's Church Anniversary Holidays: Festive Peasants as Instruments of Repressive Humor." *Simiolus* 12 (1981–82), 191–213.

Murray, John J. *Antwerp in the Age of Plantin and Brueghel* (The Centers of Civilization Series 27) (Norman: University of Oklahoma Press, 1970).

Nauert, Charles G. *Agrippa and the Crisis of Renaissance Thought* (Urbana: University of Illinois Press, 1965).

Nietzsche, Friedrich. *Daybreak: Thoughts on the Prejudice of Morality*, tr. R. J. Hollingdale (Cambridge University Press, 1982).

O'Loughlin, Michael. *The Garlands of Repose* (University of Chicago Press, 1978).

Oyer, John S. *Lutheran Reformers Against Anabaptists* (The Hague: M. Nijhoff, 1964).

Ozment, Steven E. *Mysticism and Dissent: Religious Ideology and Social Protest in the Sixteenth Century* (New Haven: Yale University Press, 1973).

———. *When Fathers Ruled: Family Life in Reformation Europe* (Cambridge, Mass.: Harvard University Press, 1983).

Panofsky, Erwin. *Early Netherlandish Painting*, 2 vols. (1953; Cambridge: Harvard University Press, 1971).

———. *Perspective as Symbolic Form*, tr. Christopher S. Wood (1927; New York: Zone Books, 1991).

Pollock, Linda A. *Forgotten Children: Parent-Child Relations from 1500 to 1900* (Cambridge University Press, 1983).

Rabelais, François. *The Histories of Gargantua and Pantagruel*, tr. J. M. Cohen (Harmondsworth and New York: Penguin Books, 1955).

Reiss, Timothy. *The Discourse of Modernism* (Ithaca: Cornell University Press, 1982).

Riedemann, Pieter. *Account of Our Religion, Doctrine, and Faith* (1540–41), 2nd English ed. (Rifton, N.Y.: Plough Publishing House, 1974).

Schama, Simon. *The Embarrassment of Riches: An Interpretation of Dutch Culture in the Golden Age* (New York: Knopf, 1987).

Screech, M. A. *The Rabelaisian Marriage: Aspects of Rabelais's Religion, Ethics and Comic Philosophy* (London: Arnold, 1958).

Sears, Elizabeth. *The Ages of Man: Medieval Interpretations of the Life Cycle* (Princeton University Press, 1986).

Sedlmayr, Hans. "Die 'Macchia' Bruegels." *Jahrbuch der kunsthistorischen Sammlungen in Wien*, series 2, N.F. VIII (1934), 237–59.

Shakespeare, William. *The Tragedy of Coriolanus*, ed. R. B. Parker (Oxford and New York: Clarendon Press, 1994).

Steadman, John M. *The Hill and the Labyrinth: Discourse and Certitude in Milton and His Near-Contemporaries* (Berkeley: University of California Press, 1985).

Stechow, Wolfgang. *Pieter Bruegel, the Elder* (New York: H. N. Abrams, 1955).

Steinberg, Leo. "Guercino's *Saint Petronilla*." *Studies in Italian Art History* 1 (1980), 207–34.

Strauss, Gerald. *Luther's House of Learning: Indoctrination of the Young in the German Reformation* (Baltimore: Johns Hopkins University Press, 1978).

Stridbeck, Carl Gustav. *Bruegelstudien: Untersuchungen zu den ikonologischen Problemen bei Pieter Bruegel d. A.* (*Acta Universitatis Stockholmiensis. Stockholm Studies in the History of Art*, II) (Stockholm: Almquist & Wiksell, 1956).

Sullivan, Margaret A. "Madness and Folly: Pieter Bruegel the Elder's *Dulle Griet*." *Art Bulletin* 59 (1977), 55–66.

———. "Pieter Bruegel the Elder's *Two Monkeys*: A New Interpretation." *Art Bulletin* 63 (1981), 114–26.

Swain, Barbara. *Fools and Folly during the Middle Ages and Renaissance* (New York: Columbia University Press, 1932).

Thomas, Keith. *Religion and the Decine of Magic* (New York: Scribner, 1971).

Tietze-Conrat, E. "Pieter Bruegels Kinderspiele." *Oudheidkundig Jaarboek*, II, series 4 (1934), 127–31.

Tolnay, Charles de. *The Drawings of Pieter Bruegel the Elder*, 2nd rev. ed. (1925; New York: Twin Editions, 1952).

———. *Pierre Bruegel l'Ancien*, 2 vols. (Brussels: Nouvelle Société d'Editions, 1935).

Unger, Roberto Mangabeira. *Passion: An Essay on Personality* (New York: Free Press, 1984).

Verheyden, A.L.E. *Anabaptism in Flanders, 1530–1650: A Century of Struggle* (*Studies in Anabaptist and Mennonite History* 9) (Scottdale, Pa.: Herald Press, 1961).

Welsford, Enid. *The Fool: His Social and Literary History* (London: Faber, 1968).

Wenger, J. C., tr. and ed. "Two Kinds of Obedience: An Anabaptist Tract on Christian Freedom." *Mennonite Quarterly Review* 21 (1947), 18–22.

Williams, George Hunston. *The Radical Reformation* (Philadelphia: Westminster Press, 1962).

Winnicott, D. W. *Playing and Reality* (London and New York: Tavistock, 1971).

Woodbridge, Linda. *Women in the English Renaissance: Literature and the Nature of Womankind, 1540–1642* (Urbana: University of Illinois Press, 1984).

Wright, Elizabeth. *Psychoanalytic Criticism: Theory in Practice* (London and New York: Methuen, 1984).

Zupnick, Irving L. "Appearance and Reality in Bruegel's Virtues." *Evolution générale et développements régionaux en histoire de l'art in Actes du XXIIᵉ Congrès International d'Histoire de l'Art, Budapest, 1969*, 3 vols. (Budapest: Akademiai Kiado, 1972), I, 745–53.

Index of Games

General Index

WORKS BY BRUEGEL ARE LISTED BY TITLE

PAGE NUMBERS IN ITALICS REFER TO ILLUSTRATIONS